Acting and Performance for Animation

Acting and Performance for Animation

Derek Hayes

Chris Webster

Focal Press
Taylor & Francis Group

NEW YORK AND LONDON

First published 2013
by Focal Press
70 Blanchard Road, Suite 402, Burlington, MA 01803

Simultaneously published in the UK
by Focal Press
2 Park Square, Milton Park, Abingdon, Oxon OX14 4RN

Focal Press is an imprint of the Taylor & Francis Group, an informa business

Library of Congress Cataloging-in-Publication Data
Hayes, Derek.
 Acting and performance for animation / Derek Hayes and Chris Webster.
 pages cm
 ISBN 978-0-240-81239-7 (paper back)
 1. Animated films. 2. Motion picture acting. 3. Animation (Cinematography) I. Webster, Chris, 1954– II. Title.
 NC1765.H34 2013
 777'.7—dc23

 2012043270

ISBN: 978-0-240-81239-7 (pbk)
ISBN: 978-0-080-96217-7 (ebk)

Typeset in MyriadPro
Project Managed and Typeset by diacriTech

Contents

Contents

Contents

Acknowledgments

The Authors

One would have thought that two grown men, supposed experts in their field would find writing a book on a subject that they have practiced and taught for many years would find the task an easy one. Not so. It seemed to us all those months (years) ago when we set out on this venture that this would be, if not exactly a walk in the park, than surely something well within our capabilities. Sad to relate that, without the firm guiding hand and stabilizing influence that we received from our younger and betters, we would have been all at sea. Thankfully enough, we found not only the necessary guidance and stability but encouragement, support, and patience initially from Katy Spencer at Focal Press who was foolish enough in the first place in agreeing for us write this book. When Katy left for pasture new (or to get away from us, we never could be sure), David Bevans manfully stepped into the breach and saw the project to fruition. His calming influence and great organization saw us through the tense final stages. Our text editor Beth Millet deserves not only our admiration and respect, but also a medal as large as a frying pan for her sterling work on turning our almost random thoughts and scribbling into something resembling a coherent text. She did this with tact, diplomacy, and a level of patience while balancing her own very busy family life. How she managed to get any kind of sense out of us I will never know, at times it must have been rather like herding cats. She is clearly not paid enough.

The initial meetings between us, the authors, lead to conversations completely tangential to the purpose of the book, and we always found ourselves in discussions that descended or transcended, depending upon your point of view into joyous anarchy. There was always quite a lot of laughter involved though not a great deal of progress. While a degree of confusion, indecision, and uncertainty is perhaps to be expected in the elderly, it was a surprise that these qualities permeated the entire development process. Given that a willful procrastination followed hot on the heels of these qualities, it is something of a minor miracle that you are now reading this.

Both authors thank all the people for their contributions to this book, naturally the interviewees for the insight into their individual practice and the often strange ways of a strange industry and the individuals who have supplied and selflessly allowed us to use images from their films and their development work. They have our undying gratitude and thanks.

Derek Hayes

I'd like to thank my wife, Lee, for her wholehearted support for my intention to write this book. I'd like to say but sadly her first words to me when I told her I had agreed to co-author a book on Acting and Performance for Animation

were; "Why do you want to do that; you hate writing?" Not quite true, I like writing scripts, I like writing treatments and proposals for films but, true enough when it comes to other things. Nevertheless, she has been, before, during, and after what we now have to refer to as "the book episode," a constant source of strength, encouragement, and love, and I would have been able to do nothing without her.

As for my collaborator, Chris Webster is one of the most inspiring people I know, and any time I got lost in my attempts to actually write something that made sense, he would be there to encourage, revitalize, and point out a new way forward. That, and make me laugh at the same time. His students are very fortunate people; I hope they know that.

I'd also thank the people I work with at Falmouth University, Andy Wyatt, Kathy Nicholls, Georg Finch, and Ann Owen, for their support and friendship and all the students I have taught for helping me understand what it is I actually know and how to put it into words. After working in animation for so long, it is the people I have worked with at Animation City and beyond who have been my teachers; my gratitude to them is immense.

Finally, I cannot fail to acknowledge the debt I owe to Phil Austin who got me into animation and taught me so much in the eighteen years we worked together before he left us. Love you mate.

Chris Webster

Undertaking a project such as this is at best foolhardy, whilst attempting to balance it with a full time job, one's own animation practice and research, family commitments, conferences in China, and the all-important fishing trips demonstrates not simply a foolhardiness but is more likely to be symptomatic of the deterioration of brain function. Given my low-level starting point, the thought of further deterioration is startling. The credit for this book, if any credit is due, must in all fairness be shared with a whole range of people while any blame belongs squarely with me and my fellow conspirator and author Derek Hayes.

While the task of writing this, for me at least, has been a huge one, the results of my efforts remain rather modest. Even these would not have been possible without the support of those around me, principally that of Derek Hayes. I have known Derek for more years than I care to think about, and I have always been a great admirer of his work. To get the opportunity to work alongside him on this has been a great privilege and honor. I have learned so much from him. If there is anything of value within these pages, it belongs to Derek, and if you find fluff and waffle, you have found my contribution. Without his many kindnesses and support (and despite his almost incessant jibes and comments about my Yorkshire heritage), I could not have made this meager contribution, so thank you Derek.

I thank all my colleagues in the Bristol School of Animation within the University of the West of England, who once again have shown me support and levels of patience that makes them very valued friends: Rachel Robinson, John Parry, Arril Johnson and Julia Bracegirdle, Mary Murphy and Ian Friend.

I must give a huge thanks to all my students, the current ones and the many graduates I have seen over many years (far too many to count let alone list) complete their studies and enter the industry. I thank them not simply for their practical assistance with providing images for the book but for keeping me inspired and for keeping the love of animation, design, and film alive within me.

As always my family deserve to be mentioned because without their love and support *nothing* would be possible. I am eternally grateful that my three children Marc, Richard, and Rachel still manage after all these years to tolerate their old man. It is my wife Pauline who is most deserving of my gratitude and all of my love. Being married to me, she has a lot to put up with, even so she is always there to support me in everything I do. It is to my darling wife that I dedicate my part of this book.

Introduction

For me, one of the most wonderful things about animation is that we can create a character from pencil, paint, clay, or pixels and then make an audience believe in him to the point where they laugh and cry along with him. As with any art, we hope to touch our fellow humans and to do that we have to convince them of the reality of our characters. Where does that reality reside? Obviously, we are going to be talking about acting and the way the characters perform on screen and making an engaging personality is essential, whether that personality is a hero or a villain, but how can we construct a living being that is more than a puppet controlled by our off-screen hand? It is easy to see how an actor on stage is an independent person because, even when playing a set role, the hand of the director is not obviously present, unless the production is over-burdened with an overwhelming set or odd staging, and the actor seems free to vary the performance. There is an opportunity to react to the audience, to allow for a response like laughter, for example, and there is the unacknowledged possibility that something might go wrong every time the play is performed. In live-action, we are watching actors again, but there is little that can go wrong here, at least within the film itself, but we still feel that the characters have a life of their own. As long as the script and direction don't hem them in with too many implausible moments that challenge our suspension of disbelief, we will continue to believe in the characters within the film story.

With animation it is sometimes harder to get an audience to buy in to the reality of the players, even though they are very willing to try, because we are starting with figures they know to be constructed, so we have to be clever in the way we deploy the tricks of our trade to help create a believable character in a believable world.

Animation Principles

When students start to learn to animate, they will often begin with classic exercises like the Bouncing Ball and the character walk. They will, at some point, come into contact with the idea of the 12 Animation Principles, developed at the Disney studios and still in use throughout the animation industry from Pixar to Aardman as well as in the 2D studios where we might expect to find them.

The 12 principles are

1. Squash and Stretch
2. Anticipation
3. Staging
4. Straight Ahead Action and Pose to Pose

5. Follow Through and Overlapping Action
6. Slow In and Slow Out
7. Arcs
8. Secondary Action
9. Timing
10. Exaggeration
11. Solid Drawing
12. Appeal

Apart from the final one, Appeal, which is based on the idea that characters be well designed, with interesting and distinct personalities, the Principles tend toward the functional, the purely technical (in a movement rather than a technological sense). They are all essential to the creation of a well animated character, but a too tight focus on technique can lead to characters that move well while being inexpressive, that go through the motions while failing to connect with the audience as believable personalities. Without a good performance, the animation will have less impact and the idea will fall flat. For John Kricfalusi, even "stock animation acting" can be missing from many animated films and TV shows.

I believe the key to creating a real, living character lies in the word **autonomy**, from the Greek, "one who gives himself his own law," or self-government. For me, this means that the characters must appear to be independent of the film maker's control, able to make their own decisions, and not entirely predictable; they should appear to have an interior life and appear capable of thinking and feeling.

In this book, we work through all the ways a good, and appropriate, performance can be achieved, from the use of the camera to follow rather than lead the character to the ability to perceive the thought process at work in a moment of silence.

Becoming an Animator

The road to becoming an animator is a long and convoluted affair and as varied as the individual animators travelling along it. It would be impossible and a complete waste of time for us to attempt to define exactly what it means to be an animator, as "being an animator" means so many different things to each and every one of us. While we may have reached different destinations, but interestingly many of us may share a common starting point.

We usually begin, at a very early age, scribbling simple shapes with crayons. These scribbles and simple shapes usually start off as little more than irregular circles or a series of wobbly lines, and soon enough they begin to be arranged into loose forms that become "mummy and daddy" or "dog" or "house." Each step of the way, we are not only learning more and more about our environment, but through this form of play, we are also learning how to use tools and,

just as importantly not simply, *how* to express ourselves creatively, but we begin to recognize that we *can* express ourselves creatively.

What form this creativity takes and in which direction we apply it varies from individual to individual, drawing, singing, dancing, storytelling, model making, or one of a thousand different activities including areas of science and business (creativity is clearly not limited to those within the arts). This may result in an individual initially being drawn toward one area or another for a variety of reasons, though many creative individuals are likely to express their creativity in various ways and through more than one medium. No doubt had the technology existed Leonardo de Vinci and Michelangelo would both have been first rate animators.

While we may be attracted to working in different medium and using different processes and expressing our creativity in different ways, I believe that we all have something fundamental in common. We share a creative "urge" to which we demonstrate a primary response to those creative challenges that may also be shared but at the same time are distinctive to the individual practitioner. We also share the very real pleasure that meeting these creative challenges brings. It is this never ending challenge and the pleasurable pain (often accompanied by frustration) that this brings that keeps the enthusiasm keen and the creative spark shining bright.

Whichever route we took to become animators and regardless of the disciplines we work in, as animators we now face many of the same concerns, difficulties, and creative challenges. When we first set out to become an anima-tor, the development of craft skills and all of those issues that are related to the simple task of actually getting things to move on screen were probably upper-most in our mind. And let's face it there are a great many of these challenges. For some of the lucky ones, the technology of animation presented little difficulty and that may even have been what first attracted them to animation. For them, the technology may be more of a route to creativity, rather than a barrier. For others (I count myself amongst their numbers), technology may seem to be much more than a challenge and more like a curse, an obstacle to overcome at best and at worse a necessary evil we need to face down in order for us to achieve our creative goals. But the technology associated with film and animation is only one of many areas that we need to deal with.

Animation is more often than not dependent upon quite a broad range of skills and techniques. One mistake that students of animation make is in believing they must become experts in absolutely every aspect of animation production. Well we are here to tell you right here and right now that this just isn't so. Let's consider for a moment just a few of the processes that may be involved in creating even the most modest animated films. Naturally enough, some of these processes will vary depending on technique and discipline, but many of them are common to all forms of animation. Working through in no particular order: concept design, script writing, script editing, directing, storyboarding and cinematography, art direction and concept art, character

design, sound design, backgrounds and set design, production, production management, sound recording, sound editing, animatics, model making, rigging, texturing, blocking animation, editing. Oh yes, and then there is the little problem of animation.

It's quite a list isn't it, and what is excluded from the list are any of the related technical requirements such as color grading, sound dub, sound effects, music, rendering, exporting to different formats. The list goes on. I won't even attempt to list all of the other very important roles associated with commissioning, financing, and distribution of the films.

If we consider for a moment the process of live action film making, no one would expect an individual to become an expert in all of these different areas, yet many of the animation students we meet get the idea into their heads that it is not only necessary for them to become expert in all of these but it is VITAL if they are to become a professional. It isn't. This misconception can prove to be very stressful particularly for young animators when they first begin to study animation and discover for the first time all that animation production entails. True, they will benefit from an understanding of these processes and how they relate to one another within a production, particularly when they are considering their career options, but they don't need to know everything let alone become an expert in every process. Perhaps this misguided notion stems from the way that some animators are seen to work as artists, and as artists are entirely responsible (or *appear* to be entirely responsible) for all aspects of their work. Clearly a small number of them are; many more are not.

Animation is a very broad church, and within it there are many different disciplines each involving a different set of techniques, methodologies, and processes. Not all animation involves performance-based character animation of course, but a great deal of animation product does. Acting is a critical part of those productions, while for other forms of animation, it is not at all appropriate. This text is aimed at helping in a very practical way with the issues related to acting and performance.

Becoming an Actor

This book takes a look at the issues around acting and performance from the perspective of the animator. Animators do not get out on stage in front of an audience or stand in front of the camera alongside other actors. Instead, we send our puppets, drawings, or pixels out into the wide world to do the job for us.

Despite the fact that they do not perform directly for an audience, animators working with character-based performance animation ARE actors. Unlike the many actors of stage and screen that become well known, the vast majority of animators remain quite anonymous though the characters that we play and even some of our individual performances may actually be better known than our "real life" counterparts. Many millions of people around the world

are familiar with Mickey Mouse and many of these will remember his performance in *Steamboat Willy* (1928), yet how many are familiar with the name Ub Iwerks? How many of us will remember key moments in animation history that made such an impact on our lives, moments such as when Mowgli left the jungle to join the "man village" in *Jungle Book* (1967), or the occasion when Buzz Lightyear first meets Woody in *Toy Story* (1995). The fiery relationship between Bugs Bunny and Daffy Duck or the mad antics of Ren and Stimpy and any one of a thousand moments in the Simpsons demonstrate the very real and tangible nature of these characters. These characters are not only believable they are real, we know them, we recognize them for who they are, and maybe we even recognize something of ourselves in them.

We could go as far as to suggest that the greatest performances of the animator easily match those created by any of the finest "real" actors. If flexibility can be used as one criterion for defining a good actor, then surely the demands placed on the animator offer them the opportunity to show their acting abilities. How many "real" actors are regularly required to undertake roles that cross gender or race, or cover age ranges from 1 to 101, let alone creating a performance across *species*. Animators are also asked to create character-based performances using inorganic objects and even abstract shapes that not only imbues them with a personality but makes them completely believable. Chuck Jones did exactly that with the film *The Dot and the Line* (1965).

Acting and performance is such a large topic with many different disciplines that we could not hope to cover it fully within this text. We will, therefore, be concentrating on acting as it relates to animation and different animated forms, though even this is a major undertaking. The practical aspects of animation may differ within each discipline, and the constraints placed on the stopframe animator are very different from those working in CG animation. However, many of the issues that relate to performance and acting are common to *all* animation techniques. We will not be telling you how to make a humorous performance by altering slider controls within a software package or recommending a particular type of pencil to make your characters more engaging. There are NO shortcuts to developing your craft, and there are NO formulas to follow. There is no technology that will provide you with the acting skills; they come from within. However, as with animation timing skills, performance and acting skills are completely transferable. Good acting is good acting regardless of the animation process.

We will be taking a look at many practical aspects of acting and performance. We hope it provides some very real and useful tools for the aspiring animator / actor backed up with real examples and case studies. The text will provide you with some very thought provoking issues that will encourage a deeper exploration and development of the art from we love. We do not expect you to agree with everything we say or propose; you will have your own ideas on these topics and that is the entire point. We are not trying to lay down rules or principles here, but what we do want to achieve is a text that helps the animator move forward in their own way as an animator and performer and actor.

xvii

Becoming a Storyteller

It seems to us that there is very little difference between what we do as animators and what our ancestors did when they gathered around a fire in family groups. They told one another stories. They built mythologies, created legends, passed on vital information, gave instruction, and entertained. It became a vital part of all our different races, passing down traditions and histories through which we began to build a group identity, create societies, and develop cultures. We are still doing that to this very day.

Much of animation production, certainly performance-based animation, is first and foremost a form of entertainment, and central to most animation entertainment is storytelling. While action has a vital role to play in anima-tion and in storytelling, entertainment and action are not necessarily the same things. Action alone may be considered as entertaining; consider for a moment the spectacle of a fireworks display or the beautiful abstract animation of Oscar Fischinger, both are highly entertaining though neither necessarily constitute a story. Naturally, all animation depends on the move-ment of characters and objects, but it does not necessarily depend on the use of movement in just one way. Action, in its simplest form, may be nothing more than the movement of objects through time and space without any need at all for an emotional engagement on the part of the audience. This is not acting. It is the engagement of the audience on an emotional level that underpins storytelling and is the foundation of acting and performance.

In order for a character to become interesting, we need at least to understand them, not necessarily to like them, and actually in some instances, it is vital that we don't like the characters. We will be covering this at some length. Let's face it the reason that millions of people go to the movies to watch animated feature films every year is not because of the great animation or even the eye watering technology being used. It's for one thing and one thing alone: story. This is timeless and regardless of the advances in technology, the ways in which we make animation and despite the ways in which we consume anima-tion, audiences will continue to be drawn to animation for the same reasons they have always been drawn to it: stories. Interesting stories full of interesting people doing interesting things.

There is a reasonable illustration of this that I have written elsewhere but still hold good for the purpose of this text and demonstrates simply how storytell-ing determines the success of an animated film.

Good Idea + Poor Animation = Good Film
Poor Idea + Good Animation = Poor Film
Poor Idea + Poor Animation = Stinker
Good Idea + Good Animation = Award Winner

I hasten to add here that this is not a formula for making a successful thing. Of course, the one thing missing from the illustration is acting and performance.

Without a good acting performance, the idea, no matter how good, is likely to be left dead in the water or, at the very least, it will not reach its full potential. It remains necessary that the animation is delivered through a good performance.

Now what exactly creates a good performance is open to interpretation and discussion. Rather than categorizing a performance in a way that dictates certain traits that equate to a good performance, it would perhaps be better to look at appropriate performances. Drama is often very different from comedy and not all dramas or comedies are the same. Rather like animation timing, a certain approach to acting will prove to be more suitable to one film than another. Let's compare the rather simplistic animation performances within *South Park* to the far more elaborate performance used in *The Incredibles*. The simplicity of the animation seen in *South Park* may not be suited to bringing out all of the complexity of story and characterization we see in *The Incredibles*. Likewise, the highly crafted and subtle timing and acting of *The Incredibles* would probably subvert the almost anarchic and stripped back designs in *South Park*; it just wouldn't be as funny. *South Park* is brilliant *because* the animation performance is simple not despite it.

Becoming a Creative Practitioner

Millions of people spend billions of dollars each year to enjoy feature films and other media. By and large they do not do this because of the technology; they do it because they enjoy storytelling and because they enjoy things that are new and intriguing. As a result, we see trends take shape after the success of a forerunner. For example, the use (or should I say reuse) of 3D projection in James Cameron's *Avatar* (2009) and the many more 3D films in its wake.

But audiences will quickly tire of or accept as normal the latest whiz-bang trend. The developments in technology are transient; the real value is to be seen in creativity.

If you are to achieve your full potential as an animator, it is important that you remember how you got here, along the path of creative play and investigation. Perhaps it's as well to consider yourself first and foremost as a creative practitioner and *not* as an animator. In doing that, it is vital that you look beyond animation for your inspiration. The great Czech animator Jan Svankmajer is highly regarded throughout the world for his very particular and distinctive work. It has been said that he considers himself first and foremost an artist, then as a surrealist, then as a filmmaker, then as an animator. It is evident that his creativity cannot be constrained by or confined to the boundaries of animation nor is his creativity limited to animation for its source of inspiration.

We wish to encourage you to look beyond your discipline for influence. Look beyond animation for inspiration. Using only animation for your inspiration will limit your creative development and the work you produce. There is

absolutely no point simply trying to imitate Tim Burton no matter how good you think he is (and he is). This will only result in you becoming a second rate Tim Burton. The world doesn't need one of these — we already have a first rate Tim Burton. Far better to strive to become a first rate "you." By using animation as your starting point for your studies, you are in very real danger of producing much less interesting work.

Look beyond animation, toward live action film, television, theatre, music, opera, dance, literature, fine art, games and play, sport, photography, politics, the environment, wildlife, science. Nothing should be off limits. Above all as animators that engage in performance-based work, we need to have a good understand of people and what makes them tick. In developing your practice, the act of "people watching" is as good a place to start as anywhere. You should still use animation for inspiration, but it should not be your primary or only source of investigation.

Finally, we urge you to not place yourself in any particular creative box or category. Allow yourself to grow and to be open to different influences beyond the boundaries of animation, engage in serious study (both within and beyond animation), and finally be interested, really interested in something. Almost anything will do as long as you are REALLY interested in it. If you are interested, you will be interesting. If YOU are interesting, your WORK is likely to be interesting.

The world is a wonderful place. Let's celebrate it.

So what exactly can you expect to gain from this book and how can you get the best from it? You can to dip in and out of each of the chapters as and when you find them most appropriate to the issues you are currently addressing. The case studies on our website provide useful real life illustrations of how other animators have dealt with the self-same issues you are dealing with.

There are practical tips and some technical information that are intended to be of direct benefit to your own work. You will find plenty of practical advice on working with actors, the nature of audiences, hits and tips on how to develop characters, and how to prepare for and make a performance. All of this is backed up with the firsthand experience of practicing animators and directors and relevant illustrations.

Aspects of Acting for Animation

As animators working with character-based narratives, we must start by considering ourselves as actors and performers; it is just that instead of treading the boards ourselves, we send out our creations to do our bidding in front of the audience. We must also appreciate that acting is not simply a group of characters performing the lines written in the script. Much of a performance may be completely unrelated to the actual dialogue a character delivers, and it may not be even be shaped or driven by the characters at all but by a raft of other elements relating to the narrative. In this chapter, we take a brief look at a number of elements that the animator may have to consider when dealing with performance-based work. You will see that what makes a good performance possible is the coming together of these elements, with each having their own part to play.

As an actor of any worth, you must gain a full appreciation of the story you are attempting to tell, but in addition to this, you must be aware of cinematography, editing, the environment, backgrounds and sets, sound, and character design. All of these aspects shape and determine the type of performance you are able to achieve. Who said being an animator was easy?

Creative Approaches to Animation

It might prove useful at this stage to discuss how the approach the filmmaker, not the animator (in this instance, they are not one and the same thing), takes toward creating animation and animation timing impacts on the kinds of performance that are ultimately achieved. Animation may be categorized in various ways, and one of these classifies animation in a way that helps to determine the type of performance the animation is designed to achieve. It helps to establish a creative approach to animation. This form of classification of animation allows it to sit within three distinct categories: simulation, representation, and interpretation. By understanding which *creative* approach you are taking, it will help you determine your *practical* approach to animation and performance and give you a clear idea of the results you are aiming to achieve. If what you aim to achieve is clear to you, then you are in a better position to ascertain if you have been successful or not.

Simulation

This classification of animation is one that aims for a high degree of accuracy in its *replication* of naturalistic actions that can only be applied to movements that are seen in nature. By the very definition, nothing can simulate the action or behavior of things that do not exist. Simulation animation aims to replicate *exactly* or as nearly as possible the *actual* action or dynamics of objects or phenomena. Using this approach, it should be possible to test the simulated animation against the action of real objects or events. This approach is often used to create highly naturalistic movement of objects, figures, and effects such as water, flame, and smoke that appear in live-action films. In these instances, it is critical that the suspension of disbelief be total, and in order to do that, the animation and must sit together seamlessly. A good example of this can be found in the film *The Perfect Storm* directed by Wolfgang Petersen (USA, Warner Bros. 2000). This relied heavily on the simulated effects of a hurricane at sea. To maintain the suspension of disbelief creating the illusion of water in all its separate forms was vital: the swell of the ocean, the giant wave, the individual waves that occurred on the surface of the giant wave, the small wavelets that appear on the surface of these normal size waves, and finally the spray and spume that occurs where water and air meet. All of these combined to create a totally believable illusion. Simulation animation is used when a high degree of realism is called for, and in most instances, animators need not go to such lengths. There is an old adage that animators sometimes use and may be useful to bear in mind: if it looks right, it's right.

Representation

The kind of animation that falls into the category of representational animation does not have the same constraints as simulation animation. It may demand less accurate movement than can be seen in the *actual* behavior of the subject, and while this classification of animation may be extended to movements that seem real, it can also be applied to subjects that may pass as real. We see this in the animation of things that no longer exist and in things that have never existed and are a creation of our imagination.

The highly acclaimed BBC TV documentary series *Walking with Dinosaurs* (1999) dealt with this issue very well. There is no doubt that these animals actually did exist, but there is no hard *evidence* of how they moved, and though we can get a good idea from the evidence of their fossilized remains, there is still a degree of disagreement among paleontologists. Be that as it may, animators are left with the task of making animation that *represents* what we believe to be true. Reasonable assumptions about dinosaurs' movements can be made and as a result rather convincing or at least acceptable animation can be achieved. If it looks right, it's right.

Using this same approach, it is possible to create "believable" animation of creatures that are completely fictitious. Using reference material gathered

from appropriate sources will allow the animator to make a more than passable performance. While an audience may not be able to compare the animation with the real thing, he or she may be able to see the comparison with things that are similar, of a similar size and shape, and therefore of action. It becomes perfectly possible that unicorns, dragons, trolls, and hobgoblins—even Old Nick himself—may all be represented by levels of believable motion. Some of the animated elements in *The Lord of the Rings* directed by Peter Jackson (USA/New Zealand, New Line Cinema, 2001–2003) integrated within the live-action footage are completely convincing. The evil Nazgul's dragon-like steeds are not only terrifying, but they also are totally believable.

This representational approach to animation applies not only to motion and dynamics but also to lip sync and acting. Using this approach, it is perfectly possible for animators to create believable lip sync for creatures that we have no first-hand experience of that once lived but became extinct long before man set foot on the earth and that never spoke when they did exist. *The Land Before Time* directed by Don Bluth (USA, Universal Studios, 1988) is packed with talking dinosaurs that move, behave, perform, and *talk* in a completely convincing manner. I guess that's the magic of animation.

Interpretation

This kind of approach to animation allows for a more creative and individual use of animation and dynamics. It opens up possibilities for a more personal creative expression that neither depends on naturalistic or believable movements nor is constrained by considerations other than the imagination of the animator. Abstraction of movement and dynamics, which includes the creation of completely abstract animation, falls into this category. However, interpretation is not limited to abstract forms. Some of the best-known and well-loved cartoon characters are simple interpretations of the subjects they represent. In its most abstract form, interpretative animation may not be animation *of* a subject but may be animation *about* the subject. The work of Clive Walley, one of the most underrated animators of our time, is a good example of this. His piece *Dark Matter* (one of the six three-minute films in *Divertimenti* 1983) deals with subatomic matter and theoretical aspects of quantum mechanics. It is a beautiful film that neither illustrates nor explains these topics but is a personal response to them, a creative *interpretation* and engagement with something that remains hidden to our everyday experience and yet permeates all of creation.

Other work that is less abstract may still, due to its very design, display movements that are clearly never intended to reflect the actual movement of the subject. It has become almost a given that cartoon characters have a physiognomy that is rather extraordinary: large heads, oddly shaped

bodies, hands with insufficient digits, and a basic anatomy that defies all the restrictions a regular skeletal structure would incur. As a consequence, they move in a manner that is determined not by nature or natural laws (though they may conform to some of them) but by the imagination of the artist. Rather than obeying the same laws of physics as the audience, many cartoon characters seem to be ruled by cartoon laws of motion. They are able to shed and gain mass almost at will, capable of impossible feats of strength and agility and can be broken apart and reinstated in the blink of an eye.

Many animated characters possess few if any discernible physical qualities that their "real" counterparts possess, yet the audience is still able to accept them as being representatives of their forms. This seems to be possible as long as they possess the minimal requirements for recognition. Bugs Bunny and Daffy Duck have few real rabbit or duck attributes but perhaps have enough to engage the audience. I would not argue that these are there to create the suspension of disbelief, surely no one seeing Daffy Duck would interpret the character as an actual duck, but instead to create a unique cartoon duck; a creature of the artist's imagination and one that conforms to the parameters set by the artists. The extent to which the artist and the designer are able to take this interpretation is extreme, and as long as it provides a logic (albeit a twisted one), the audience may go along with it.

Story, Story, Story

All forms of animation (documentary, comedy, drama, etc.) need a gripping narrative structure and characters we want to get to know; even if they are unsympathetic or villainous, the audience must be interested in what they do and why they are doing it. Obviously, if the character is the hero of the piece, then it is even more important to make sure the audience connects with his or her personality and concerns.

If you keep abreast of developments in moviemaking, it won't have escaped your notice that the idea that story is king, and the basis of all good films has become a kind of mantra. Sadly for scriptwriters, it seems everyone has an opinion on a script and everyone has notes that will transform it into a work of genius. Studios will change scriptwriters on a project at the drop of a hat. There are many books, seminars, and courses that promise to reveal the formula for writing the perfect script. In the majority of animated features coming out of Hollywood, the script is not the end to changes in the story either; at the point that everybody is happy with the current version of the script, it is turned over to the storyboard artists whose job is not just to render the script in pictures but to add ideas, business, even new subplots, and sometimes to take the film in a whole new direction.

You might think that all of the above would produce scripts that were well honed, tightly plotted, and fun and often that is the case. A new writer can provide an outside eye that can spot the flaws in the previous scribe's work, and storyboard artists can provide brilliant moments and often catch and strengthen the tone of a piece. A few years ago, I was visiting a friend of mine who was working at DreamWorks for a tour. As we were leaving, I noticed some design work on the wall from a different production and asked him what it was. "Oh," he said "that's a thing called 'Shrek', but it isn't going well and they can't seem to get the feel of it right. They're thinking of canning it." Later, after "Shrek" had come out to massive acclaim, he told me that it had been a storyboard artist (I'm guessing it was Conrad Vernon), new to the job, who had come in and done the sequence in which Lord Farquaad tortures the Gingerbread man, who had given the movie a whole new tone. When Jeffrey Katzenberg saw that, he had immediately decided that this was the direction in which the movie had to go and the rest, as the cliché has it, is history. Or at least movie history.

However, films keep coming out that have clichéd storylines, flat, obvious narratives and lots of pop cultural jokes and references in place of real characterization.

This is not a manual for writing the animated film, but directors and animators must understand something about story and script before they can begin to produce a vital and interesting character performance. Where is the essence of the film coming from, if not the script?

Character design is full of clues to personality (and we will cover this later), but the design will have come out of the needs of the script; it is much harder to start with a character design and find a story than to start with a story and design the character. Just as an actor will mine the script for clues to her character's personality, so too must the director or animator who wants to produce work that rises above the merely pedestrian, that is, original and really engages an audience's imagination.

We need to look at this when writing and working with our own scripts as well as looking at what directors and animators need to do when working with scripts from other writers.

Working with an Existing Script

As an animator, I think it is vital that you read the whole script, not just your part of it. You will get so much more information about the intention of the piece and about who the characters are, even the ones you aren't animating. Those characters' actions may have a definite bearing upon yours, *even if they never come into contact.*

Have you any empathy for the story or characters? It may be that what is going on has very little relevance to your life, the story may be set in an

unfamiliar milieu, the characters may act in a way you find ridiculous or plain stupid; how do you get a purchase on the script so that you can do your job to the best of your ability?

If a little research would help you understand the script better, then do it. Try to find links between your own life and aspirations and that of the characters, break things down so that you can see the needs and desires behind their actions.

If you need to talk to the scriptwriter to find out where he's coming from on the project, do so.

Consider the script as if it had no words, try to forget what the characters are saying, and tell the story without dialogue. It would be worth finding a sympathetic ear, someone who isn't involved with the production, and try to do this out loud. In this way, you may find you both understand the story better and can create a structure that doesn't rely on the words. You may, in fact, be able to drop a line or two and show rather than tell.

Writing Your Own Script

Most students, and many people who make their own, independent films, write their own scripts; indeed, this is the great attraction of making your own film, the opportunity to tell your story the way you want to tell it.

The upside of a self-penned script can be the filmmaker's real engagement with the material and a thorough knowledge of the situation and characters. The downside can often be that, having come from the visual side of the process, the filmmaker may be too interested in working with a new animation technique or doing something visually stunning or wildly experimental. There is nothing wrong with any of these things, but audiences do not go into cinemas or turn on the TV for the visuals; they are looking for a strong story and compelling characters. The character design and visual effects are just a bonus to an outstanding story.

In a culture that often values words over pictures, it is hard to fight the urge to write a line that will explain a situation rather than work to understand the situation well enough to create images that will do the same job in a more direct and vital way. Our sense of sight is more powerful than our sense of hearing, and the visual cues will provide enormous amounts of information before we hear anything at all. Animation tells stories without words, and if its practitioners can short-circuit the habits of verbal thought, this can lead to images of telling simplicity and emotion. Michael Dudok de Wit's *Father and Daughter* (UK, Belgium, Netherlands 2001) is a great example.

Don't put into a script things the camera can't show. It is no good saying that a character has a happy-go-lucky disposition if you don't show this. Creating a problem for a happy-go-lucky character won't work if she hasn't been established as happy-go-lucky by some previous action.

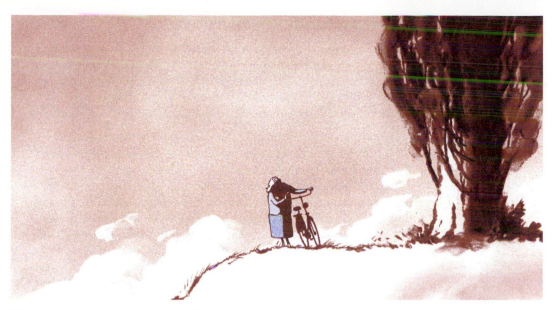

FIG. 1.1 *Father and Daughter* (Michael Dudok de Wit) tells the story of a father who leaves his daughter behind when he goes on a trip. As the years pass and he fails to return, the girl grows up and has a family of her own, but she never loses faith with her memory of him. A wonderfully affecting story of enduring love, defined in the simplest of graphic terms, but with a very sophisticated sensibility. A well-deserved Oscar winner. © CinéTé Filmproducties & Cloudrunner Ltd.

Equally, remember that all good stories come from somewhere, they have "backstory," the events that led up to the story you are telling. You may not show any of this but you need to know it exists, particularly on a character level so that whatever you write for the character is true to that character's personality.

In talking to students and looking at their screenplays and storyboards, I often find myself saying, "I think what you need here is X," and I often get the response, "Oh, I had that in there but I took it out because I thought it was too obvious." Remember that the audience knows nothing about your story beyond what you put on screen and something that is meaningful to you will not necessarily hold any meaning for them (and vice versa, remember). You will have gone over the script or board many times (or you certainly should have) and know everything about it, but the audience will come to the film fresh and may only see it once.

In animation, it is easy to create different worlds, and not just science fiction worlds—though painting a background plate of an office building on Mars is no harder than doing one of an office in the City of London—but the world you create must have an internal logic of its own and you must stick to it. This means that Roadrunner will always be able to run through a tunnel painted on a cliff face and Coyote will never manage it. An audience will conspire with the filmmaker to accept any situation as long as the film conforms to its own internal logic, but will feel cheated if some trick is pulled out of the hat that hasn't been set up earlier.

Cinematography and Editing

A good script is key to a good film, but when we sit down to watch a film, it isn't the script we are watching, but it is the transformation of a written language into an audiovisual one. "Show, don't tell" was the keynote of the previous section, but how to show, how to translate words into images, and how those images help to construct a performance are what we need to look into now.

The animator, working within a conventional studio environment, will generally come on board a production when much of this work is done; the script is written, the storyboard is drawn, and, for a 2D film, the layouts will also have been done. On a model animation film, the director will often have planned out camera positions and a lot of the staging, and in CG, there may already be a roughly blocked-out gray-scale version with camera moves. In most cases, there will be some kind of animation, but it is important that the animator doesn't feel that there is nothing relevant to him or her here because an understanding of the principles of cinematography and editing is vital in the construction of a good performance. If you don't understand how the camera will perceive your character, then a lot of what you fondly imagine to be great work may go unseen or even work against the intention of the shot. If you don't understand the effect the shot you are working on will have when put against the shots on either side of it, you will fail to build a performance that works in an appropriate cinematic time frame across the whole film.

The two most basic elements of film grammar are mise-en-scene and montage; the former means what happens within the frame and the latter means how shots work against one another. Mise-en-scene deals with composition, framing, lighting, camera moves, color, tone, staging, and the movement of the characters. Montage is concerned with shot duration and the continuity or discontinuity of form, movement, location, time, and themes of shape and color.

Not all animated films use all of these elements, but all of them partake some of them.

Mise-en-Scene

A film like *Jumping* (1984, Osamu Tezuka) is based on only one shot, the point of view of the protagonist, without any editing, and starts out on a country road where the character makes a little jump. The jumps get higher and higher and soon the camera is going even higher and dropping down into a city, the jungle, the ocean floor, a battlefield, and even Hell before arriving back on the same country road where the film started.

It might be thought that there would be little room for acting or performance, apart from the reactions of the characters whose lives are suddenly interrupted by someone dropping in from above, but even here, the way the camera moves gives us a clue to the state of mind of the protagonist.

The timing of the jumps shows us the initial excitement of finding it is possible to leap high into the air, there is a sense the protagonist is having fun startling people, then there is a mounting feeling of panic as the destinations turn into battlefields and the underworld. At the end, there is a kind of relief to be back on the familiar road but, ever human, the temptation is to begin jumping again. All this achieved by the way the jumps are timed.

So, even in a film with no overt editing and without a shot of the protagonist, we can still intuit character from camera movement. In films where we do see the protagonist, his placement in frame, how the camera moves in relation to him, and how his design or color works with the other elements around him give an even greater clue to his personality.

Any character the camera follows and any character the camera favors will immediately look like the main protagonist. We will often be granted shots from the character's point of view, allowing us to understand how he sees things, and in a dialogue scene, the hero's eyeline will often be tighter to the camera lens than that of the secondary character allowing us to confront his personality in a more involved way.

Almost exclusively, the hero will be the only one allowed to "break the fourth wall" and make an aside to the audience.

The other side of this equation is obviously that a secondary character will not be the main focus of camera or staging and will need to be placed so as not to upstage the main character.

A character seen in long shot will need to perform in a different way to one seen in close-up. It is obvious that a small gesture will not be seen and that the acting will need to make more use of broader body language for it to register. This is a consideration in live-action performance as much as it is in animation; we need to be able to read what is going on from a distance.

It is worth looking at *Father and Daughter* again to see how this can be done with subtlety. Since we don't see close-ups of the characters' faces, and the only close-ups we get are of things like bicycle wheels, we must understand the characters' interaction through the attitudes of their bodies, the way they hold themselves, and the way they relate to each other in space.

It has been something of an article of faith for many years that animated characters should not be held in close-up since, it was said, there is so much less going on in a drawn character's face than in that of a real person. Even if that was the case, with the advent of very sophisticated CGI, it becomes less and less true, but it is still possible, even with less detailed animation, to produce an effect with the use of a close-up.

In live-action films, whether drama or documentary, the camera is following the actor's movements, not anticipating it. The person is understood to have the freedom to go where he or she pleases (despite the fact that, in drama, we know all we see is staged) and becomes a real person, not a puppet

controlled by the director. Recreating this kind of movement in an animated piece creates the sense that the characters have a life of their own and are therefore more believable. If the camera follows their movements, a little late, as though a real camera operator is reacting to them, they start to exist as autonomous beings.

Lighting and color are both able to provide strong reinforcement to a performance by creating a mood and heightening the drama. Though we don't want to lose the performance in the darkness, it is sometimes much better if the audience can't catch everything that is going on, and if they are rooting for a character in a fight scene, the fact that they are not quite sure exactly how he is doing is going to get them leaning forward in their seats and engaging with the action. Similarly, the introduction of a new character from darkness, or set against a bright light, will all add to the audience's desire to know more and thus their engagement with the story.

Montage

The second major component of film language is montage, or editing, and we can see that the length of time devoted to a character and the juxtaposition of shots of the character with other shots will have a huge bearing on how the audience perceives a performance.

An unsympathetic edit can certainly undo much of the effect of a good performance and good editing can add immeasurably to it. What is certain is that human beings look to the face, and particularly the eyes, for clues to emotion and are able to read very subtle facial variations, and expecting to see a particular emotion will often find one where none is present.

Like framing and camerawork, editing is designed to establish what is, and is not, significant in the story. Therefore, the main character will get more screen time than others, and the editing will take us in to close-up to see his private thoughts and reactions. It will give us a view of what he sees and the shot's duration will tell us how much significance it has for him. When we are shown something he can't see, the dramatic irony inherent in the situation enhances our empathy for the character and makes the performance more fully charged.

Pacing, in terms of camerawork and editing, can also affect a performance or the amount a character will need to do in a scene. In the case of rapid cuts and a moving camera, complex or detailed acting may be detrimental to the needs of a shot; there will be too much for the audience to take in and a simpler, more straightforward action needs to be played. In this case, the performance needs to drive to the heart of what needs to be portrayed at this moment. Luckily, this kind of camera movement and editing are often used in action scenes or other very dramatic situations where there is really not much doubt about what the character thinks about the situation; getting out of the way of a stampeding herd of Wildebeest rather than anything more complex is what concerns Simba in *The Lion King*.

It is the case, though, that the opposite is true, and overly complex or fast paced cinematography and editing can take the life out of a performance. Style sometimes takes precedence over content, to the detriment of the film. Examples that immediately spring to mind are the number of action films where fast cutting and moving camera take the drama out of a scene rather than enhance it. It is often more believable and therefore more exciting to watch an action happen in one shot; when we see, for example, a piece of kung-fu action broken into lots of cuts, we begin to suspect the performance has been created in the edit and the performer can't actually do all the things we see on screen. We marvel and laugh at the films of Buster Keaton because we can see that there is no trickery (or no obvious trickery) to the stunts; Buster really has had a house front drop round him and that is a real train that crashes through his shack on wheels.

Fast cutting is not new or a consequence of viewing pop videos on MTV; Eisenstein, Dziga Vertov, and and D W Griffiths all produced films where shots could be only a few frames long. The advantage these directors had in storytelling was their iron grasp of the "mental geography" (a term used by the film director Alexander Mackendrick) of a scene, their clear delineation of the layout of characters, and props within a defined location, and this understanding is central to helping create believable character interaction.

It may seem strange to introduce these ideas into a discussion of animation, after all, isn't all animation constructed, unreal? The truth is that animation, though completely created by the filmmaker, is still part of the spectrum of moving pictures and partakes of the same logic; we expect the same suspension of disbelief on the part of the audience and we have to work to maintain it. Therefore, if we can make a scene more effective by presenting it simply and clearly, we do that rather than allow style to undermine our efforts to create a winning performance.

Environment and Screen Space

There are three main ways in which to look at environment and spatial problems in connection with performances on screen: the setting of the story, the handling of physical space through cinematography and editing, and the type and size of screen on which the finished project will be shown. We might even add another element if we were to discuss the impact of physical production limitations on the design and shooting of animation.

The Setting

The setting of a film, the physical and historical environment in which the story happens, must, in the first place, have an impact on the type of action and performance our characters can produce. It is obvious that an underwater setting will provide different challenges and opportunities to a mermaid or a shipwrecked sailor, but it is also true that certain environments will make a

psychological impact on the participants in the drama and may even come to feel like another character, even an antagonist. Think about the way in which Monument Valley became more than just a backdrop in the films of John Ford, how the majesty of the harsh landscape throws into relief any petty concerns of the settlers who journey through it, and how a character can become heroic just by being able to survive in such a place. Immediately, any story told against this background becomes special and is moved to a higher plane, since the stakes are so much higher here.

Interestingly, the very same Monument Valley landscape appears in the Coyote and Roadrunner cartoons and, in a comedic way, partakes of a little of the same feel of characters fighting for survival in a hostile environment. Since the audience understands the setting from numerous viewings of cowboy movies, Chuck Jones can play a parodic version of the confrontation in the desert or the Indian ambush, and, in addition, he has a very distinctive and simple canvas against which to play out the iconic chases.

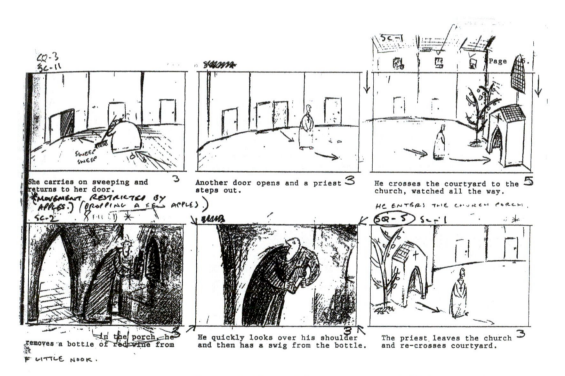

FIG. 1.2 *The Village* (Mark Baker, 1993). The deceptively simple style of Mark's personal work is used to create stories that reveal dark, adult themes. In the village, the inhabitants spend their time alternatively trying to ferret out their neighbors' dark secrets and conceal their own.

In *The Village* (1993, Mark Baker), the design of the village itself says much about its inhabitants before we get to know them. With the houses formed into a circle and windows overlooking the action, we immediately understand

the kind of closed rural mentality we will encounter where everybody knows their neighbor's business and every action is scrutinized from on high. Every character, when going about their daily lives, knows they are being watched and their body language, though simply done, reflects this. The priest is literally "upright" when walking in the square but constantly bends down or ducks behind things to take his secret drink; the nosy old lady, spiteful and spiky, leans out of her window like an accusing arrow pointing at the alleged wrongdoer.

Of course, many animated films have very little sense of an environment at all, they may be abstract films, dependent on the nature of the materials used, or their action may take place in a kind of nonspecific space. A film like *Feet of Song* (1988, Erica Russell) exists on the screen as a 2D picture like a moving painting, and the environment becomes the physicality of the human body; we are forced to notice the rhythms and dynamics of the body because there is nothing to distract us from them.

The environment is not simply what is present in the screen space in front of us; sound plays an enormous part in creating the "space" of a piece, allowing us to feel that life exists off-screen and therefore enhancing the believability of our characters. However, within the design of the film, we need to think deeply about the world we are creating if we are to successfully enhance the character performances in the way the films cited above do so well.

Whether we are creating a science-fiction world, where nothing is familiar, or placing the action on ordinary city streets, we need to understand, in the same way we devise a backstory for the characters, how the environment works and what went into making it as it appears on screen.

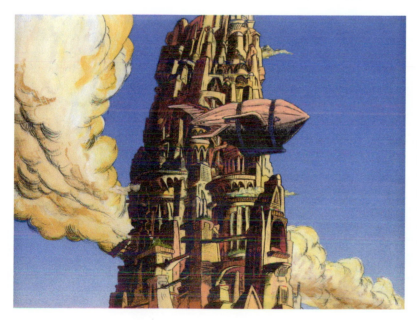

FIG. 1.3 *Max Beeza and the City in the Sky* (Derek Hayes and Phil Austin, 1977). The city is a 12-mile high tower that rises out of the pollution shrouded earth. Consequently, there is lots of room up and down, but very little side to side and all the action has to reflect this. In this case, the setting becomes one of the characters, as everyday pursuits are tailored to fit a different environment.

In *Max Beeza and the City in the Sky,* by Derek Hayes and Phil Austin (UK, National Film School, 1977), made while students at the National Film School, they developed a story set in a tower city, ostensibly 12 miles high. While they ignored certain facts that would have made the setting impossible (any materials would literally melt under the pressure from such a structure), they hoped to create a suspension of disbelief and an acceptance of the environment by thinking through the implications of living in such a city. Thus, since space was limited, all the vehicles had three wheels so that they could turn around in their own length, and since the city was vertical as well as horizontal, trains went up and down as well as side to side. None of this is commented on in the film or is anything more than background, but they hoped that by making the environment consistent and believable, they would suggest it carried on outside the frame and that the characters were situated in a real place. Their actions then grew out of reality, an imaginary reality, to be sure, but one that was functional and supportive.

Monsters Inc. (2001), Pete Docter, Lee Unkrich, and David Silverman, has a fantastic and unreal premise—a world of monsters powered by the screams of children menaced by the creatures who come out of their closets. But it has a consistently real (in the film's own terms) environment and everything within it works to underpin the world that has been created. On the other hand, while the film *Signs* (2002, M Night Shyamalan) works brilliantly to create suspense and draw us into a belief in some mysterious and malign force that is menacing humanity, it arguably throws away all the good work done in such things as the meticulously created news bulletins by finally revealing that aliens who can be killed by water are trying to invade a planet that is covered in the stuff.

Setting a story within a familiar environment means that there are a whole lot of things that don't have to be explained, but even here an understanding of how the setting works will help create a much more believable character performance. Do our characters take an interesting route to work, for example, what are their opportunities for interaction with neighbors, is their kitchen laid out in such a way that they need steps to get the sugar? Answering questions like these creates the opportunity for interesting performance as the character reacts to his surroundings, and his reactions define his personality to the viewer.

Not attempting to create a real environment, or building one that is clichéd, can lead to the characters becoming less real and more clichéd themselves. Often, the two go hand in hand when creators, enamored of previous work in a genre, repeat the outward aspects of a character or setting without understanding what made them vital in the first place and, in love with iconic moments, repeat them until they are drained of any originality. How many times have we seen the sinister castle on the hill and the winding road that goes up to the front gate illuminated by the lightning? The dusty

western frontier town, in the wrong hands, seems to automatically call forth close-ups of squinting eyes and the ruined future world is always full of hugely muscled men in inconveniently spiky costumes and pneumatic women in very little.

Almost all of the characters created to inhabit these settings will act and talk in ways we've seen a hundred times before, and, though they may delight the fan who can spot the sources, everybody else will find themselves quickly bored and longing for a different take on the familiar setting. So, if the setting is familiar, even more work needs to be put into devising a character performance that will avoid cliché and bring a stock situation to life.

The concept of "mental geography" also comes into the design of the environment, since it is not solely a creation of the editing process but relies on a combination of design, cinematography, and editing.

What is important is that the audience must be immediately able to understand the geography of a scene if they are to follow the action. An audience struggling to understand who is talking to whom or where certain important items are located will fail to get the point of the scene and it is possible to work with fast cutting only if the performance area has been well established.

If we are trying for suspense, we need to understand, for example, that Character A is lying in wait for Character B in a certain spot and that B is heading toward that spot. Or, in comedy, that if character C carries on the way he is walking, he will certainly walk through the door that has the bucket of water balanced above it. Establishing these relationships is not just a matter of showing all the elements in one wide-shot (often this can't be done anyway) but of establishing screen direction or the spatial relationships of other objects the protagonist may pass. When making a model animated film, the settings must be built and therefore concrete choices must be made as to where things are in relationship to one another. This applies in much the same way to CG films, but 2D films need to be designed with a consistent sense of space in mind. To this end, it is always worth doing a plan of the setting before creating backgrounds. It is also possible to use tools like SketchUp to create a layout in 3D to act as a guide to the background designer. As in any type of filmmaking, we will naturally cheat a little to ensure that we can show what needs to be seen in any shot so long as we do not thereby disrupt the audience's sense of the space. If, for example, we need to see both edges of a roof when the character has to jump a gap, we can move model buildings into shot or angle them slightly; in 2D, we can draw them the same way but we must always have a firm grasp of what is possible within the space without destroying the audience's understanding of it.

Quite simple staging can have large implications, often established on an almost subliminal level. In *Father and Daughter*, the passing of time is not only shown through the physical aging of the girl who waits for her father's

FIG. 1.4 Understanding the space in which your characters are operating is vital and the director and animator both need the "mental geography" of the scene firmly in their heads. Creating a floor plan of the space in which you are operating makes it possible to work out what will be seen in each shot of the film and where each character is in relation to any other. Here is an example of first thoughts on a layout for a scene from "Ben and Holly's Little Kingdom" from Astley, Baker, and Davies.

return but also by the fact that what was once the body of water he rowed away across has become a grassy meadow. Even more poignantly, when she goes down into the new meadow as an old lady, she finds a boat, no doubt his boat, rotting, half buried in the sand. It is pointing back the way she has come, from the polder where she has watched for him so faithfully, indicating, to these eyes at least, that her father was on his way back to her when the boat sank.

Much early animation, like much early cinema, including the films of Melies, inhabited a filmic space akin to that of the theatre; the characters performed within a virtual proscenium arch with little in the way of movement toward or away from the camera and little movement of the actual camera. Felix the Cat operated in a primarily 2D world and this is still one tendency within animation; children's series in particular often work like moving picture books. New methods of making animation, like Flash, lend themselves to this kind of approach with environments of flat planes and movement across screen rather than at angles. Performance here can tend to the stylized, but while such an approach can constrain, it does not have to constrict, look at *South Park* for an example of a series, which says a lot with a limited approach to 2D design.

Feature animation developed away from the simple 2D approach, along with the rest of cinema, in order to portray a realistic world and create a believable universe for its increasingly more complex characters to inhabit. The multi-plane camera was introduced to produce the sense of a 3D

environment, and in later movies, such as *Mulan,* the computer took over the task of adding a dimension to the settings in what the Disney studio referred to as "Deep Space."

Screenplay (1992, Barry Purves) brilliantly combines two ways of staging a story to chilling effect. The first part of this retelling of the Willow Pattern story is staged on a very theatrical set, changes being introduced by moving screens and the rotating stage. The action is formal and essentially in two dimensions as the characters operate in planes in front of a static camera. The acting is stylized and theatrical devices are used to convey natural phenomena—red ribbons stand in for blood and flowing banners for water. In the second part, just as we think the story has ended happily, the samurai bursts through the paper screens and the camera is set free to capture the action in close-ups, high angles, and moving camera shots. Instead of taking place on a stage, the sets are 3D with a clear indication of interior and exterior, the moving camera reveals more of the house, and in doing, so we understand we cannot see everything in one shot. Suddenly the action has left the confines of the theatre and what is outside the frame has become the unknown, a source of danger or the possibility of escape. The acting too becomes more cinematic and naturalistic, frenetic, and staccato rather than flowing and dance-like. The characters are no longer choreographed with the movement of the set but have to operate in a real environment; they must negotiate obstacles in order to try to escape or are thrust rudely through the paper screens as they are slaughtered by the samurai.

FIG. 1.5 *Screenplay* (Barry Purves 1992) tells the story of two lovers who defy convention and family to be together. In the first part, the action is told in a style influenced by Japanese puppet theatre, in a very formal style limited to one camera position. In the second part, the conventions of cinematic narrative are reestablished to present a very sequence of fast cuts and tight framing that echoes Samourai movies.

Screen Format

Before we leave this section, we ought to say a few words about the different forms of viewing experience available and the way they impact on performance. When movies started, there was only one way to see them, with an audience watching a big screen. Since then, the cinema experience has been joined by a host of other ways to view audiovisual material, from TV to computers and now on hand-held devices including mobile phones, and it is clear that what works in one format may very well not work on another.

In creating a performance, we need to understand the format we are working for and to tailor it accordingly; the gesture that would be small but significant on the cinema screen will vanish on the mobile phone screen and a talking head that would be amusing on the phone will be both boringly simple in design and annoyingly frenetic in its lip sync on a big screen.

Sound

The use of sound within film is a major element of the audiovisual experience integral to the cinematic narrative and one that impacts on performance and acting. This is particularly true within character-based animation. This would, on the face of it, appear to be fairly self-evident though unfortunately sound is occasionally neglected and appears as a secondary element relegated to a supporting role. Far from being the poor relative of the visual experience, sound should be considered to be at least an equal partner to the visual elements and often the most important element within the design process of a film. The way a film sounds not only creates drama, mood, tension, and pace but may often drive and shape the narrative.

While it may not be important for an animator to have the same level of expertise as a sound engineer, a good grounding in the way sound is used in film will prove to be useful and more is available in the bonus chapter on sound on our book's companion website.

Early silent films used sound (a small theatre orchestra or single pianist accompanying the moving images) as an integral part of the experience and as an attempt to deliver a more entertaining narrative.

One of the earliest and most famous of all animated films *Gertie the Dinosaur* (1914) created by Winsor McCay used the spoken narrative of its creator as part of the *performance*. The film was screened as part of a vaudevillian tradition of live entertainment and used sound in a way that enabled the animated character to demonstrate personality and to act with McCay himself.

Silent animated films often used graphic representation of sound in order to deal with any shortcomings that more often than not meant the use of caption cards to deliver important aspects of the narrative, rather like

their live-action counterparts. They also sometimes incorporated the use graphics within the animation itself, such as speech bubbles. Sound, in the early *Felix the Cat* films, was often depicted as radiating exclamation marks or even the use of the written word to denote a sound such as an explosion.

With the advent of sound in cinema, storytelling, performance, and acting took a major leap forward enabling a level of sophistication that had hitherto been for the most part impossible. Disney's *Steamboat Willie* (1928) was originally released without sound though it had fared little better than many other films made by Disney and other studios. The revamped version appealed to the audience of the day and created a demand for more of the same. Initially, the way sound was used was somewhat simplistic, often with the sound mimicking or illustrating exactly what the characters were doing on screen. It became such a distinctive feature of the way in which the animation studios of the day, but particularly Disney, used synchronized sound the technique became known as Mickey Mousing.

The use of Mickey Mousing may have been acceptable to early audiences, but as they and the animators themselves became more sophisticated and discerning, the use of sound also became more sophisticated and inventive. One interesting twist on Mickey Mousing can be seen in *Duck Amuck* (1953) in which Chuck Jones reverses the earlier policy of using the soundtrack to depict the exact the visual action he replaced it with an unexpected one. As the main character of the film Daffy Duck undertakes a series of actions, the sound is nothing like the expected. When he strums a guitar, it is to the sound of a machine gun and he opens his mouth in protest; he is shocked into silence that he has acquired the cacophonous voice of a Kookaburra.

It is clear that the use of sound within film transforms the medium, but it is the *creative* use of sound that provides the additional narrative element that not only supports a visual performance but provides a totally different take on the story.

Music is an obvious aspect of sound that provides an evocative addition to a film, one that denotes atmosphere, mood, temperament, drama, and comedy. It can also provide a broader context for the narrative, locating it within a historic or geographic setting.

One of the simplest uses of music may be to provide a musical interlude; on the other hand, it may be fundamental to the genre of the film. Disney's *Jungle Book* (1967) and Tim Burton's *The Nightmare Before Christmas* (1993) illustrate this rather well. These two examples, while ostensibly similar, may illustrate a different approach to the use of music.

Jungle Book boasts some splendid and memorable music and treats its audience to some fine entertainment through classics such as *The Bare Necessities* and *I Wan'Na Be Like You*. These songs are imbedded within the

narrative in a very different way to the music of *Nightmare Before Christmas*. The former uses songs as a kind of musical interlude and, while the music does develop narrative and character, the latter has the feel of a musical, in which the characters use song to deliver important aspects of the narrative and character development.

Of course it is with the use of dialogue that the animator has the greatest scope to impact on a performance within a film and on its narrative. Personality and the voice are intertwined in an intimate and very subtle manner. It allows for an approach to acting and performance in a way that no other audio medium can match. It is the distinctive quality of the voice and the words *performed* (not simply spoken) that are the greatest signifier of mood. An animator's job is made so much easier and the end result enriched to a great extent by a good voice performance. The value of the voice artist is not lost on the audience or for that matter the animation producer. A good character voice has qualities that instantly resonate with an audience. It draws them into the narrative, makes the characters believable in a way that images alone cannot do. Mickey Mouse, Vincent Price, Fred Flintstone, Homer Simpson, it's all the same, the power of the performance stems from the quality of voice and it's the voice performance that shapes and gives meaning to the animated performance.

We will be looking at this aspect of acting in much more detail in the following chapters, covering ways in which directors and animators may shape and incorporate voice performance, how to direct voice artists, and how to link the visual aspects of character design with voice casting and sound design.

Character

Audiences watching any kind of performance-based storytelling be it in a theatre, in a cinema, or on a TV screen are generally concerned with only a couple of things: interesting stories and interesting characters. Interesting stories told in an interesting manner and performed by interesting and engaging characters. Characters that we can relate to, that we can understand, that we love or hate, and that have emotional depth but perhaps above all characters that are believable. This is clearly important for all forms of storytelling, not just for narratives that are performance based, since the writers of novels or short stories have created some of the most emotionally complex and enduring personalities the world has seen. It is through their skills with the written word that they are able to do this, the written word and the imagination of the reader.

Though an author may well establish a number of very clearly defined characters with a range of strong and enduring personalities, it is difficult if not impossible to paint in each and every detail of these personalities, certainly presenting every aspect of their physical appearance will prove difficult

and even their psychological makeup may be difficult to fully explore. The physicality of an individual's movement will most likely be beyond the scope of the written word.

On the face of it, it looks like I am suggesting that the written word offers a greater opportunity for the development of the character. Not a bit of it. It simply offers *different* opportunities. While performances underpinned by *implied* character traits may well leave room for the imagination as opposed to the *explicit,* the explicit performance may be capable of presenting a story that leaves little room for ambiguity, allowing greater control of the audience experience.

Of course, by the time the animators get around to working with a given character, the options open to them for developing that character's personality may be fairly limited. It may be possible for an animated character to develop over time and over a number of episodes of a TV series, though this is something normally established by the writers and director, relegating the animator to the role of actor. If a character were to change unintentionally to such an extent that they were not the same personality as when they began the story, there could be a problem with the way the audience perceives the character. Unintentional changes of this nature over the short period of an episode of a TV series, a feature film, or even the extended (though still reasonably short) period of a season of programs may look rather strange. I do not refer here to the changes that a character may undergo as part of the narrative; those changes and developments may well be vital to the storyline, in which case the changes are intentional and will hopefully make perfect sense to the audience.

We have seen the development over a time period spanning a number of TV series of certain animation characters such as Homer Simpson and Ren and Stimpy. In the case of Daffy Duck, we can see this development takes place over a period of years as he appeared in a number of cinematic shorts. In these films, we don't only witness the development of a character and the growing relationship between the animator and the character but the animator developing an understanding of acting and performance for a specific *personality*. Animators working on longer projects, either TV series or feature films, may be somewhat limited and constrained by a character that is already well known and well loved by an audience. The practical demands of industrial-scale productions are that ALL the animators working with a single character must create a performance that appears to be the work of a single hand. The characters must act in the same way throughout the production; there is little scope for an individual take on characterization. Acting within these limitations presents its own challenges.

One animator perhaps above all others working in a large-scale commercial environment managed to stamp his own distinctive acting voice on the characters he worked with. Tex Avery has an almost instantly recognizable

acting style, one that extends well beyond the physical design or graphic rendering and into the animation timing and, I would argue, the very personality of the characters. Avery clearly demonstrates that characters are not simply defined by their personal appearance, nor do they have to conform to a predetermined set of design aesthetics, in fact they seldom do. Avery seems to break all the animation conventions of scale and volume within his characters, and while other cartoon-based animators may squash and stretch their characters beyond the naturalistic, Avery takes this to extremes. Eyes pop from heads; bodies grow to immense proportions, or diminish to next to nothing; movements become simplified, often using key frames only, and all conducted at break neck speed. It is the way in which Avery handles form, disassembling and reconstructing his characters that makes his animation style distinctive.

Interestingly enough, we can see how different animators and directors have handled working with the same characters and tackled the problem of developing a distinctive performance for them. Such a development can be seen in Daffy Duck. As seen in his first screen appearance in *Porky's Duck Hunt* (1937), he is little more than a psychotic ball of energy, a shallow character whose only saving grace is that he seems to possess the ability to bounce across a pond on his head. It was only after considerable shaping over a number of films by Tex Avery and Chuck Jones that his final, fully rounded and rather loveable personality emerged. At the best of times, Road Runner and Coyote are fairly simplistic characters with a limited palette of characteristics to draw upon, yet there is a considerable difference between these two, when they were at the height of their game as animated by Chuck Jones, and the poorer creatures they became in lesser hands.

In contrast to the large-scale animation production that often leads to a formulaic approach to script development and character design, the auteur animator has a creative freedom resulting in a more intimate one-to-one relationship with their creations. A character of the animators own design, more often than not a one-off design, may allow for a distinctive approach to acting. Such work, usually written, directed, and animated by a single hand, or at least by a very small crew, allows for much more control. This is not to say that the characters born of this more intimate relationship are more believable to the audience; indeed, there is evidence to support the argument that the development of a believable character may be better crafted as a result of collaborative effort.

As a solo creation of Joanna Quinn, Beryl, the star of *Girls Night Out*, and *Body Beautiful*, is a sympathetic take on a type of character that seldom finds a voice. Beryl reflects all of those aspects of an ordinary working class woman, living in South Wales, that are of interest to Joanna. Her complete engagement and empathy with her creation has ensured that Beryl is a totally believable character.

FIG. 1.6 As Joanna has explored the possibilities in the character of Beryl she has grown into a complex and wonderfully 'rounded' character; in more ways than one!

As a contrast to Beryl, we can use Bugs Bunny as another completely believable character, though one developed by a number of animators over an extended period of time. The early version of the character was rather simplistic, though with input from others, most notably Chuck Jones, Bugs became a more complex personality.

Through the skill of the animator, even abstract shapes may take on personality and humanistic characterizations and some characters with *personalities* may transcend the organic form. Pixar's 1987 short *Red's Dream*, directed by John Lasseter, featured a unicycle that not only manages to display a range of emotions throughout the performance, joy, disappointment, and sadness, but the character begins to display a personality of its own, and, in a final act of humanity, "dies" as Red returns to his inorganic form of the unicycle as object. Chuck Jones' film *The Dot and a Line* (1965) simply used a series of marks, squiggles, lines, and splodges that changed and morphed as they took on distinct personalities. Perhaps, the finest example of how personality and character can transcend form can be seen in some of the abstract animated films of Oscar Fischinger. He often managed to make some of the individual marks, often little more than a streak of white against a black background, take on a personality of their own.

Through his use of animation timing, triangles, circles, and dashes would display actions that were more familiar in living organic forms and he even managed to give them the semblance of a more concrete human trait, an air of playfulness.

Animation, if it is anything at all, is an entertainment and while these shows may vary a great deal, in format or content, be they comedy or drama, horror or adventure, they all depend on those self same elements, a narrative and protagonists that present the narrative. The most engaging stories, which are a result of a well-crafted script supported by inventive design, stunning sets, and backgrounds, will never gain the full interest of the audience if the characters themselves are uninteresting or unbelievable. In order to fully engage an audience, the characters must go beyond the role of a simplistic walking clothes horse and begin to demonstrate a believable personality. And what is that believability based on? Nothing more than behavior that conforms to our own human experiences, even if the character in question is a duck. The development of personality within character-based animation is fundamental to any performance that aspires to go beyond a moving manikin. It's the development of a personality that creates appeal, villains, heroes, and the ordinary guy and instills empathy and sympathy in the audience.

The subject of character development is dealt with in much more detail in the later chapter on *Character and Personality*.

Summary

A character performance never stands naked on the screen; there are a host of elements from which the performance grows and more that contribute to the effect it has. In this chapter, we have looked at some of the basics of screen narrative and the tools we use to tell stories.

However, you tell stories you will need to have a thorough knowledge of the stories, their meaning, and the lives of the characters within them; you will also need to realize that what you make of these things is not necessarily what the audience will get out of the work and you will need to find a way to put yourself into the place of the audience to see with their eyes what is working and what is not.

Make sure that, whether you are director or animator, you do the research necessary to give you a firm grasp of what the script is trying to say and the means it used to do so. Being able to see the whole film in your head is essentially what is required of the director, but it is also extremely important that the animator also has a complete grasp of what is going on. How else will he or she be able to understand the choices made by the character, and therefore know how to pitch a performance without this knowledge?

The setting in which the character appears will have an important effect on the audience's expectations and understanding of the character. The setting

is more than just a frame and our knowledge of an environment can be used to add to a performance, creating continuity or contrast and acting as an adjunct to backstory. Finally, characters themselves can be simple or complex, but the development of personality through performance is dependent on an understanding of human experience and behavior. The better you are at this, the more the audience will believe in your characters and come to empathize with thems, so take the time to study real life so that you can better create life of your own.

Types of Performance

This chapter looks at the nature of performance, its history, and the way theories of acting have developed and how that is related to ideas of performance in animation. We examine the ways in which we can use performance ideas from theatre and cinema to add to what we do in animation and the things that animation can do that are not open to other media.

From its inception as a novelty to its current status as one of the world's box office champions, animated cinema has developed alongside live-action cinema and has dealt with the same kinds of subject while creating its own special kind of appeal. Those who make the mistake of calling animation a "genre" are corrected in no uncertain terms; animated films have been made in all genres, and animation is just another way of making films. There has long been a cross fertilization between the two arms: from animators using live action as reference footage at the Disney Studios to directors like Brad Bird moving over to make live action films, and from the combination of the two in the Fleisher's *Out of the Inkwell* cartoons and Disney's *Alice in Cartoonland* through Jerry Mouse appearing in films like Gene Kelly's film, *Anchors Aweigh* (1945, George Sidney, to the full on blend of live action with animation in *Who Framed Roger Rabbit* (1988), Robert Zemeckis.

Frank Tashlin is a director who started out in animation, working for Paul Terry, Warner Bros., and Disney, and then moved into live action as a gag writer for the Marx Brothers and Lucille Ball and finally as a director with films like *The Girl Can't Help It* (1956), which he moved along at the pace of a cartoon and stuffed full of sight gags. Tim Burton is a director who, from the time he attended college, has seemed at home in both animation and live action, producing films that owe nothing to the idea that there are restrictions on creativity created by artificial demarcation lines within cinema.

Fewer live action directors have moved the other way until relatively recently; although Steven Spielberg has had a long involvement in animation, mainly as a producer, and his 1979 film *1941* contains a host of gags that nod to Warner Bros cartoons, he didn't direct an animated movie himself until *TinTin* (2011). Latterly, we have seen names like Gore Verbinski, *Rango* (2011), Wes Anderson, *Fantastic Mr. Fox* (2009), and George Miller, *Happy Feet* (2006), directing animated movies.

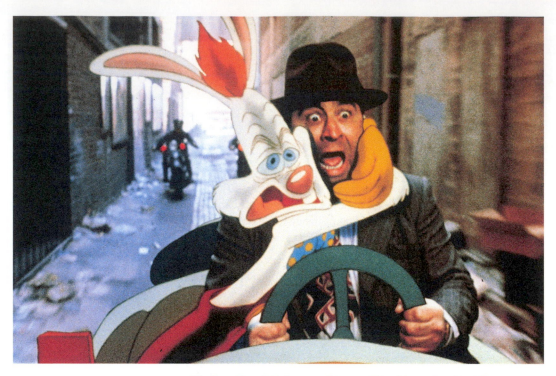

FIG. 2.1 "Who Framed Roger Rabbit" was state of the art in 1988 and done without the aid of computers, except in the motion control cameras that allowed shots to be repeated consistently in the live-action filming. © Touchstone Pictures and Amblin Entertainment. Inc.

Many animation enthusiasts will question whether we can call motion captured movies animation at all and look with disdain on the recent output of Robert Zemeckis, in particular. I think we have to acknowledge that it is becoming harder and harder to define what animation actually is and that there are scholarly journals that spend a lot of time arguing the point. This is not the place to try to settle the question, rather, I would say that, unless we want to paint ourselves into a small corner, we ought to embrace the fact that animation is now present in every area of film, TV, games, etc. and be happy that we have a larger canvas on which to work.

The amount of what we once have called animation appearing in live action movies has increased to an incredible extent with few big movies appearing these days without some visual effects content. Visual effects are present not only in the obvious genres, like science fiction and fantasy, but period films have entire harbors of sailing ships recreated in the computer or armies of Roman soldiers digitally inserted into dusty battlefields. *Titanic*, James Cameron (USA, 1997), wasn't the first film to insert digital "extras" into a film, but it arguably brought the idea of the "synthespian" out of the world of the VFX technician and to wider public attention. Now we realize that large portions of the vast crowds we see on screen were not actually

present when the main action was shot or that the secret agent falling out of the helicopter is neither the star, nor his stuntman, but a computer-generated figure.

As the two worlds of animation and live action have come closer together, this synthesis has thrown up questions for the art of animated performance and about the nature of the reality of a screen image. On the one hand, there are different outlets and usages for the animated image and therefore different ways a character performance must be constructed; on the other hand, there is the question of where we pitch the level of realism in our work.

Stanislavski, of course, is the person who is credited with having the greatest influence over acting and performance on stage and screen for the last 100 years or so, and it is worth looking at what he achieved. Stanislavski was the stage name of Constantin Sergeyevich Alexeyev, born in 1863 to one of the richest Russian families of that era. He took a stage name to hide his interest in acting from his family, since actors in Russia, at that time, had very low status.

Although Stanislavski is, to many people, the creator of a new tradition and a radical break with the old ways of acting, he was actually part of a movement that was dedicated to bringing realism to the arts and theatre.

Stanislavski's System

Stanislavski's intention was to put together a kind of toolbox that actors could use to create a truthful performance and to that end came up with a set of principles that could become the basis for such a thing. Let's go through them and look at their relevance to animation.

Study

It is obvious that, as we grow up, we develop our own particular way of moving and talking, things that our friends recognize as part of our personality. Our body language, although it might contain universally understood nonverbal signals (See Chapter 5, Principle of Performance—Body Language), will be modified by our own particular physique and emotions and contains things specific to us. Obviously, if an actor fails to take this into account when on stage, his performance will be undermined by the presence of physical actions that do not relate to the character he is playing.

As animators we can't just walk on stage to perform, we have to learn the skill of making things move in a believable way, so we might think we are already ahead of the game here. However, if we are honest, once we have started to learn how to make things move, there is a great temptation to rely on those principles for everything we do. Sometimes it can become easy to recognize one animator's work, no matter what the character he is animating, and he

FIG. 2.2 "Going Equipped", from the Animated Conversations series, is a brilliant use of a real conversation as the basis for an animated performance. An early film from Peter Lord and David Sproxton of Aardman, it is totally real and believable performance of an almost documentary kind. "The clues", Peter Lord says, "must come from the voice."
© *Aardman.*

therefore loses the particularity and thus the reality of that character. We all need to keep observing real life and finding ways to incorporate it into our animation, even if we are creating imaginary characters, so that there is always something real there.

Emotional Memory

One of the techniques that Stanislavski developed required the actor to find something in his own life that would allow him or her to understand what was going on within the character. But even further, by looking back at an incident that had triggered sadness in her own life, the actor could not only understand what the character might be feeling but, by calling that memory up in preparation for going on stage, or actually on stage, the performance would come from a much more truthful place than if the emotion was merely imitated.

Stanislavski felt that performances needed to come from the inside as well as the outside and developed a way of using physical actions to help generate internal feelings. His focus was on the way in which internal feelings and

external, physical actions are linked in a two-way communication and the way in which any psychological experience will give rise to a physical display. Therefore, a man waiting impatiently for the cab to take him to an important interview will manifest that impatience in actions that might include pacing, drumming fingers, an annoying whistle, or even rearranging the magazines on his coffee table.

How might these ideas be useful to animators? Well, as we explore later, to create a performance that works, and is convincing, we need to be able to get inside the character and understand his mental processes and, in the case of Empathy, we have to look at our own experiences to find a way of connecting with what drives a character. If we can call on a memory of some incident in our own life that gives us a purchase on the motivation of the character we are animating, we might be able to find some specific of that experience that will inform the performance and change it from something obvious into something with that extra spark of real life.

Analyzing the Script and the "Magic If"

One of Stanislavski's innovations was to get actors and director together to analyze the script and the nature of the characters and try to come to an understanding of their personalities and motivations. One of the ways in which this analysis would work was by having the actor put himself in the shoes of the character by asking questions, as in, "What would I do in this situation?" They would pose the question as to how they might act if they had had the same life experiences as the character, drawing on their own life to find some empathic connection to that character. Then, having begun to get a feeling for the character, they could ask, "What might (my character) do if the situation was different?"

The way to do this through the "magic if" is, of course, through Empathy. By identifying experiences that we have had that approximate to those of the character, we can begin to understand the driving forces in that character's personality. It doesn't matter that our experience is, perhaps, less intense or of a different magnitude because, thankfully, we can empathize without fully understanding someone. I may not be a tiger, like Shere Khan, but I can understand that he feels threatened by the presence of the "Man Cub" in "his" jungle. Shere Khan is the boss, everybody defers to him, but he knows that Man is different and dangerous and individual men might be easy prey, but when they get together and come hunting with their fire and their spears, they are a different proposition. If I were in his position, what would I do? I'd want to pick off this interloper while he was still relatively helpless and before he brought any of his tribe back into the forest. But would I go round looking anxious and asking all the other animals to help? Certainly not, I have a reputation to keep up, and my approach would be as cool as I could make it.

We aren't tigers, ruling the jungle, but many of us have been on top of the heap in some way and then found someone else come in who threatens to unseat us, whether it be a new sibling or a new animator on the team, and we know how that feels.

As Stanislavski said "Never allow yourself externally to portray anything that you have not inwardly experienced and which is not even interesting to you."

Motivation

Stanislavski asked actors to look in depth at their character's motivation, what it was that was causing the character to act in the way she was doing. Motivation can spring from many different places and we will go into the question in greater detail in Chapter 5, Principles of Performance, but what is important here is to ask the question, "Why am I doing this?" In the example above, Shere Khan acts as he does because he feels threatened by the presence of Mowgli in the jungle and motivation often comes out of the most primitive of desires, the desire to merely survive. This may have been the initial case with Wile E Coyote too, since we often see him flipping through the cookbook to the page with the Roadrunner, but I get the sense that this part of his motivation often gets overlaid by a desire to get even with the bird that has humiliated him so often.

The character is mostly unaware of his own motivation or believes it to be other than what it actually is, but the actor, or animator, needs to be aware of it so that he can go on to the next part of the system, the character's objectives.

Objectives

"What do I want?" This time, the character may be able to articulate an answer to the question of what his goal might be, although in terms of acting, the answer will not cover the whole of what the actor needs to think about.

Stanislavski taught that every character must have an objective, a goal that they want to achieve and that this goal could change. A character's over-arching desires are called the super-objective, and this will run through the play or film: the Coyote wants to eat the Roadrunner, Cinderella's stepmother wants her daughters to marry well, preferably to a prince. Such objectives can change; for example, what Shrek wants, and what drives him for most of the film, changes as he discovers more possibilities in life.

Within this structure there will be other objectives, each scene will have an objective for the character and within the scene there will be smaller objectives. Take the scene in *The Incredibles* (2004) Brad Bird, where Mr. Incredible goes to see Edna Mode to get his superhero suit fixed: Mr. Incredible's super-objective (no pun intended) is to carry on being a super

hero and doing all the crime fighting and world saving he used to do. A secondary objective, due to the fact that such derring-do is outlawed, is not to let anyone know that he is doing it. In his visit to Edna, his objective is to get his suit repaired and not to let her know what he is doing with it, so the actions he performs in the scene are all in pursuit of this objective, including the way he acts as he tries to gain entry to her house. When Edna looks at his torn suit and throws it in the bin, his reaction is to quickly retrieve it because, without it, he can't pursue his main objective. The way he looks at the suit is a wonderful illustration of the hopes and fears that it embodies, the sentimental tenderness of a man attached to the past that it represents, and the fear that, without it, he will no longer be the (super) man he was. Edna then offers to make him a new suit and he momentarily forgets that he isn't supposed to be doing this any more; his objective shifts to wanting to accept and get a great new suit; "something classic, like Dynaguy". Moments later, after Edna has vetoed the idea of a cape, he remembers he is supposed to be keeping this stuff secret and his secondary objective re-establishes itself as he goes back to asking for his old suit to be repaired. In doing so, he takes on a blatantly false jollity that doesn't convince Edna (or us) for a moment.

Even background characters are important in this respect, and if we have the opportunity (i.e., the budget) to give them something to do, they can help to underpin the believability of the scene, as in *The Iron Giant* when Agent Mansley comes into the room filled with town officials. There isn't much movement from them but the way they look at him and shift ever so slightly creates a palpable nervousness in the room and a deference to his rank that is very clever.

If you can find your character's objectives in each scene and then take a look at how often he achieves them, you'll get a fair idea of what his emotional state is going to be throughout. He doesn't have to constantly

FIG. 2.3 Mr Incredible and Edna Mode both have objectives in this scene and the way they interact in pursuit of these objectives is often called a "negotiation" by theatre coaches.
© 2004 Disney/Pixar.

manifest these emotions, but by understanding them and the character's "wants," you'll be able to come up with a more convincing performance. Once again it comes down to believing in your character, whether he's a snake or she's a dragon, and going with the reality you are trying to create.

Obstacles

The things that crop up to get in the way of our character's objectives Stanislavski called obstacles. These obstacles may be minor bumps in the road or they may be very serious upsets, they may be natural occurrences, like the lack of a corkscrew when the character is trying to entertain a new date, or they could be the deliberate result of another character's objective, such as when Edna throws away Mr. Incredible's old suit because her "want" is to make a better one.

Tools or Methods

Tools or methods are the different ways a character devises to get around obstacles and get to their objective; Richard sends murderers to kill his brother, the Duke of Clarence, who is ahead of him in line to the throne; the Coyote orders another great gadget from Acme; Mr. Incredible retrieves his costume from the bin.

Actions

Actions take the idea of an objective right down to the scale of the individual line and encourage the actor to find a reason for each thing he says or does. This doesn't have to mean that every single action is driven by the main objective, even the Coyote isn't that obsessed and his actions, although they come about in pursuit of his obsession, change due to the situation he's in. So, although he wants to eat the Roadrunner, his attention will soon enough be focused on trying to keep from getting squashed by his own machinery and each movement will come from that.

In Stanislavski's system, the idea of playing an objective (sometimes also called a task) is to take the actor's focus from playing the line (of dialogue) and keep them "in the moment" on stage. Actors may take their time to say a line or move across the stage, but this doesn't go on for too long and they can afford to be "in the moment"; for animators who may take a day, or even days, to make the same line or movement work, there is no way we can do the same thing. What we can get out of this idea of objectives is the way to approach a scene to make it shine, to stop it simply going from A to B.

FIG. 2.4 "The Pirates" (2012), Peter Lord, Jeff Newitt. "We did a scene in The Pirates! where the hero and his sidekick meet the villain, and, of course, they all play the scene differently, because the villain is calling the shots and knows exactly what's going on from the start of the scene so she doesn't react very much because everything is playing out according to her plan. And then our hero, who is a rather special hero, because he has an inappropriate degree of self-confidence, feels more in control than he is, and the third character in the scene fully realizes the danger they're both in, so each of those three people approaches the scene differently, sees the scene differently, and it's fun to catch that in the performance." (Peter Lord).
© Aardman.

Method Acting

It is likely that Method acting (developed by Lee Strasberg of the Group Theatre) is the only theory of acting that a member of the general public would be able to recognize; if asked, such has been the effect that it has had on film acting and thus the star system of Hollywood. Strasberg's students include some of the all-time greats of the movie world of the last fifty to sixty years, names like Marlon Brando, Marilyn Monroe, James Dean, Paul Newman, Jane Fonda, Dustin Hoffman, Jack Nicholson, and Robert De Niro. This is more to do with the fame of those actors than it is with whatever system of acting they espoused, but it has certainly made The Method a recognizable "brand."

The "method" is derived from Stanislavski's "system" but was modified by Strasberg and his colleagues. We can't go into all the differences here but the main ones (and the ones that give rise to much of the notoriety) are the ideas of substitution and emotional memory. Stanislavski had asked the actor to imagine "What would I do in this circumstance?" Strasberg's question was, "What would motivate me, the actor, to behave in the way the character does?" This asks the actor to replace the play's circumstances with his own and is called a "substitution." Emotional memory requires the actor to draw on his own memories and experiences to use when playing a part so that, for example, when playing the part of someone with a dying father, the actor might bring to mind the time when a relative was dying. The Method differs from Stanislavski in that these memories need to be dredged up on stage or in front of the camera, rather than using them in an empathic fashion to get into the mindset of the character.

Naturalism and Reality

What we are talking about when we talk of naturalism or reality in animation are two things, one being the attention paid to the physical reality of the performer and setting and the other being the psychological truth of the performances. In terms of physical reality, we are talking about the animation principles that the Disney animators are credited with formalizing in the early 1930s that we know as the 12 Principles of Animation (Trumpets, drum roll). We'll talk more about them in Chapter 6, Making a Performance, but, for now, we can précis them as the creation of a character that has personality, weight, solidity and whose movements not only betray a quality of agency but adhere to a physical reality, even if it is a cartoon physics. After the Disney studio enshrined these ideas in a system, there would be no more times when a character could pull off its tail and use it as a hook, as Felix the Cat used to do until years later.

Playful Pluto (1934), Burt Gillett, is held up as the first time a cartoon character really appeared to have a mind of its own and seemed to be thinking, and Norman Ferguson, the animator of the sequence where Pluto gets stuck in fly-paper, is credited with kick-starting the move to a more real sense of character. It isn't exactly what you'd call realistic, but the fact that Pluto changes how he feels about the situation he's in, as he gets more frustrated about being stuck, registered with audiences, and was eye opening for the animators involved.

The work of development undertaken by the studio in their films from this point on would culminate in the big breakthrough of *Snow White and the Seven Dwarfs* (1937), David Hand, William Cottrell. Walt Disney had, by this time, become convinced that, although animation should not seek to ape reality, it should at all times be based in reality. "I definitely feel that we cannot do the fantastic things based on the real, unless we first know the real" were his words to his animators. To this end, the animators attended a new life drawing class, and the film is also noteworthy for its use of live action reference for the

FIG. 2.5 Walt Disney had said early on in the process of bringing "Snow White and the Seven Dwarfs" to the screen that the dwarfs were one of the main attractions of the story for him and had suggested that they should all have distinct personalities. The dwarf names were chosen from a selection of over fifty that alluded to their characteristics.
© *Disney*.

character of Snow White and the Prince (some of the scenes were actually rotoscoped, despite the objections of some of the animators). Where the film really scores in terms of its animation and the way in which a quality of real life is infused into the characters is in the dwarfs, each of whom is given an individual personality through the way in which they are designed and animated.

No one would contend that the dwarfs are very realistic characters, in the sense that we see people like that every day (I'm talking about their actions and personalities rather than their stature), but we can connect with them since their drives are so human. What they do is based on observation of real people, so that though they may act in an exaggerated manner, they are still portraying real emotions rather than using signs to denote emotions.

But, even if the performances are based on reality in some way, are we seeing some form of reality on screen? From today's perspective, I would argue that the acting in this, and many subsequent Disney movies, really could be

categorized as very *broad* and not in the least bit naturalistic and that this is a stylistic choice that was new and exciting at the time and opened up new avenues for animation. What we had on screen were characters that seemed to have an inner life and reacted to the circumstances of the plot with realistic emotional intensity.

It can be argued that Felix could walk along and seem to be considering things, and, of course, Winsor McCay's creations always had a real sense of life to them that came from being drawn by a genius, but this was the moment that the way to make this trick work was turned into a workable system that could be adopted and refined by any able animator. In saying this, I don't intend to imply that it was a way in which anybody could get the same results that animators like those at the Disney studios were capable of. This was a system in the same way that Stanislavski had a system, a codified set of principles that could be used by a talented individual to produce good work and that can be built upon by diligent study and practice, which necessarily includes observation of the real world. As Bill Tytla said about his work on *"Dumbo"* (1941), Samuel Armstrong, Norman Ferguson: "I don't know a damned thing about elephants; I was thinking in terms of humans and I saw a chance to do a character without using any cheap theatrics. Most of the expressions and mannerisms I got from my own kid. There's nothing theatrical about a two-year-old kid."

FIG. 2.6 Though it is short, "Dumbo" contains some of the most affecting scenes in animated movies. Moving from elation at finding his mother to sadness at being unable to get to her, Dumbo's feelings communicate brilliantly to the viewer. © *Disney.*

They're real and sincere-like when they damn near wet their pants from excitement when you come home at night. I tried to put all these things in Dumbo."

Disney, of course, is no longer the only game in town when it comes to the animated feature. Although for a long time the studio lead the way in both the artistic and commercial development of the form, there have always been other studios, other countries producing films, and other styles of film. One of the greatest directors of animated features working today is Hiyao Miyazaki, founder of Ghibli Studios and a man revered by animators both east and west. Although his films are not quite as successful in the west as they are in his native Japan (where they are always coming top of the box office), they have a devoted following, including people like John Lasseter of Pixar and animators at Aardman Animations.

The animation in Miyazaki's films, while observing many of the concepts of the Disney Studio's twelve principles, has certain differences that set it apart and provide an alternative example of a naturalistic style. For those who are wedded to the Disney style, the character animation in a Miyazaki film can often seem a little opaque and the characters underpowered in some ways. Though, at the start of his career, he worked on several films that used the Disney style, he never adopted it as his own, and what his films specialize in are characters who, I feel, cannot be completely known by the viewer. Like our own acquaintances, who we may have known for a long time, but can still surprise us, Miyazaki's characters hold back a little of themselves even as we recognize them as real people. In *Spirited Away* (2001), Hayao Miyazaki, the main character, Chihiro, is a recognizable little girl who pulls at the hem of her T-shirt and, at the start of the film, runs in a funny childish manner with her hands held up to her chest. Miyazaki has obviously looked at how little girls act, and indeed this production came about because he wanted to do something that would appeal to 10-year-old girls like the daughters of the friends with whom he went on holiday.

"Every time I wrote or drew something concerning the character of Chihiro and her actions, I asked myself the question whether my friend's daughter or her friends would be capable of doing it. That was my criteria for every scene in which I gave Chihiro another task or challenge. Because it's through surmounting these challenges that this little Japanese girl becomes a capable person."

While Miyazaki's films are full of wonders, they all have a very real background that makes the science fiction or mystical elements work in context; they have all been developed in a way that feels real, even if not everything is completely clear. The world of each of these stories has a logic that makes even the strangest occurrences completely believable; all the characters, even the soot sprites that appear in *My Neighbour Totoro* (1988), Hayao Miyazaki, and reappear in *Spirited Away*, have a function, and even if we don't know what it might be, the context reveals their purpose without necessarily explaining it. In *Totoro*, once the house the sprites are living in becomes inhabited by a new

family, they drift away, and in *Spirited Away*, they actually have a job helping the boiler man. In the first case, although we don't know their function in the world, we can see that they are responding to what is happening and so, like any natural phenomenon, we accept their reality, and in the latter film, they are given a job to do that accords with their look and feel. The way they are animated, with a wide-eyed singleness of purpose, tells us just how simple they are. The behavior they exhibit is not that of insects, which have such a single-minded directness that we cannot connect with them, nor is it the flocking behavior of birds, because they exhibit interest in what other characters are doing, but it is a brilliant depiction of a very limited, but real, intelligence.

The depth that Miyazaki gets into his worlds, the design, the depiction of believable places, the concern for real problems like environmental ones or the role models for young girls, proves a very strong support to the characters, and it is impossible to think of them apart from each other. People tend to describe the realistic feel of the whole film before they pick out any character, and this may be a reason some feel his characters lack expression, they cannot, perhaps, see these characters in another story or outside this one. However, that criticism could be leveled at any number of films, and I think that few people would be desperate to see what Pinocchio did after his story had been told and he had become a real boy.

I must admit that, in some cases, the animation in a Miyazaki film can be a little too like conventional anime and that some of the human characters are sometimes, especially facially, a little immobile. No film is perfect, and to my mind, this is the counterpart of the animation excesses in a Disney film where too much business and distortion can go on without it adding anything to the understanding of the character.

So both *Pinocchio* and *Spirited Away* can be seen as real and their characters' performances are natural to their own worlds; they both benefit from the animators' close observation of the real world and their attempts to use that knowledge in pursuit of greater truth.

Epic Theatre

Germany's Bertolt Brecht's created theatrical events that, while making believable characters, never asked the audience to believe that the actor had become the character. The play is, at all times, merely a construction and a representation of the real world and not the world itself. By emphasizing the construction of the play and the way it could be altered, he hoped to show that everyday life was itself a construction. He wanted the audience to realize that the character was, at all times, making choices and choosing one action over another, as a way to show that the state of the world was caused by the actions of people and that people could choose to change the world. In his plays, he allowed the actors to talk to the audience or "break the fourth wall" as it is known, and they tended to play several parts. Captions

and the speaking of the stage directions were other techniques to promote what he called the "verfremdungseffekt", translated as "distancing effect or estrangement effect."

I have seen nothing to suggest that Brecht had any thoughts on animation or that Hollywood cartoons contributed in any way to the formulation of his theories, but it seems to me that animation does contain a lot of what Brecht was talking about. In the first place, we are automatically distanced from the film due to the nature of how it is made. We, as an audience, have to accept that what we are looking at are drawings or puppets or computer generated characters, and we have to suspend disbelief to enjoy the film. It is obvious that, though they use all twelve of the Disney studios animation principles, Warner Bros cartoons featuring Bugs Bunny, Daffy Duck, the Roadrunner, and the others refuse to conform to the tyranny of the plot or sentimental happy endings. As in Brecht, characters often break the fourth wall and talk to the audience and captions are used extensively, especially in the films of Tex Avery. More importantly, in this regard, the characters are always playing at being whatever they appear to be on screen. Even when we find Bugs hanging out in a rabbit hole before being hunted by Elmer Fudd, we always get the sense that he is there only to get the picture going and that a sophisticate like him is really at home with the other stars and probably has an apartment in Beverly Hills. Indeed, we often see him doing other jobs or in other situations in the manner of a star cast in a different role, including in *Duck Amuck* Chuck Jones (USA, Warner Bros. 1953) as the animator of the titular cartoon. Duck Amuck takes the self-reflexivity of the Warner cartoons to its logical conclusion with the unseen animator tormenting Daffy, the "star" of the cartoon, by repainting his backgrounds to make his Musketeer costume inappropriate, then repainting him as a different character and then going into even wilder flights as Daffy is broken apart and rebuilt, and the very film itself is restructured around him.

In a similar vein, *Who Killed Who?*, Tex Avery (USA, MGM 1943), is a parody of detective and horror films where the live-action host who introduces the show turns out to be the murderer in the end, and the victim can be reading about his fate in the book of the film he's in. Playing with the method of making the film (2D cel animation), Avery has a scene in which a cupboard is opened and the butler, tied up, falls out toward camera. And keeps falling! The cels are repeated until they suddenly pause with the character in midair, and he looks out at the audience and says, "Quite a bunch of us, isn't it?" and then continues falling.

In all these films, the characters act as if they know they are in a film and playing a role, and the acting is generally broadly played as a parody of whatever genre they have taken on but it can contain moments of subtlety, usually when the character finds himself frustrated by the limitations of the role he's stuck with.

Of course, the other important way in which these characters differ from their Disney counterparts and what makes them fit into an examination of the Brechtian style is something that Brecht could never have seen from any of his actors, the completely extreme nature of their bodily distortion. These characters literally embody the emotions they have in a way that holds nothing back. So if the wolf sees an attractive female, he will hold nothing back in displaying what that attraction has done to him; his entire body will erect itself while his jaw will drop to the ground and his eyes will pop completely out of his head. Instead of the old fashioned theatrical way of making a gesture that acted as a signal to what the character was supposed to be feeling, in Avery's work, the character's whole body is a representation of an emotion in a way that Terry Gilliam calls, "the most wonderfully liberating spectacle".

Though the director often uses his characters and the form of the piece to examine the nature of the type of film they are parodying, the main difference to Brecht's theatre is the fact that these Hollywood cartoons are not political in the sense that Brecht was aiming for. Though a film like Duck Amuck reveals the methods of its own production, it does so only to make a joke at Daffy's expense and not to show the ultimate hand behind the production, the money-men, who Brecht would, no doubt, have attempted to expose.

Nevertheless, the political, in whatever way you want to look at it, is present in much animation, and the style of performance can owe something to both the naturalistic style of Stanislavski and to the non-naturalistic style of Bert Brecht. A film like *Britannia* (1993), Joanna Quinn, takes the British Empire and uses the classic personification of it as a bulldog to look at what that empire did to the world. As it flows continuously from one image of conquest to another, the film portrays the dog rushing through a range of roles from the playful puppy he is at the beginning, through bully, thief, and lecher until he ends up

FIG. 2.7 Britannia, a beautifully drawn, satirical swipe at British history.

as the bewildered lapdog of an old lady. The film uses all the classic principles of animation to bring out the body language and facial expressions and, as with all Joanna's films, there is a masterful use of drawing to give the character weight and describe the forces running through the body. At the same time, these naturalistic tendencies are played at such speed and are combined with metamorphosis, as the dog turns into other characters like a judge and Queen Victoria, that there is never any sense that this is anything other than a didactic entertainment.

I Met the Walrus (2007), Josh Raskin, is an animated illustration of an interview John Lennon gave a young man called Jerry Levitan who had managed to sneak into the star's hotel room in Toronto in 1969. A complex array of ideas and techniques serve to illustrate, comment on, and illuminate the ideas that Lennon is propounding and the performance element of the film is not restricted to the characters that appear throughout. The performance here is not about acting in the way that *Dumbo* is, though the individual characters all act perfectly well and the figure of John falls to the ground perfectly realistically when he is being denied entry to the US. Instead, the whole graphic style of the film is choreographed to elucidate the same connections that Lennon is making and uses animation principles to create a well-timed and snappy piece that blends education, comedy, and art. Smart timing and an apt choice of illustration are the important elements here.

Comedy

Comedy, possibly more than anything else, depends on us knowing our characters and our audience and getting the timing right. Unlike the stand-up comedian who can get an immediate reaction from the audience and adjust his performance to fit, leaving a bigger pause if the gag gets a longer laugh or changing direction if the jokes aren't quite hitting the spot, we have to make the film and try to anticipate the reaction. Comedy can come from gags, both verbal and visual, from character and situation, and from a combination of all of them, and the way it is put over varies just as much in animation as in any other medium. The performance can be very broad or understated, it can be quick-fire and explosive, or it can be slow building, but the key to making the acting funny still seems to come from believing in the character, as you would for any other role.

In the interview with Peter Lord of Aardman Animations, in the bonus chapter on our book's companion website, he talks about the importance of "real moments," when the audience recognizes a gesture or a look that really speaks to them of themselves or someone they know. This is as true of comedy as it is of drama, and we can look at great comedians and see this happening. Charlie Chaplin has often been cited as a performer who does this constantly, and Ed Hooks, in his book *Acting for Animation*, notes the performance where Chaplin gets his foot caught in a bucket and tries to get it off. Ordinary comedians, he says, would try to get laughs by frantic attempts

to lose the bucket, but the difference with Chaplin was that he would look around to see if anybody had noticed his problem and try to conceal his embarrassment. In doing so, the audience becomes party to his thoughts, they understand and recognize the similarity of his emotions to their own, and empathy ensues.

Comedy, as we all know, is a very subjective topic, and we all have our favorite comedians and comedy films. Ed Hooks loves Chaplin and consigns Keaton to a much lower rung of the acting pantheon because he feels that Keaton ignores, or does not know of, the importance of empathy. He was, says Hooks, "uneducated and unsophisticated about the actor/audience contract and about empathy." Despite this, his films got, and get, big laughs and in the last half-century have quietly worked their way to a position where they are often seen as funnier and more modern than those of Chaplin. Chaplin is lauded as an actor's director and connected to a deep well of emotion or damned as a throwback to the acting styles of the 19th century and a reservoir of cheap sentiment and pathos. Keaton gets praise for his brilliant staging and use of the camera and his cool persona, and he is done down for being detached or a little heartless. The argument goes on and on, and a good rundown is the debate between critics David Fear and Joshua Rothkopf in the *New York Times*: (http//newyork.timeout.com/arts-culture/film/75837/feud-chaplin-vs-keaton).

Suffice it to say, Chaplin and Keaton still both get laughs and they are both worth watching and learning from, as is Harold Lloyd, whose films often out-performed both of them at the box office. The Marx Brothers and the stars of Warner and MGM cartoons, as well as the characters in *South Park* and *Life of Brian* (1979) Terry Jones, are all regarded (though not by everyone, naturally) as funny. What unites these shows is the fact that the characters all inhabit fully realized worlds and what they do; the situation they are in is, for them, the most important thing in the world.

Steven Horwich (tipsforactors.blogspot.com) writes, "This is true of both comedy and drama. In fact, it's especially true of comedy. A character must feel that what is happening to them is critical and as close to life and death as possible. Moliere's great comic characters seem to be ever on the brink of utter ruin and destruction, and no one's plays are funnier. The bigger the problem, the funnier the character becomes."

The lesson for the animators among us is to make sure that what we do with our characters contributes to the whole scheme of the film or show. Mugging, overacting, or merely doing things that are more complicated than the other animators have done is just showing off and adds nothing to the work. The humor is the thing, and if the shot is working and getting laughs, then it isn't about the animation anymore, and there is no need to do things just for it to be seen as great animation. For the director, it is an admonition to make sure that everything you have in the work is there for a purpose. If adding that extra gag will make the scene funnier and build the character a little more,

that's great, but beware the temptation to push things too far and lose the thread of the story or undermine the character. If that gag is funny but not really in the nature of the character, then you have to bite the bullet and get rid of it—even if it is already animated!

Summary

Performance is a multifaceted thing and there is more than one way of animating a cat. Animation allows us to choose where we place our emphasis on the spectrum of realism and what we regard as the right kind of performance for our material. Since we can work in two-dimensional space as well as three-dimensional space, we can use graphic visual tricks as well as realistic ways of portraying things, and so have a greater control over the way we present our characters. The performances our characters give can, therefore, be influenced by any part of the history of acting, so having a sense of the history of performance gives us a much wider range of influences and ways to solve the problem of how we present ourselves to ourselves.

Format, Genre, and Audience

In this chapter, we take a brief look at aspects of storytelling that shape the kind of performances we make. Format deals with the manner in which animation is distributed and consumed while genre places the product into categories. Both format and genre may be used as a way of identifying and reaching an audience. Audience is perhaps the single most important thing to bear in mind when developing a project and creating a performance within a narrative. It seems obvious perhaps but well worth mentioning nonetheless that we as animators seldom (if ever) make work for ourselves, we make it to be seen by a *specific* audience.

While format, genre, and audience may not have the same immediate and direct impact on the *practical* aspects of creating animated performances such as the production processes or the technical constraints of any specific animation discipline or technique, they do shape and categorize and *target* the very nature of our storytelling. We cover some of this in what follows.

The stories that we write and tell one another are owned equally by both the audience and the storytellers. Stories form an important part of our lives and are a part of the very fabric of our societies, they shape and define us, and they link our pasts with our futures. The stories that we pass down from generation to generation have played a central role in the development of our civilizations and cultures. Stories bring both storyteller and the audience together in partnership to create a unique experience, one that has endured for millennia. It is probably true to say that the need we have within us to tell and listen to stories has not changed since we first sat together around the communal fire. Our need for stories and storytelling may not have changed, but the way in which we tell them certainly has.

A great many of us around the world still sit around a communal fire to exchange stories and to strengthen family ties and bonds of friendships, but many more of us now get our stories remotely through advanced technology of one sort or another. The stories we tell and the way in which we tell them are pretty much shaped around the targeted audience and the technology used for storytelling. The spoken word, music, dance, games, performance, the printed word, opera, and interactive media provide a wide range of different kinds of storytelling. Books, magazines, radio, theatre, television, film, computers and the Internet provide the vehicles for storytelling to targeted audiences.

Audiences

The circumstances surrounding the storytelling and the targeted audience do much to shape the story, the manner in which the story is told, and the technology used for the telling of it. A parent telling a bedtime story to their child is an intimate and very personal event, and the book is a very good vehicle for this; it allows for personal involvement, interaction, and the strengthening of family bonds. Telling stories online to audiences on the other side of the world clearly does not have this level of intimacy though the technology that allows for a wider and perhaps more disparate audience. Sitting in a darkened room with hundreds of strangers brought together to share an experience of 3D imaging and surround sound is a completely different experience to hearing the same story in the comfort of your own home on a laptop computer. Different but not necessarily better.

Know Your Audience

If we are to create successful product that reaches our target audience, the first thing we must do is to understand our audiences. This extends to understanding the stories they want to hear, how they want to hear them, and the techniques and performances that are used to tell those stories.

Audiences are varied and come in all shapes and sizes, and most people fall into a number of different types of audience. We may have a very good idea of what would be considered in general terms as family entertainment, children's or adult entertainment, but it's not to say that all animation falls easily within distinct categories. Audiences are not fixed, and individuals that fall within a particular audience demographic may not fit neatly into nice little boxes. There is a considerable degree of crossover.

The nature of an audience, how large it is, where they are located and the makeup that audience may determine the manner in which they are reached, and the vehicle used for reaching them. The revenue that each project will generate is determined by the audience it reaches, which in turn places limitations on the production budgets.

It is clearly evident that some audiences have a degree of loyalty to the work of particular artists, performers, and filmmakers (Elvis almost seems to be as popular now as he ever was), and there are some examples of animation enjoying long-term popularity. Audiences do tend to change and shift, and things do come into and fall out of fashion. Some animation continues to attract audiences many years after the original audience is long gone. If we consider the 1940s and 1950s, work of Tex Avery still receives a great deal of acclaim, and, with the advent of You Tube, the audience is wider and perhaps even larger than ever. In its turn, Avery's animation and his particular brand of animated performance has been responsible for other newer productions that have gained their own

mass audiences. We can see his influence in both the animation series *Ren and Stimpy* (original series broadcast 1991) and the Jim Carrey's performance in *The Mask* (1994).

Audience demographics change across cultures and nationalities and across ages. What the audiences of the early forms of film and animation found engaging would today in all probability be met with disdain or at very best mild curiosity. By and large we are all so very much more media savvy than our parents and certainly our grandparents. While media has become even more elaborate and technologically advanced since those early days of film and animation, we still have one thing in common with those earlier audiences; the desire for the novel and for the new. This desire for new experiences has driven the industry forward. Regardless of the latest developments in cinematography such as films in 3D, there is still plenty of room in the market for more traditional media.

The way in which we consume media is ever changing, and the pace of this change is on the increase. The impact of these changes on media is far reaching. With the advent of television, audiences began to move away from the cinema. With the advent of the Internet, audiences are starting to move away from television. With the advent of the e-book and online stores such as Amazon, people are moving away from the bookstore and even from the physical book.

It may be possible to consider audiences as being defined along age, cultural, political, and socioeconomic and gender lines. Such audience categorizations may be rather simplistic and to some, no doubt rather offensive. However, they may provide us with a basic framework in which to begin to identify and target an audience for our work.

The audience and their particular likes and dislikes will determine not only the kind of story told but also the kind of animated performance to deliver the story. Anime offers us a good illustration of how performances are suited to particular kind of narrative structure and audience. The traditions of Japanese animation stems largely from a graphic style to be found within their comics — manga — which itself has a much longer tradition. Anime has found particular favor in the west among younger generation's animation fans and the legacy of this art form can now be seen to be emerging within productions around the world.

Target Your Audience

Animation along with all other forms of media is produced to be shared, and there can be little satisfaction to be gained from creating animation that no one ever watches. Research is important; you must know your audience before you can effectively target them.

The animation and performance within any given production should be appropriate to the audience and the different formats. Feature film animation is generally rather sophisticated with performances based on naturalistic motion, even if this is animation of fictitious creatures they generally behave

49

in ways that attempt to give a naturalistic representation of movement in an effort to create believability.

Animation aimed at the preschool market is often rather simplistic and less dynamic. This may be cheaper to produce but just as important is suited to an audience that is perhaps less critical of animation timing and more likely to concentrate on other aspects of the animation such as the story, the songs, the design and behavior, and the performance of the characters.

Commercials are generally concept and design orientated, targeted at a particular consumer and user group. I think it would be quite interesting to look at the changes in script, design, and animation used in television advertising aimed at adults over a number of years as a way of analyzing the trends in behavior, social norms, and humor of a particular audience. Targeting a particular audience may require a different approach than it did just ten years ago.

Despite my generalizations here, audiences are not predictable. There are many examples of how a particular production has gained mass popular acclaim and perhaps more importantly generated good box office returns despite, rather than because of the best efforts of broadcasters, film executives, music

FIG. 3.1 While audiences may not be entirely predictable, one can make certain assumptions based on consumer habits and market trends. There are clearly approaches to styling that are suited to certain target audiences.

executives, and commissioning editors. In their desire to back a certain thing and their drive for market share, executives and media bosses occasionally find themselves behind the curve when it come to the demand of the market. On the contrary, as positive as it is may sound, I am not convinced that the ghostly voice from the film *Field of Dreams* (1985) that urged 'Build it and they will come' is a good enough basis on which to target an audience.

Genre

As a professional animator working within a studio environment, you may find yourself limited in your choices of which genre you work within. You animate what comes your way. However, if you have the opportunity to work on self-directed and self-initiated work, then this will be determined by your personal preferences and your own interests. Just because you have an interest in a specific area does not mean that you are best suited to that kind of work. There is a very real creative (as opposed to simply technical) skill to work within different disciplines and find your own creative voice in an area that you are suited may take time. Each genre presents its own challenges, and it is easy to spot when an animator is working in an area that they well suited to, they approach the work with a natural connection and level of engagement that can't be faked, and the results are there on the screen for all to see.

Comedy

Laughter may be a universal phenomenon but what makes us laugh is not. It would seem that humor is not simply a matter of taste but may also be one of culture. I somehow doubt this, and while it is clear that some examples of comedy find more favor in certain societies than others, this may be due to the social referencing within the humor not being fully understood or appreciated. Or they may simply find it not funny. There are clear divisions (some of them quite substantial) of audience within a given society that find a particular brand of humor funny. Some forms of humor is also generational, what young people find funny is often very different to what their parents and grandparents find amusing.

Comedy can be a very unforgiving discipline, if something isn't funny, it's simply not funny. It lives or dies by the laughter or silence of an audience.

Drama

There are many kinds of film that fall within the broad category of drama. The majority of animated drama falls short of being feature length and as such is considered as a short form filmmaking. Animated drama often deals with all the same kind of issues and themes as live action though animation has the advantage of being able to express itself in more abstract and interpretative ways. I would use the term magical, but then again I am a little biased.

The dramatic animated interpretation of established texts and stories offer an opportunity for a different approach to familiar storytelling. Animated drama

such as the Aleksandr Petrov's version of Earnest Hemmingway's *The Old Man and the Sea* (1999) and the John Halas and Joy Batchelor's film of George Orwell's *Animal Farm* (1954) and the work of Frederic Back who interpreted Jean Giono's *The Story of Elzeard Bouffier* published in 1953, in his film *The Man Who Planted Trees* (1987), are all good examples of how animation can be used to interpret familiar work and in doing so make the work anew.

The work of Czech animator Jan Svankmajer and the American brothers defines animated drama as does the work of Barry Purves. Barry deals with myth and legend, with classical literature, drama, opera, theatre, and music. He manages this through his unique approach to animation and art and his superlative craft skills as an animator. Through all their work and the work of scores of other animators they have established animation as an art form capable of great complexity, drama, and beauty, and I would suggest of magic that no other medium can match.

Documentary

While the animated documentary is not a new development in the medium, it has recently received more attention, and there have been some remarkable examples. Perhaps the earliest animated documentary and certainly one of the best known is Winsor McCay's *Sinking of the Lusitania* (1918) that recounts of the sinking of the RMS Lusitania by a torpedo launched from a German submarine during her passage across the Atlantic on her way to Britain by during World War I.

There have been a number of animated documentaries screened in cinemas though short form animated documentaries for release on TV have been the more usual format. The range of subject matter dealt with is wide, and a number of these films have met with critical acclaim. *Ryan* (2004) a film that uses interviews with animator Chris Larkyn won an Oscar for its creator Chris Landreth. *Animated Minds* created by Mosaic Films in 2003 presented a series of short films dealing with topics around mental illness in a manner that was not only inventive but dealt with the subject in very sensitive manner. Using real accounts of those suffering from mental disorders, the two series made in 2003 and in 2009 managed to provide a remarkable insight into a range of conditions and provided much welcomed educational material.

Public information films, while not strictly documentaries, do deal with factual information intended to educate and be of benefit to sections of society. Not as widely distributed as they once were, such films were typically short and dealt with issues such as road safety, the emergency services, calling the coastguard, litter, the danger of fire in the home and the country, the country code, stranger danger, and poisonous substances at home. One of the longest running series of public information films in the 1970s and 1980s was the *Charlie Says* series included the antics of a little boy and his cat Charlie. Created by animator Richard Taylor who was also responsible for a series of films *Protect and Survive* that dealt with topics related to civil defense in the event of a nuclear strike or accident.

Format

The formats covered below are far from a comprehensive list but are used as a way of illustrating the constraints and opportunities that different formats offer you as an animator. The experience of each is varied, and any comparison cannot be based on which is best. There is no "best," there is just "different." Some work lends itself well to one format over another just as the individual animator/filmmaker find themselves more suited to working in one format and genre than another. By giving some consideration to these, you may perhaps begin to see which areas you are drawn toward and which sector of the animation industry you are best suited to pursue a career in.

Features

The format of the feature film and the duration (80 to 210 minutes) allows for the development of personality, characterization and the complex relationships between characters that other shorter formats cannot match. The duration of feature animation provides unique opportunities for developing performance and acting within these extended time frames. It also allows for substantial change and complex developments within the narrative and allows for characters to be developed over time.

FIG. 3.2 Production values are generally much higher for feature films. It could be argued that for some genre of film and for some audiences, the spectacle of the film form itself, the aesthetic of the film, the quality of image, and the sheer cinematic experience are just as much an important aspect of the film as the story itself.

53

Short Form

Short form film (3 to 10 minutes) often presents the opportunity to experiment with design, character development, graphic styling, and a range of techniques that includes interdisciplinary practice that other forms cannot offer.

Perhaps one of the best examples of how short form filmmaking can result in commercial success is the work of Nick Park. His first student film *A Grand Day Out* (1989) featuring the antics of Wallace and Gromit won him many plaudits and critical acclaim. The main characters have appeared other highly successful films and helped grow Aardman Animations into one of the best animation studios in the world.

FIG. 3.3 Short form film.

Television

For people of my generation, television is without a doubt the greatest invention of mass media distribution.

Television and television audiences benefit from the wide range of work that it encompasses; TV series, TV specials, miniseries, feature films, documentaries, factual, news, quizzes, music entertainment, religious programming, education, business and political broadcasting, comedy, specialist programming, commercials, public information films, trailers, interstitials, and more recently reality TV.

TV Series

Acting and performance and the development of characters that can be sustained over a series of TV shows differ from those within longer formats. The shorter duration of the TV series episode means that the narrative has less room for development. This coupled with the repetitive nature of series work has an impact not just on performance but also on character design and character development.

The format of the animated TV series offers little room for the development of the characters, and they are generally not episodic. This puts a demand on the filmmaker to ensure that the characters are established from the very beginning. The audience needs to be able to recognize the personalities very quickly. These personality traits may be reinforced over many episodes and lead to familiarization, but this is not the same as character development. This does not mean that the characters are simplistic or 1D they may have complex personalities. While these are generally clear and understood from the very beginning, our response to them may grow as our familiarity grows.

Let's consider for a moment Roadrunner and Coyote. Here we have two fairly simplistic charters, the coyote wants to catch and eat roadrunner, and roadrunner wants to avoid being caught and eaten. This relationship provides a vehicle for almost endless episodes without the scenario ever becoming dull. Predictable yes, and that is the point but dull, never. In contrast, we could consider the cast of the Simpson's. Homer, Marge, Bart, Lisa, and Moe are all complex characters (with the exception perhaps of Moe) that go to make up a *very* complex family. If that wasn't enough complexity, the series is populated by a wide range of well-established characters all with their own very distinctive personalities and stories to tell. In addition, there are often one off "guest" characters that add to the complex mix. While the storylines are varied, the characters interesting, the scenarios are believable (within the bounds of the *Simpsons*), the stories are worked around well-established parameters and easily identified and accepted, but *never* are they formulaic. The program, the characters, and the storylines are instantly recognizable and accepted. This is the strength of this particular show.

Many of the programs are linked to the marketing of toys, books, games, and other products. Indeed the revenue from licensing generally exceeds that of the show themselves. It could be argued that this relegates (at least in some cases) the TV series to little more than animated commercials.

Internet

The impact that the Internet has had on television is far reaching, and there can be little doubt that the Internet has changed the face of all media not simply in the way it is distributed and consumed it is now beginning to impact on manner in which media is produced. For those wishing to become involved in commercial production, the opportunity to break into the market has never been greater. With the increase in product available and the numbers of producers involved, the prices paid for product by broadcasters has tumbled to a point where it becomes difficult for producers to gain a healthy profit from their efforts. Distributing your work on the Internet is an obvious and relatively easy option though the challenge of creating a revenue stream from it is far from easy.

In recent years, we have seen how the production of animation has shifted across the globe to take advantage of lower labor costs. I first started out in the industry at a time when the production of animation television series made entirely within the UK was common. In an effort to cut costs and increase profit, producers deemed this too expensive and moved production overseas to other European countries where labor costs were lower.

The economic climate also impacts the nature of the material produced, the production values, and the type of work produced. Given the constraints on finance and profits, we may find an increasing reluctance by broadcasters and producers to create work other than the tried and tested, established titles, linked to merchandising and other media.

Hand-Held Devices

The development of computer and mobile technologies has brought us a range of small hand-held devices, including the cell phone.

We can experience all manner of media on our smart phones and tablet-like devices such as the iPad. This technology presents another opportunity for the development of animation and other media specifically for these technologies.

These developments in mobile technology has enabled a form of interactive storytelling using GPS technology, triggered by location and made site specific. Audiences for this are still relatively small in comparison with other mass media formats, but the potential is vast. As ever the real challenge is perhaps not the creative exploration of the media but, in commercial terms, the business model for its development and exploitation.

Corporate Video

Classification of this format is not easy as the range of material that could fall under this classification is huge. While the majority of the material made under this heading is used for the purposes of corporations communicating within its own framework, some of this is also intended for business to business communications. They can be used in order to promote an internal service, product, or to elicit a change in structure, behavior, or practices. It is not intended for mass distribution to the public. The audiences in such cases are very specifically targeted and often very specialist in nature. There may be little difference between the techniques and processes and the different discipline including animation, information graphics, and live action used in corporate video than for commercials. Communicating very specialist and highly technical information presents many challenges to the filmmaker. Making such information accessible and easily understood may be difficult enough, but this is often to be balanced with the aim of making it engaging and even entertaining in some way. The use of animation within corporate videos is used to illustrate abstract concepts, complex information, or data or processes that are difficult or even impossible to see in any other way.

Games

It would be a mistake to consider computer games as a single genre of media production as the games and the audiences that play them are so very varied. Computer games may fall into rather distinctive classifications that are targeted toward a range of equally distinct audiences that are determined at least to some degree by age range, gender, and individual tastes. Some are clearly intended for adult use and have violent and even sexual content while others are intended for children and in some instances *very* young children.

The use of characters in computer games is varied. Many of them are simply figures that carry out the action of the game-play though there are some that are based on established characters and long-standing shows that appear in other forms of media. There have also been some very strong characters and storylines that have developed out of computer games and made the transition into other media. Foremost amongst these must be Lara Croft the feisty female hero of the *Tomb Raider* series of games that did much to widen the appeal of games and bring gaming to a wider audience. It also brought the character to the cinema audiences and thereby widening the audience reach even further.

The range of computer games and the platforms that they are delivered on is extensive. The audience for games is also extensive and very broad. The one thing the animation has in common across games and platform is that the performance and acting of the characters within a games context is largely action based. The focus of animation is on game-play and the user experience

and not on character development, narrative, or a performance that extends beyond action. The scope for acting and performance within games may be less than other formats, but the demands for the animator may be equally challenging in part due to the restrictions of the game format.

Commercials

Many animation students get it into their heads that in order to develop an interesting narrative and good performance-based animation, one needs an extended period of time in which to do it. In fact it is perfectly possible to deliver an engaging plot using interesting characters within a very short time frame. Television advertising has been doing just that for many years. The duration of a TV commercial is often between 20 and 30 seconds. On the face of it, this does not seem like a lot of time to develop character or explore complex narrative structures, nor is there time for acting and performance, at least not performances that are nuanced or complex and built throughout the story. It means that any performance must get the point across very quickly. Working within such strict time constraints is an art in itself.

Some characters have been associated with product for many years and become synonymous with the product.

The modern image of Santa Claus has been associated with the Coca-Cola company through their advertising campaigns that ran in the 1930s and has been cited as being responsible for his modern red and white appearance.

One of the aims of using recognizable characters is to associate them with a product, the actions and performance they give or the lines they speak then become associated with the character, the performance associated with the action and before long we are all familiar with a catch phrase or action and the product it is linked to. This may be run over a campaign lasting many weeks, months or years.

Perhaps one of the most successful campaigns over recent years that has run in the UK demonstrates a performance involving characterization and personality built up over an extended period. The advert was for a market comparison site, Compare the Market.Com. They used a clever play on words a charming character Aleksandr the meerkat who was ostensibly trying to promote his own company Compare the Meerkat.com. This has been taken to great lengths with websites, TV, and press advertising and even the promotion of soft meerkat toys. A number of animated stories have built up the character and history of a noble family of meerkats. A great example of how such a short medium of the commercial can be used to target audiences and develop recognizable characters.

Summary

Having looked at the issues around audience, format, and genre, you are better able to appreciate that the targeting of audiences and the manner in which animation is distributed and consumed determines, at least to some extent, the nature of our storytelling and the kind of performance we are able to make for these audiences and formats. In some instances, the way the material is consumed is an integral part of the work itself. What plays well in one format will not be suited for another.

You may have also started to consider your own part in all of this, the kind of audiences you are interested in speaking to, how your own work will be distributed and consumed and the kind of animator you are or want to be.

It is important that we are aware of the ways in which our work is seen by our audience, it will not only shape your storytelling, your approach to acting, and the kinds of performances you make but may also shape your career in the animation industry.

My final point must once again be to point out that the most important aspect of animation production, performance, and acting is your audience. You should keep them uppermost in your mind all the time you are animating; you are after all making work for them and *not* for yourself.

Character and Personality

In the previous chapter, we took a little look at audiences and formats, and in doing, we so established the importance of storytelling to the cultures and societies around the world. One of the assertions made was that the real essence of storytelling could be summed up simply by saying a compelling story was one that had interesting things happening in interesting places to interesting characters. The key here is the word interesting. Without that interest, a character is in danger of becoming reduced to the status of manikin. At the heart of any great story are the characters that inhabit, shape, and determine the story.

This does not simply apply to performance-based stories; the same holds true of all stories based on characters regardless if this is in theatre, literature, film, radio, or animation. The most important aspect is characters, recognizable and believable characters with personality. Regardless of the exact nature of character, it is largely through those characters, though not exclusively, the narrative of the story is delivered.

We need to give some thought to the contextualization of the characters we work with and the kind of characters and personalities the stories we are telling require. Some stories of the Wild West would become almost meaningless without the context of the settlers and the conflict of cultures between the Native Americans and the largely European newcomers (the invaders). Similarly, stories about rescuing damsels in distress from fearsome dragons need knights in shining armor while the exploration of the outer reaches of the galaxy at some point in the distant future needs astronauts. However, cowboys, knights in armor, and astronauts are not exactly characters, and they are certainly not personalities; these categories only represent *what* these individuals are; they do not represent *who* they are. Strip away all of the superfluous detail that surrounds the rather facile characterization of cowboy, knight, and astronaut; and you will find personalities just like you and me. Yes, these individuals may be more heroic (or more cowardly), and they may demonstrate aspects of human nature in the extreme; but ostensibly they share with us the human condition. It is those human traits that attract us to the characters and make them recognizable, not the clothes they wear or the role they play.

I have said it before but if the storytelling is to be interesting then the characters within the story need to be interesting.

Character Development

The importance of character development in performance-based animation cannot be overstated, and it is clear that the nature of the character will shape the nature of the character's performance. The practice of character development may begin with the concept design, a part of the process that precedes the writing of a final script and continues through the design process including storyboarding and on into production. This ongoing development may be impractical for formats such as feature films or TV series, but it may be true of episodic one-off short productions (as opposed to TV series). A good example of this may be seen to have taken place during the development of Bugs Bunny and Daffy Duck that appeared within a number of films over a number of years. They progressed from being characters of a rather 1D nature to become complex individuals with distinct psychological traits. For the most part, this kind of development over an extended period is impractical as characters cannot be developed over the period of a feature film or a TV series as it is important to maintain continuity throughout. Any development needs to be completed and the characters established before the production begins, or at least the parameters for the performance needs to be set. What I have covered here deals with the development of a character's personality over a number of appearances. This is not the only kind of development that a character may undergo. These changes may happen over a much shorter time frame and may be a result of the circumstances and events that they are subjected to within the narrative. Characters that appear within longer formats will be more subjected to the kind of changes that are brought about as part of the story they appear in. Indeed, it could be argued that the very nature of feature films is to tell stories about the changes the characters undergo.

FIG. 4.1 Begin to explore the physical nature of your characters based on the script and in doing so look for personality traits that emerge from your concept art in addition to those that may already be established in the script. It may be useful for you to use a range of media that allow for different qualities to surface. You may find that modeling your characters at this early stage allows you to discover aspects of your character that drawings or paintings don't allow.

Throughout the whole of the design and character development process, the director, the producer, and the designers will normally collaborate as a team. The role of animators, if they are involved at this stage, is largely secondary. That is not to say that the animator does not have a contribution to make, it is only once the animator begins to work with a character that it truly begins to come alive. Not simply by adding movement to a character but through a skilled and creative use of animation timing adding performance.

FIG. 4.2 Using your concept art as a starting point you can then go on to make designs that take into consideration the mode of production and any constraints that animation production will place upon your characters. Production designs allow you to determine exactly how the characters will look on screen.

FIG. 4.3 These are the characters that actually appear on screen. All of the practical and esthetic design considerations should have been worked out before the animator gets hold of them leaving the animation team to concentrate on acting and performance. It is critical that you consider the practical implications on animation production when making your designs.

Animators cannot simply rely on the basic instructions received from the director or the voice track provided. Of course, these make an invaluable contribution to the way in which the story is told and the manner of the performance, but it is said that the devil is in the detail, and so, it is with acting. The way actors perform will make the story come alive in ways beyond what was originally envisaged. In order to do that, it is necessary for the actors to be comfortable with the characters they are acting.

It is clear from the work of two of great cartoon animators Chuck Jones and Tex Avery that they developed real affinity with their creations. Interestingly enough, we can see how Bugs Bunny and Daffy Duck developed over the years as the understanding of the characters grew. In his book Chuck Amuck, Jones talks with genuine affection for Bugs and Daffy and his later creations, Roadrunner and Wile E. Coyote.

Issues such as the physicality and psychology of a character will not only determine empathy but also that almost illusive but very tangible quality that Disney termed *appeal*.

Formats

The different animation formats an animator may be asked to make work for will offer different possibilities and constraints for the work and for the way in which character-based animation will be undertaken. The development of the animated character may also be dependent on the format the characters for which they are being designed. TV series, one-off short-form films, commercials, features; all of these formats will place different demands on the narrative, and each will allow for varying levels of the character development. However, animation is increasingly being made for distribution across a number of formats, or at least much of it is now being repurposed for distribution using different formats. When designing new characters, artists and designers may need to ensure that their designs are suited for multiformats; large screen, hand-held devices, print, computer games, etc.

The duration of each of the formats will determine or impact the narrative structure and, in turn, the narrative will determine the character's performance within the story. Feature films are around 80 to 120 minutes, TV series will vary in duration depending on the slots within the schedule. Products intended for preschool animation and series aimed at older children or a family audience may vary a great deal. The number of episodes that make up a series or series has varied from 13 to 26 weeks, and, quite commonly, now 52 episodes are commissioned. Animation made for the Internet varies in their duration, whereas TV specials come in at around 30 to 40 minutes.

The screen size on which the animation will be viewed will also have a big impact on the way an audience experiences a performance. Cinematography and the choice of shots such as the use of extreme close-ups panoramas, panning, and tracking will probably vary depending on the format. The

director making animation intended for the cinema, IMAX, television, computers, hand-held devices, or other formats will utilize a range of different shots taking these formats into account. What works well for one format may not work so well for another.

At the extreme ends of this format spectrum are the IMAX cinemas and small hand-held devices. The usual IMAX experience is one that deals with immense spaces, and grand sweeping movements. This lends itself very well to long shots and shows off-sensational panoramic views that no other format can quite match. The BFI's IMAX in London has a screen of 20 meters high and 26 meters wide. Such a large screen has the effect of filling the audience's vision and immersing them within the image. That is the point. Subjects that deal with scale such as large landscapes, space, and underwater films are sensational in this format. They provide an illusion of complete immersion within the film and use of the audience's peripheral vision to achieve these remarkable experiences. The use of extreme close-up shots, fairly common within the context of a work of drama, will probably work a good deal less well in this format simply because of the sheer scale of the screen. An huge format shows off a landscape to great effect, but an extreme close-up of a human face may prove to be more than a little disconcerting. The reverse is also true that what makes for an ideal shot for the IMAX cinema making it such an enjoyable experience may be totally unsuitable for smaller formats. Large panoramas will not have the same impact when viewed on a screen measured in inches rather than meters. The modest screen of the mobile phone will offer less detail, but a close-up of a face will be more easily read and perhaps far less disturbing though the panoramic shot will be rather disappointing lacking the necessary scale.

Viewing Environment

When developing characters it might also prove useful to give some thought to the context in which the story and the characters will be seen. Will it be viewed in a large public space such as a cinema, within the home, as an individual experience on a computer or a laptop or will it be viewed on a hand-held devices, either alone or in small groups? Each may offer their own opportunities for character development.

While the duration of a TV commercial seems to offer little in the way of scope for character development and perhaps not much more in the depth of the performance, the skill of the animator in getting across issues such as appeal is no less important. It could be argued that the issue of character performance is even more important in commercials given the limitations of the format. The time constraints of a TV commercial dictate that the narrative must be delivered quickly, which means that the characters need to be quickly and easily recognizable and understood by the audience. Within such a limited time frame, there may not be a great deal of scope for a sustained or elaborate performance from the characters, but there is still scope for a range of characters with different personality traits.

Compared to a commercial, a TV series may present much more scope for the animated performance. There may be more opportunities for characters to be more rounded and more complex indeed if they are to sustain the interest of the audience and get them returning week after week they will need to be. Character development over time as the series progresses may be possible but difficult as the nature of the series means (mostly) that the episodes are seen as standalone events within a series. Any development over a number of episodes may present difficulties with continuity.

Feature films offer far longer periods than a single episode of TV series in which a more complex story with more complex characters may be developed. Feature films are often standalone events that provide characters with a one-off performance unless of course because the popularity of stories sequels are made and they become episodic. In such cases, character development may extend even further. I am thinking here of the Harry Potter series.

Budget

Budgets for different animation formats also have an impact upon the development of a character and will invariably determine how much developmental work has been undertaken for the characters. As a rule of thumb, we would be pretty safe in assuming that the lower the production budget, the less character development will take place.

The commercial and industrialized nature of the creation of much of the animation that we see determines the way an animator may approach acting and performance. The requirements of a format or the needs of an advertiser place constraints on the animator on how they set about exploring acting and performance. One-off films made by independent producers and auteur animators offer a wider scope but often reach smaller and more specialist audiences.

Regardless of the nature of production, if it be commercial or independent design, character, and script are critically linked in the development of the personality of a character.

Animator as Actor

The animated character may well be the concept of a writer and developed by a designer, a producer, or a director, but it is often the animator who makes the character tangible, believable, and ultimately real. The animator has the power of transforming the characters from an idea, a concept, and design into a living personality. As an illustration of the believability of characters as real personalities, I can do no better than recall for you the time when a group of young school children visited the animation studios where I was working on the TV series Super Ted. These very eager youngsters were shown around the

studios and introduced to different people working in different departments where they were told something of the production process. They were very patient and seemed reasonably happy to speak with the various crew members and polite enough to show a degree of interest when shown the wonderful backgrounds and storyboards and equal attentive when touring the camera rooms and the paint and trace departments. When they made it to the animation department, the animators made a great show of presenting drawings and layouts and taking time to explain in simple terms how the animation was made. We really pushed the boat out to impress them but they seemed a little distracted and we weren't sure why. As it turned out, while they could see that the animation drawings were *of* Super Ted but were not *actually* Super Ted. What they *really* wanted to do on their visit to the studios was to meet Super Ted himself, they knew he was a cartoon character but to those young children he was very real. They left quite happy with their trip to the studios, but there was more than a hint of disappointment on their faces at the explanation given by a fast-thinking production assistant that Super Ted wasn't in the studio that day.

Creating this level of believability is the ultimate goal, though when this is not achievable characters should never be relegated to the role of walking and talking objects that do little more than wander through a film, simply colliding with, or avoiding or interacting with other walking and talking objects only as and when the script demands. If the animator fails to appreciate and explore the personality within a character, the character will never be anything other than a tailor's dummy and not really worthy of the term character. A less than thorough approach to the development of your characters will more than likely result in an unbelievable performance, and there is nothing more certain to kill a good script stone dead than a poor performance.

Often, the source of a poor performance, other than lack of animation skills or laziness on the part of the animator, is the animator's inability to empathize with or completely understand the character. It is evident that as animators we need to develop our animation timing and other craft skills, but far more than that we must consider ourselves as actors and as such develop those acting skills as well. Unlike the thespian, we the animators are the kind of actors that need not tread the boards or appear in front of camera ourselves, and we may rely on the characters we work with to do that for us. However, these characters are entirely reliant on what the animator gives them in terms of personality, character traits, and behavior. If we are agreed that Homer Simpson is a completely believable character, it is due entirely to the skills of the designer, the scriptwriter, the voice artist, and the performance skills of the animator. Without those performance skills, the character is in danger of becoming just another funny drawing.

The roles animators play in creating performances vary within the different formats they appear in and are largely dependent on how the animation is made. For small independent animation producers who may make all of the work themselves and have sole responsibility for creating an animated

performance and determining the required parameters of the film, this may not be too difficult. For animators working as part of a team in which many individuals have been employed to create the work, such as in feature films, it becomes important to maintain continuity throughout different scenes. One of the real miracles of a feature film is how the entire production gives the impression that it was made by a single hand. This needs careful planning, a single vision, and a very keen eye if this is to be achieved. In no other format, it is more essential that the characters have a life of their own beyond the fingerprints of the animator. Within large production crews, the anonymity of the animator is essential; the animator must become invisible, leaving only the personality of the characters on show to the audience. Animators working within a studio environment must learn that an animator is a chameleon, able to respond to the requirements of the narrative and the needs of a wide range of characters. Continuity throughout a film may be difficult to maintain particularly if it is being animated by numerous hands. This is where the virtuosity of animators will enable them to create quality performances regardless of the character, though virtuosity for its own sake, if this descends into showboating, is likely to be at the cost of both performance and of continuity.

For figurative animation that simply requires action, it may be enough for the animator to think that this or that character does this or that action. However, for performances that require a high degree of emotional engagement and refined acting from the characters, then it may be far better for an animator to know *why* a character does what it does. In this way, the animator begins to understand the psychology of the character. This understanding of a character's personality and the motivation behind its performance can be seen in the work of a number of animators. One of the best of these is the master animator Barry Purves. His expertise in animation performance and acting is underpinned by his in-depth knowledge and appreciation of the characters he works with. It is this that enables him to achieve believable and nuanced performances with a wide range of characters. In his animated version of Verdi's opera *Rigoletto* (1993), we are presented with a wealth of characters that are not simply animated beautifully; they live and breathe and die. *Achilles* (1995), a story told in a manner that reflects Barry's interest and knowledge of the classics and theatre clearly demonstrates his deep understanding and empathy with the *personalities* that he breathes life into. At his hands, puppets made of rubber and wire are transformed from inanimate objects to believable personalities capable of love, hate, and murder.

At its best, each character will demonstrate a distinct personality that shows them to be individuals with an inherent attitude that is demonstrated in their relationship to things, circumstances, and most importantly of all, other personalities. The smallest of details may provide a catalyst for a performance. A character may love carrots, hate them, or be completely ambivalent toward them. Whatever way they feel about carrots (or anything) will be an emotional response. Now, if you can capture that in your animation, then you are truly creating a personality.

As with more "traditional" actors, some animators may be more suited to a particular kind of animation and performances. Games animation requires a good sense of action timing and the economy of movement that ensures a good game-play experience. Others can handle drama very well; we have just explored the abilities of Barry Purves in this regard, whereas others have a highly developed sense of comic timing. Experience, your personal interests, and perhaps even your own natural tendencies and personality traits will no doubt shape you as a particular kind of animation "actor."

What seems quite clear cut, at least for me is the importance for the audience to be fully aware of a character's personality and have an understanding of the psychological state of the protagonists. It is through the personality of the character that the audience will experience an empathy with the character and their situations and then to react to them in a way that the director had intended. It is vital that the personality must be evident to the audience, not necessarily liked but recognized. If this is not achieved at best, the actions of the characters may be misread or misunderstood. Worse, the actions may appear to be almost completely random. The very early performance of Daffy Duck in *Porky's Duck Hunt* (1937) is just that. Despite its popularity, the animators had yet to develop the character that would become one of the most famous icons in animation into anything other than a 1D manic fool. In his first film, he was nowhere near the complex and interesting character that he was later to become.

The personality of an animated character, if portrayed well, will not just be capable of extracting a laugh from the audience, but also, in the hands of masters, a tear. The loss that Bambi feels on hearing of the death of his mother is tangible. The animation of that sequence may be quite simple, there is no great action in it, and the characters do not do amazing or dynamic things; but the acting is far from simple. It is great timing by the animators that allow the personality of Bambi to come across, and it is this personality and his very real loss that extracts the emotional response from the audience.

Know Your Characters

In order to create those believable individuals that we all know and love, we need to start by differentiating between character and personality. The important thing here is to understand that characters, at least for the most part, are not defined simply by the way they look. It is important to know your characters from the inside out. Not from the outside in. The story may well require a character to be a cowboy, which may well define his look; the Stetson hat, the cowboy boots, the horse, and the six-shooter, but the nature of the character is determined by personality, and this is neither to be found in costume or props.

Although it is important for animators to know the character, it is perhaps less important for them to *like* the character. If animators were only capable

of creating a worthwhile and believable performance with characters they actually liked, they would be very limited in the work they could undertake. There is no doubt that many animators do become very close to their characters they work with more so if they have created them or been instrumental in their development. It may not be necessary for the animator to like their characters, but it is rather important for the animator to *know* their characters as best they can if they are to get the most out of them.

It might be a useful starting point to first establish what we mean by an animator "knowing" their characters. You may say that the script and the character design would surely provide everything an animator would ever need to know about the different personalities within the film they are working on. Well, to a degree yes, but if the performance is to be fully believable, then a deeper level of engagement with the character is needed, and some further study may be necessary. This level of engagement may then lead an animator to create an interpretation of the character. As we have already discussed on the matter of feature films and the animator working as part of a team, such an interpretation will only work if an animator is to have total control over a character's performance. Within the context of a format in which there are many animators working with a single character, this would clearly become impractical. You couldn't have a number of animators giving their own interpretation of a character and maintain any kind of continuity.

Let us assume that you are developing a character and not simply working with one given to you. So, how do we go about knowing a character from the inside out?

Well, we could start by asking ourselves a few simple questions about the character, the answers we get will start to define him and through those, he will begin to show his personality. First and foremost, you should ask yourself if your character can exist off screen, is it possible for him to have a life beyond the context of the script? Consider the character as real person, with traits that are shared perhaps with someone you know or a number of people you know. These do not have to be people you know personally but may be well-know nindividuals that are in the public eye, or they may be historic figures or they may even be fictional. The key here is to think about the *personality* of these individuals not simply what they do. Starting to consider your characters as having a personality will at least enable you to "focus" on them and through that you will begin to see what is underneath the skin.

The first question you could ask yourself about your character is what you think they would do when the camera isn't on them, when there is no audience to look at them, when they are not performing, and when they are off duty. What does your character do on his day off? Does he sleep late or get up early, does he go out and if so where? Where does he spend his day, does he go shopping, to the cinema, to the country? Does he visit friends or does he stay at home? The answers to these questions give rise to other questions such as where does your character live? What kind of house or home does he

have? Where is it, in the town, city, or the countryside? How does he have his house decorated, is it old or new? Is he house proud or is he slovenly? Or is he homeless? If he is homeless, how did he get that way?

So, now we know where he lives; but here's another question for you, who does he live with? Does he live with his parents, his wife or a girl friend or is he a loner perhaps sharing his life with a just a little dog? If he has a partner, what kind of girl would he choose to be involved with him? What car would your character drive, what drink would he order from the bar, where does he go on holiday and with whom and what kind of a holiday would he like; action and adventure or sitting by the pool in a five star hotel? What political party would they vote for? You get the idea. With all of the information, you will have made a good start on building a character with personality, but we can go further.

Now, you have a good idea about who your character is and you could start to consider who your character was. We all have back stories, and your characters are no different. This back story does not need to be pertinent to the script, or the storyline you currently have your character appearing in, though it might help. The question here is not *if* your character has a history but what kind of history he has? Ask yourself what was your character like as a child, what were his parents like, what was his relationship with them, did he love them, did he loathe them, did they die and leave him all alone, is he bitter about that, or does he blame himself in some way for their untimely death?

Once you have a history for your character, you might wish to look at more details of his personality. What is his temperament like? Is he calm and placid, is he nervous and edgy? If your character is angry, you should ask yourself why he is angry, NOT what he is angry about; the storyline will probably tell you such things, but what you need to know in order to get a deeper understanding of his temperament is the reason *why* he is angry or not.

Asking questions such as these is not just idle day dreaming; it will genuinely help you to create a more rounded personality for your characters. Such questions will allow you to learn quite a lot about your characters, so much so that the characters will almost start to invent themselves. Naturally, most of these questions will be completely out of context with the film your character is appearing in, and indeed, most of them may never be directly relevant to the characters, but they may well help you get a firmer grasp of your characters' personality, and it is the personality that will provide the basis of a believable performance.

You should now have a good profile of your character. Armed with this, it then becomes easier to see them working within the confines of the script. They will have already answered the questions of how they will respond to different situations.

The importance of building a character will obviously depend on how you intend to use them. If they have a walk on part, all the above may be overkill; but if you see them as making recurring appearances such as

the Wallace and Gromit characters, the time spent building a personality will bear fruit. It will certainly prepare your characters (and you) for the performances that will follow.

Physicality of Characters

As an animator working with a range of characters, the first and most obvious aspect of getting to know these animated personalities is to begin to become familiar with the outer, physical aspects of the character. It is vital to establish their physical capabilities and their limitations. This, after all, is the raw material that the animator has to work with. Any performance will come from the physical manipulation of the characters with hands, pencil, or mouse. Studying the character designs or model sheets is a good starting point in establishing what the animator can do with the animation drawings or the models. This will not necessarily place limits on the movements of the animation in any practically way as animators may choose to make the action as extreme as they like or the model and designs will allow. Getting to know your characters through exploratory play will give you a deep understanding of what your characters can do before you get down to the real business of production.

The parameters of an animated character's movement will be determined not simply by its physicality but by its *personality*. Knowing a character then becomes all about knowing its personality. A careful study of character designs will help to establish what kind of actions the animator may expect to get from the character and hint toward the kind of movements such a *personality* would make. Of great concern to animators working in stopframe animation is the need to consider the physical condition of the models and the range of actions it can make. The strength and flexibility of the armature, the material nature of the model, how fragile or robust the model is, and the range and limits of articulation it has will determine what the animator can physically ask the model to do. This will then have a strong bearing on the type of performance, and therefore, the range of acting the animator is able to achieve. If the figure is designed with very large feet and short legs, it is obvious that even the kind of walk it will be capable of will be different from that of a more naturalistic figure. The material nature and the design may place limitations of what is possible but may also be used to very good effect. One character Talos, the giant statue of bronze animated by Ray Harryhausen in *Jason and the Argonauts* (1963), moved according to his physical nature, he was stiff, slow and very, very heavy reflecting the material he was supposed to have been made from. With the Medusa character he designed for *Clash of the Titans* (1981), he faced another difficulty in the form of her lower body. Formed from a large serpent, she wriggled and writhed her way slowly across the set with her upper torso held in a vertical position. The model may have been a little

awkward for some actions perhaps, but the performance was nonetheless very convincing.

The first thing an audience experiences of any character is its physical presence. The physicality of a character has a major impact not only on how the character moves and behaves but also on its subsequent performance. It is the material nature of the character that will almost certainly determine the way in which the animators make the character act. It will also become evident that the way in which a character is designed extends beyond the mere physical attributes. It is evident that in some instances characters are defined simply by their appearance and the physicality of the design. Some characters may initially be designed for other media and purposes other than animation, and the animation characters may only be a secondary consideration. Such characters may work very well for the printed page or as a still image but are perhaps less well suited to animation. Redesigning such a character specifically for animation purposes may be possible without compromising the original design too much. However there may be limitations to the characters that are difficult to overcome, transcribing a very flat image to a 3D object may not be practical.

You should consider how the design of a character will determine the nature of the animation and therefore the nature of the performance. Abstract design will lead to abstract motion.

Character Design

Earlier in the chapter, I suggested that the animator may experience certain physical difficulties in animating with characters; but perhaps the most important question is not *how* the character will animate but *if* the character will animate. This question of "will it animate" is of paramount importance to character designers. Clearly, the design decisions made when creating a character will influence the kind of animation possible. The more restrictive the nature of the designs, the more difficult it will be to animate. The designer must be aware of the job a character has to fulfill and be aware of the difficulties that animators face in the animation process and give them at least a fighting chance to achieve the required performance.

The different processes and techniques used different animation disciplines such as cut out, CG animation, 2D classical animation, and stopframe animation will, to a degree determine, the kind of animation and performance that is possible. A physical object inherently has difficulties that drawings don't. Simply balancing a two-legged figure in stopframe animation presents difficulties that a 2D classical animator doesn't face. In stopframe animation, the animator has the benefit of exploiting actual materials that may be elaborately patterned. They can utilize lighting to great effect that

animators working in other disciplines would find prohibitively expensive or just too difficult.

Naturally, all the disciplines present their own completely different set of problems. Cut-out animation is inherently flat, and the animation of characters in perspective may be more restricted than 3D or 2D animation. A head turn that may be a simple enough action in stopframe or CG animation may, using cut out techniques, involve the use of a series of replacement heads. This may then prove to be a little less smooth in its action unless very many heads are used. Alternatively, a different approach to creating the same action may need to be found. The beautiful work of Lotte Reiniger provides an excellent example of how the animator is able to work within the constraints of the discipline. Rather than struggle against the nature of the technique, she used its distinctive qualities to, great advantage, creating a work of immense sensitivity and beauty. The flatness of her cut-out shadow puppet-like figures present a very clear profile. The detail of the shapes was clearly defined as silhouettes that she often set against much lighter backgrounds and sets. The movement of the figures in the profile made for strong graphic images that were easily read by the audience. This same approach to creating clarity of an image was a technique that the Disney animators later adopted in the process of silhouetting when making 2D animation. This entailed the key frames being drawn in such a way that created a balance between the use of both positive and negative space, placing the limbs away from the body and allowing a little negative spaces to appear between the legs. The secret that Lotte Reiniger knew only too well was that if you created a strong key possess the action would be more easily read. Body language was enough to get the meaning of the performance across.

FIG. 4.4 The nature of the animation techniques determines, at least to some degree, the approach to character design. This does not necessarily place constraints on the design in terms of personality and character but may limit them in the way the characters will be handled by the animation team.

Regardless of techniques, there is no restriction on creativity. Each of the techniques has their strengths, and they all have their limitations. Good animation actors are capable of making a performance of the highest order regardless of the discipline they work in.

One of the most important questions to ask yourself when you begin designing an animated character is: will it animate? Not will it simply move, but will your character and the way in which it is animated allow the animator to get the range of movements necessary for the performance?

Naturally, this will be different for each of the disciplines and require very different technical considerations. Stopframe animation is limited by the physical constraints of the puppets and models; some of them may be very simple and inexpensive to make using basic armatures or no armatures at all. Others may be very elaborate pieces of engineering and require very specialist skills to create them. The puppets used by Barry Purves for the film *Rigoletto* were capable of the subtlest of movements (even incorporating a device that gave the illusion the characters were breathing).

FIG. 4.5 The physical nature of the stopframe puppet will create challenges for the designer and the animator but with it comes the potential of using materials and objects in a way that have the potential to resonate with an audience in ways that other disciplines can't.

The physique of the character, its age, size, and weight create a range of physical possibilities and limitations may determine what a character is capable of undertaking. The animated short *Dot* made by Aardman Animation for Nokia and billed as the world's smallest animation incorporated the use of replacement models throughout the film. The individual models were so small (about the quarter of the size of a bumble bee) that it was not practical (or maybe even possible) for them to be articulated.

There are a number of difficulties that 2D design presents the animator, but uppermost amongst these are that drawings have the problem of representing, on a 2D plane, 3D characters within 3D environments. This often requires excellent drawing skills though these skills are no guarantee of getting around all of the animation problems, and it may be necessary to "cheat" some of the solutions by making very improbable drawings as part of the movement. As the animation is made up of drawings seen rapidly in sequence, individual drawings often pass quite unnoticed by the audience. Remember that old adage: if it looks right, then it is right.

Let us consider the design issues of perhaps the most iconic and well-known characters in the history of animation, Mickey Mouse. One of his most notable features along with his red shorts and his white gloved hands are his large round black ears. If we take a look at his ears as he moves around, they do not necessarily follow all of his actions. Regardless of the orientation of his head, the ears remain as flat circles and are read as such. They are not read as spheres but as disks that are always face on to the audience, seldom appearing obliquely. While 2D classical animation allows such difficulties to be "cheated" away, 3D design has no such opportunities.

CG animation faces its own difficulties not least among them has been the quality of the textured surface. Up until quite recently, there was a definite "computer look" to all CG animation, good texturing and modeling was difficult. With the latest modeling tools, it has become somewhat easier to create more organic shapes with believable textures. Having modeled the characters, these need to be built and rigged in an appropriate way to create the necessary articulation. The appropriate controllers for the animator need then to be provided to make the animation process as easy and as intuitive as possible. The easier it is for animators to gain full control over a model, the more convincing the movements and the performance will be. Good acting skills are linked directly to other discipline-specific technical skills.

When designing characters for animation, you must keep the animation process uppermost in your mind. Naturally, the designs must be appropriate to the concept, the narrative, and the characters, but you must consider the consequences of your designs.

As we have already discussed, the psychology of a character cannot be entirely divorced from its physical appearance. A character's appearance and its *personality* cannot be restricted to the physiognomy of the figure. What it

FIG. 4.6 Drawn animation allows the designer to explore a wide range of techniques and approaches through drawing and painting. The animator is presented with the opportunity to deal with issues such as volume and weight in a way that stopframe animation does not readily allow. However, maintaining continuity of form and scale is a problem that CG animators and stopframe animators don't face.

wears, the props it carries, and a range of other things that may be associated with it (car, house, boat, horse) help define and contextualize the character.

There is an old expression that states clothes make the man and it cannot be denied that what we choose to wear says a great deal about who we are. For many people around the world, our clothes are the outer expression of our inner selves. From them, we can get a good idea of age and gender, where we are from, our cultural background, and our social status; it may even give an indication to what we believe in, what our religion is, our political leanings, and our sexuality and sexual preferences. You tell a lot about a person from what they wear. One needs to be careful not to depend entirely on costume for the development of characters. Stetson hats may characterize an individual as a cowboy, but it may

be a simplistic characterization. It was only in the very early days of the movies when one could tell the good guys from the baddies by the color of their hats. Good character design cannot be dependent on simple stereotypical features. For completely believable performances, we need believable characters, and for that we need explore different possibilities. Characters that do not conform to the obvious physical "types" may be all the stronger for that; not all heroes are strong and muscular, not all villains are dark characters with an evil glint in their eye.

Character development extends well beyond the physical aspects of an individual and includes the voice. Indeed, many characters are primarily defined by their voice and in some instances not just what they say but the manner in which they say it. Once sound became the norm within cinema, the importance of a character's voice was very quickly understood. So an important issue was the voice in establishing a character that Disney himself took on the responsibility for voicing his most famous cartoon creation, Mickey Mouse. His now very familiar tone has become as much a part of his personality as his physical appearance.

This was not a one-off and all production studios understood the importance of developing the right voice for a character. The voice talents of Mel Blanc, probably the most famous of all voice artists, did as much if not more than the graphic artists and designers in defining the personality of a host of cartoon characters. The lisp of Sylvester, the cat, and his catchphrase "suffering succotash" and similarly with Daffy Duck's "you're despicable" typically become an instantly recognizable feature of their persona. There are many more, Foghorn Leghorn southern booming voice and repetitive dialogue, Bugs Bunny's "Nyaaa, what's up doc?" have become firm favorites with audiences around the world. We will be covering this in more detail in Chapter 9, Sound.

Given the different physical designs and vocal characteristics of different characters, the animator may need to have a separate and distinctive approach to creating lip sync. By this I do *not* mean the mechanics or technicalities of lip sync, they will stay the same, but rather a creative approach to lip sync as part of acting and performance. A personality may not simply be recognized by their voices but also how they speak and the way they uses their mouth. More often than not, speech is accompanied by movement. Look around you, and you will see plenty of examples of hand gestures, shrugs, and movements of the head, arms, and, sometimes, the entire body to emphasize the dialogue. I encourage all of my students to consider the use of body sync when dealing with dialogues before they even make a start on the actual lip sync. Much of the meaning in dialogues is understood through body language and body movements. Threats may be delivered by a character through angry gestures and loud angry voices. They may also be delivered through complete stillness and a voice that is barely audible. Context is all important here. Some personalities in some instances would rant and rave; on other occasions, they would perhaps be more reserved and controlled and as a result perhaps even more threatening. The great Disney animator Ward Kimball understood this very well. On

animating the Cheshire cat character in *Alice in Wonderland* (1951) he said, "Here I learned a big lesson in that actions that are supposed to be violently crazy are sometimes not as mad as more subtle, underplayed treatments. My animation of the Cheshire Cat was my masterpiece of understatement."

The Animation Bible

In large production teams on longer format productions where the continuity of the character performance is essential; the use of the animation bible becomes a very valuable tool. Used as guides for the production crew, the animation production bible not only covers the physical attributes of a character but also the relationships to one another. They not only show the character in various poses, they may also provide information on the range and kind of movements the character makes and the way in which it performs them. The bible may contain model sheets, height relation charts, action sheets, and even color charts. Not all of the information may be directly relevant to the animator, but the bible is intended to be a useful tool in establishing the design and animation parameters for a number of individuals with different roles within the production crew.

FIG. 4.7 The bible provides all the information a team of animators could need to help them in their efforts to make a believable performance appropriate to the director's original vision. It assists all animators to stay "on model" but more importantly to ensure that the animation looks like the performance has been created by a single hand with no variations between the work of any number of animators within the production crew.

FIG. 4.8 The full range of characters within the production is indicated in these height relation charts to ensure the animator maintains the appropriate scale between them.

Character sheets and model sheets are often used as a way for all of an animation crew to gain a better understanding of the physical traits of a character, and, through this, infer some of the behavior and even psychological traits of different personalities. Although it is clear that model sheets help determine the way a character is drawn, the same may not apply to other forms of animation: CG or Stopframe. Character designs are obviously of great use to model makers and riggers that are concerned with physically making a character for animators to work with and may influence the way a character appears on screen, but they do perform the same function as with 2D animation. Action sheets created to illustrate poses and dynamics may provide a useful range of possibilities for animators. The important part here is the establishment of a range of actions that are common to all animators within a more industrialized context of production.

Character Types

It is part of human nature to categorize things and place them neatly into nice convenient little boxes. It's a way in which we make sense of the world. The way in which we tend to place people into boxes is no different. I am making no judgment one way or the other regarding this tendency; indeed, in order to develop characters, this simplistic approach of categorization may prove to be a very useful shorthand device. Of course, the danger with this kind of labeling is the stereotyping of individuals. However, if we like it or not, stereotyping does play a role in informing our views on people, groups, and even entire cultures. This "view," however ill-informed or perfunctory, may translate itself into our acting and performance. This may not prove to be such a difficulty if all we require is a

stereotype or a very rough sketch of a character. It may be enough to define a cowboy as someone riding a horse, wearing a Stetson hat, and walking around in cowboy boots.

It is often convenient to divide groups or individuals into a goody or baddy camp. This may work in stories where armies are pitted against one another and clear divisions are possible, though when dealing with the main protagonists the range of "types" of individuals extends beyond the simple hero and villain partnership. We may at least gain a basic understanding of the animated character in terms of what the character does, and by doing this we can go on to make assumptions about them. Teacher, butcher, soldier, mother, farmer, thief, may all be assumed to be character "types" and provide an indication as to their personality, but it cannot entirely define it. The dysfunctional Homer Simpson has a highly complex personality, one that simply can't be summed up by the role he plays as a power plant technician. In Homer's case, the job he does may add depth and color to his character, and it certainly provides some interesting scenarios, but it does NOT define his personality.

Character and Personality

The size and shape of a character is important, but it is not so much what's on the outside of a character that is all important, it's what is on the inside that counts. The temperament and psychological characteristics and makeup of the character combine to form the personality of an individual. It is these character traits that an audience finds attractive or repulsive and it is these characteristics that determine the nature of the acting. Remember interesting stories told by interesting people. The inner condition of an individual differentiates them from the stereotyped character. It is possible to differentiate between a personality and a character; they are not the same. We've explored the idea of character types, perhaps, we should take a closer look at personality.

We have already established that the character design may determine the performance. We must now look beyond that and turn our attention to the importance for the animator to fully understand the character not simply as a figure to manipulate but as a "real" character with a personality capable of emotions. For a character to be fully believable, it is necessary to discover what motivates them and their interrelationships with each other in order to extract the best possible performance from each of them. I have said elsewhere that timing gives meaning to motion. Perhaps we can now take this further and claim that personality gives meaning to performance.

A good illustration of the differences between characters with real personality of those that simply fall into the categorization of "type" might be a comparison between the demon that appears on Bear Mountain in

Fantasia (1940) and the evil showman Stromboli from the film *Pinocchio* (1940). The demon is a good example of a character "type," there is no doubt that the evil being creates a large presence on screen, but ultimately it is a simplistic and 1D character. By contrast, the villainous Stromboli has a real depth of personality. Their performances could hardly be more different. The demon makes his appearance and provides a fearsome apparition of evil, very effective and most appropriate within the context of the film. The evil that appears far more real is in the deception, greed, and murderous intent of Stromboli. His threat of violence to Pinocchio is very real and all the more horrific as it follows his offer of friendship. He throws Pinocchio in a cage with a threat of enslavement and a promise of murder to come. Following this extremely violent outburst Stromboli slowly turns to Pinocchio and mocks him by blowing him a tender kiss and wishing him a goodnight. Some may find this sequence a little over animated. I think it is one of the best pieces of character animation that has ever been undertaken. The animator not only demonstrated great skill with animation timing and dynamics but also as an actor who clearly had the ability to get into the character's personality, extract a great performance from the character, and place it on screen for all the world to see.

Some animation personalities seem to develop beyond the scope and range of the circumstances they find themselves within the script. An average bad guy, if there is such a thing, may be capable of almost any kind of devilry to achieve their aims but stay within the limits of self-preservation. This trait may put a constraint on what they are willing to do. In some characters, feelings can be so strong as to overpower any other concern, including self-preservation. The level of enmity felt to protagonists on their part may be so great as to drive a character to the point of self-destruction simply in order to see their nemesis destroyed or brought low.

The development of personality within a character is perhaps the most complex of all the requirements of acting, which makes the process so engaging to both the animator and the audience.

Relationships

It is possible that if you work with the same characters for long enough you may begin to develop a relationship with them. Developing an affinity with the characters may result in animators ensuring they are able to sustain believable performances over very long period. Of course, this is not always necessary or even possible. Depending on the nature of the work, an animator may only get to work with a character for a very short period. Working in commercials or other one-off short-form films may only offer very limited scope for working with a character and the production period may be very short, and in such circumstances, there may be no opportunity to develop much of an affinity for your characters let alone a relationship with them.

The format of an animation may also negate such a relationship. The animation of characters within many computer games mostly focuses on action and not personality, and many of these characters lack any emotional depth. The principal factor in this kind of animated performances is not so much acting within a narrative but simply action-based dynamics. The kind of character-based animation in games presents its own difficulties. Game-play is all important and all manners of "ordinary" actions such as walking, running, jumping, striking, and falling. May take on a very different aspect within the context of games animation. An continuous action demands that the dynamic of these movements may be slightly at odds with the same actions made by a similar character within a narrative-based animation. They may be faster, snappier, and executed over a shorter number of frames in order to maintain the pace of the game-play. There is no doubt that animators become very skilled at producing this kind of animation and as such have an intimate understanding of them and of their dynamics.

There are many productions that do offer the opportunity for animators to build a relationship with their characters, and there can be no better example than Chuck Jones. He once said that working with characters was like a marriage, it took a while for a relationship to develop and flourish. If his work with Bugs Bunny and the Roadrunner and Coyote are anything to go by, it is evident that he had a very good point. Other animators worked with Bugs and Daffy, but for my money none of them managed to get to the "real" personality in the same way as Chuck Jones.

It is important to know what your characters are capable of, at the very least their physical abilities. This should be quite straightforward, understanding their mental capacity and their emotional range, as Jones said will take time. Some animators have developed such a strong bond with a particular character that other animators find it difficult to extract the same kind of performance from them. This could prove to be problematic if a number of animators working with the same character within the same film didn't have clear guidance as to the nature of the performance. Naturally, this then falls to the director to corral these separate performances into a coherent whole.

Managing teams of animators and their individual performances is no mean feat. Naturally, animators vary in ability but they also vary in their preferences. Some animators may prefer to work with certain character types that offer different possibilities and opportunities for certain kind of performance, dramatic, comedic, physical performances, or emotionally charged ones. Villains, comedians, and clowns often offer the greatest opportunity for animation performances. They may be larger than life characters with a wider range of actions available to them. Hero's, good guys, and victims often have a little less dynamic range. I offer this up as a huge generalization of course. Consider for a moment the film *Snow White* (1937). Even though Snow White is the main character I would argue that she is not necessarily the most

engaging. The wicked queen and the old witch are far more interesting as are the comic antics of the dwarves. As far as the prince is concerned, well perhaps the less said about him the better.

It is the personality of a character that has a lasting audience appeal. The term appeal is very import in character-based animation. Characters without appeal are just extras. Set down as one of the principles of animation by the Disney studios in the 1930s the Nine Old Men of the classic period of animated film making spent so much of their time and effort trying to perfect appeal. We should take care not to misinterpret the appeal of a character to be merely cute. Yes, there are plenty of cute characters that do indeed have appeal, but cuteness and appeal are not the same thing.

Appeal is what all the great character *personalities* of animation possess, we see it in Buzz Lightyear and his buddy Woody. It is appeal that Yuri Norstein gave to the little hedgehog in his marvelous film *Hedgehog in the Fog* (1975). It is also not restricted to the "good" characters. There are plenty of screen villains that have plenty of appeal. Appeal does not mean that the audience empathizes with them or agrees with their morals; it simply means they find them engaging in some way. Appeal may be shared by goodies, baddies, and all of those personalities in between.

Dynamics of Character Interaction—Every Hero Needs a Villain

I think we have established that the development of personality of an individual character is important to build a performance. However, individual characters do not make for a strong storyline at least for the most part. It is important if you are to create interesting stories that you populate them with individuals with different personalities that make for interesting relationships. Contrast is all important in building a performance between different characters and personalities and developing believable relationships between them. If all of the characters that appeared on screen were of a similar nature, it would make for a pretty dull performance. Every hero needs a villain in order to be heroic. Every villain needs a victim; otherwise, the character would simply not be villainous. It is this contrast between personalities and how they behave around one another that attract us to the performance and make us want to get to know what makes the characters tick. Individual personalities acting off one another create dynamic performances and work together in a complementary manner to build an overall group performance.

If you are designing a number of characters, you should perhaps consider the following questions: Do the individual characters work with one another? Is there a dynamic between them, how do they react to one another, do they change their behavior when they around one another? Is one character superior to the other or is there a pecking order within the group? Having

them all the same will never do; even in a group of like-minded individuals there will be a group dynamic.

The greatest challenge for the animator is to deal with the interrelationship between characters. None of us live within an emotional vacuum, and most of us come into contact with other people on a regular basis. At some point, these various contacts make for tensions, jealousies, and love. Such relationships and emotional dynamics are the basis of good storytelling. Characters can really only be appreciated within the context of the narrative and other characters. What you have already come to understand about your characters' personality and both the storyline and other characters they work alongside will have already given you some idea of their likely behavior.

But once again it may be useful to consider asking a few questions. Are your characters driven by common goals and mutual respect or is there enmity between them? Are the characters working as a team or against one another? Do they want different things from one another and if so how do they go about getting them? In short, how do protagonists work against one another?

Usually, characters play to one another and not to the audience though in some films a character "breaks the fourth wall" and addresses the audience directly and takes the audience into their confidence. Consider how characters in some of Tex Avery's films turn to the audience to deliver a punch line or gag. In *Little Rural Riding Hood* (1949) one of the main characters, country wolf voiced by the famous voice artist Pinto Colvig, turns to camera having had an accidental encounter with a farm animal to confess, "Kissed a cow," very funny. Usually, it is only the main character that steps outside of the action in this way, but in Avery's films almost any character can do this.

Summary

We have looked at how the practical aspects of character design not only have consequences for animation production and shape the personality of a character but also how it can help the animator to create a performance. I was asked in an interview recently what I thought was most important aspect of animation, the story, or the characters. I immediately thought about John Lasseter's comments about the three most important parts of a film being script, script, and script. A very good point but a story is surely only as good as the characters that are telling it, and an animated character is only as good as the animator's skill at acting and it is from the character's performance that the animator gives it that a character draws his personality.

On a final note, there is something I would urge you to do something before you begin animating with a character. Something that will give you the best possible chance of putting in a good performance. THINK. The first thing you should do before animating is to think. I know this may sound a little obvious but just take some time to ask yourself a number of questions. What are your

characters like, not just physically but psychologically? What are you asking them to do within a scene? How are the characters likely to react? Who is a particular character working with or against and how do these personality dynamics work? And, finally, perhaps the most important question is what do you want your audience to feel? I have seen too many young animators working with characters that simply move about like so many manikins neither acting nor performing, just moving. Take some time to consider what we have covered above and avoid falling into this trap.

Principles of Performance

In this chapter, we take a look at some of the underlying principles governing a performance and an audience's reactions to a performer that we need to understand to create a character that will engage an audience and be believable. We will be looking at the idea of Empathy and its importance in helping to create an identification with a character and how this might be achieved and at what motivates a character and how that character's needs and desires work their way through into their behavior. Understanding the forces that motivate a character helps, create the "hinterland" that makes a more rounded character with the power to make the viewer laugh or cry.

We also examine the question of what the director or animator is trying to say with the film or performance and see how, without falling into the trap of being obvious, working with a theme can make for a more adventurous and more powerful result.

Lastly, we consider how external elements like props and costumes can help in fleshing out the character's personality and, in purely practical terms, give the animator something to use to create "business" that will make the performance lively and fluid.

Empathy and Engagement

When we empathize with another person, we tune into their feelings and understand their subjective experience while remaining observers. We "put ourselves in their shoes" to take part in their experience vicariously, but we remember that those shoes don't belong to us.

If we cross the line into feeling the same thing as the person, that becomes sympathy; as we share suffering or opinions, the distance between us and the other person is reduced or nullified. We can empathize with someone with whom we disagree on the basis of shared human traits, but we find it hard to disagree with someone when we sympathize with their point of view or situation.

Why Empathy is Important

When watching actions on screen, an audience will be looking for ways in which to understand the characters portrayed; they want to find ways in which to empathize with them. It is a classic human trait and absolutely

necessary if the audience is to be engaged by the film; otherwise, they will be but disinterested observers whose attention will wander as soon as something more interesting comes along. If we make things too obscure, then we are actively keeping our audience at arm's length, not letting them participate or engage with the ideas we are exploring. If we are too explicit, shallow, or simplistic, then we leave our audience with nothing to do. Both can result in a breakdown of a shared experience.

To tread this fine line between the obscure and the obvious, we need to understand what the audience brings to a work before we begin to respond to their expectations.

At this point, we need to remind ourselves that, although we talk about "the audience," there are a wide variety of audiences with differing sets of experience, most notably that between adult and child. For the moment, we'll discuss empathy from the point of view of an adult audience and catch up with the children later.

We have, as a matter of day-to-day life, been observing our fellow human beings. Whether we are conscious of it or not, we are constantly scrutinizing each other's body language, speech, reactions to events, and clothing. At a very basic level, this is what we do to survive. Each time a new person enters a room we're in, we look up to see who it is, if they pose a threat or can become an ally, we need to know who is dangerous, who is trustworthy, and who is not. Each time a new character walks on screen, we are doing the same sort of thing we would do if they had come into the room.

In addition, we are hard-wired to read certain facial expressions in the same way, whoever we are. Expressions like anger, disgust, fear, joy, and sadness cross any cultural divide.

Finally, we use our powers of reason, drawing on all of the above, to try to understand each new character as we come into contact with them, we read the character in the same way we do when we come into contact with another human being, even if that character isn't a human one at all, and whether they are like us, agree with us, or not.

Children come to a work with many differing levels of experience, but we should never be guilty of talking down to our audience.

Since we must understand our audiences and the depth of understanding they are "likely" to have, this is where our own empathetic skills must come in, and the performances we create for children will need to be equally as subtle and skillful as those we intend for an adult audience.

Bambi is the classic example of a film created with enormous integrity. Walt Disney bravely pushed ahead with a story that others felt too dark for a family film, held up production so that animators could learn new skills in the depiction of realistic animal movement, and even brought real deer into

the studio to facilitate that instruction. What he and his team created stands as one of the classic films for children, capable of uniting parent and child in tearful empathy in the darkness of the movie theatre.

Identification and Lack of Empathy

The audience is ready and willing to empathize with a character, they want to find some point of contact because the character then comes alive for them, and they are more invested in the story. As an audience member, we suspend our disbelief to enter into the story that is being told. In film, we can be presented with amazingly realistic scenarios and, as animators, we may be called upon to create a character that can live alongside a real actor, but the whole construct is still artificial—turn your head and there may be a friend or stranger sitting in the comfy seat next to you, unharmed by the warfare on the screen.

The key here is, I think, not reality but believability. If we can believe in a character, we can begin to empathize with them, their situation, and the decisions they make. This is how we are able to cause the audience to identify with a character and bring about the necessary "suspension of disbelief."

What the audience does not do is to identify with a character based on the specific facts of, for example, age, sex, or occupation. These may be providing clues to the make-up of the person, but, if they were to identify too closely with specifics, an audience would never be able to empathize with anyone, since everyone is different. As creators, thinking we have created a character merely by giving him a specific job or visual attribute is laziness and won't work since, on the one hand, not everybody will have the same reaction to said job or attribute and, on the other hand, we fall into the use of stereotypes and bore the audience.

Engaging the Audience

It is important to remember that the suspension of disbelief involves the audience accepting the character as a real individual, although what is really happening is a communication between the audience and the creator of that character: people talking to people.

As an animator or director, you are trying to tell a story, but story does not exist independently of the people in it. A news report of a disaster is merely that, a report; it does not become a story until we find out about the actions and reactions of the people involved, the human story.

The story starts when we follow the person searching for their family in the rubble or the official who could have done more to get help to the victims. Then what we are trying to do is to communicate what it is about the

character that causes them to act as they do; we try to reveal the things in their personality that are the important drivers of the story.

Narrative is driven by character progression, and this arises from tensions between characters or tensions within the character. As new facets of a personality are revealed, engagement comes from the audience being surprised and wanting to learn more.

While it is obvious we need to understand a character and are often called to care about him or her, we do not have to like that character, indeed, at times, we can come to dislike them, even if the character is not the villain of the piece. We'll deal with empathy for the antagonist a little later, but consider this; is it possible to have a truly well-constructed and deeply engaging character without them having a flaw?

Nobody is perfect, and perfection can become very boring. Often, it is the flaws in a character's personality that make us warm to him or her and, even more often, it is the flaws that propel the story onward. The hero may set off on his quest full of good intentions and determined to right wrongs but, somewhere along the line, he will come face-to-face with his shortcomings, and it is in the way he overcomes the flaws in his personality that demonstrate his true heroism.

A classic example of the boring hero can be found in comics. DC Comics' Superman started life able to leap tall buildings and have bullets bounce off his chest but he wasn't the god-like creature he later became. As time went by, the writers added more and more powers to his arsenal so that the character effectively became one-dimensional and they had to resort to "imaginary" and "parallel world" stories as well as tons of Kryptonite to put him in any jeopardy at all. Not only was he invulnerable, he was no more than a goody-two-shoes with no real flaws in his character and therefore very little with which the audience could empathize. The advent of characters with greater depth from DC's great rival, Marvel Comics, brought about a revolution in the way superheroes were perceived and, in Spiderman especially, they changed the landscape completely. Here was a character who not only had to cope with a set of strange new powers but had to do so while attempting to negotiate the troubled waters of adolescence; the audience was able to empathize with his problems *and* his delight in his new abilities, they could certainly imagine themselves in his shoes because the fantastic elements were grounded in life as they knew it. Peter Parker didn't stop being the nerdy high-school kid because, as Spiderman, he could climb walls and shoot sticky webs at criminals, but it is his attempts to live up to the character he has become and the expectations of his public that provide the interest in his story.

In some ways, the capacity to empathize can be linked to the harm the character can suffer. If they can be hurt or killed, we tend to empathize more with them. We identify with people in danger; unlike the world of Tex

Avery or John Kricfalusi, where characters can be smashed, shattered, or squashed and still come back for more, or Superman before he was remade as a more vulnerable individual, we feel for Bambi because his world has been set up in a way that establishes that the normal process of life and death goes on.

And maybe we can even empathize with very "cartoony" characters to an extent if they suffer the same frustrations we do, like the Wolf hounded by Droopy in "Northwest Hounded Police." (Droopy himself never had much of a personality, so it would hardly be fair to see him as the protagonist in his own cartoons, that is pretty much the role of whatever poor sap has to share the screen with him.)

In a funny way the cartoon within a cartoon, "Itchy and Scratchy" in "The Simpsons" (which takes the Tex Avery worldview and adds blood), makes the characters in the rest of the show more real. Since Itchy and Scratchy can come back to life from horrible injury, it adds another "cartoonier" level of cartoon reality.

Empathy for the Villain

Most of the early Disney heroines fall into the Superman trap, because they are too good and because their personal journeys have no room for development. Snow White, Cinderella, and Beauty are all being acted upon rather than acting, and waiting for the Prince to come along rather than changing their own situation. The Prince himself is even worse, little more than a vacuous clotheshorse with no personality at all. It must have been very hard to animate those characters with nothing to fall back on—not even an interesting design. Consequently, it is the villains and the comic characters we all remember from those films.

Let's assume, though, that we have an interesting and complex protagonist for our story. If the villain is to be a worthy antagonist for the hero, he or she has to be just as complex as the main character. It is too easy to fall back on the stereotype of the ranting megalomaniac. But writers and directors (and animators who have ended up with a more nuanced script) should realize that, not only will a more complex villain be more interesting and more human, but that such an antagonist will also make the hero look better. By creating a depth of personality, there is the possibility that the story will not proceed like a train on rails but could veer off at any time, that the future is not set and that the hero will have to be more flexible and will have to think rather than simply react. The audience will not be sure of the outcome and be more engaged in the twists and turns of the story.

First, I believe the only way to create a depth of personality for a bad character is for the creators of that character to develop an understanding of what causes him to act in the way he does. "Everyone is necessarily the hero of his own life story" (John Barth), so we need to understand what we have in

common with the character and that, at root, we are all doing many of the same things and we are all trying to find a way to survive. What we as artists need to find out is why the bad choices are made, why the Queen wants to kill Snow White, or why Syndrome wants to destroy Mr Incredible. In many cases, we find a simple connection to our own life and emotions and that it is merely the scale of the reaction to a stimulus or the lack of boundaries that separates us from the bad guys. Our task as animators is to step into the villain's shoes and work out what will make his actions believable on screen.

But we're talking about cartoons here; does all this emphasis on empathy work with cartoon ducks and hares or tigers and deer?

Well, clearly it does, as we have already noted with Bambi, and how about Daffy Duck?

Audiences are drawn towards Daffy not despite his flaws (and he has many) but because of them. However, while an audience may want to see Daffy getting his comeuppance and to see a form of natural justice playing out, I believe they do feel an amount of compassion for him. They understand his greed, jealousy, anger, and fear, because they themselves have felt those emotions and, because of this, they share in his mishaps to some degree.

Animation has a long history of using animal characters, one that grew from the ancient storytelling tradition that gave us Aesop's Fables.

James Gurney (author and illustrator—"Dinotopia") wrote in his blog that "Tony the Tiger is a purely human type: a hearty enthusiastic salesman. But Shere Khan is more like a real tiger. He has a mind we can fully understand. Disney was adamant that the "heavy" in *Jungle Book* not be a slavering monster. As drawn by master animator Milt Kahl, he is cool, understated, arrogant, and poised—very much a tiger. Kahl spent a long time studying tigers from life. When it came to the animation, he didn't need to refer to photos. He drew most of the sequences from memory."

But, despite the undoubted genius of Milt Kahl, all that is waffle since Shere Khan is still very much a human in animal form. Tigers are NOT cool, they are NOT arrogant, and they are not vengeful, as Shere Khan is. They are tigers… animals. All of those traits are human traits projected onto a tiger or extrapolated from the traits we see. The tiger moves slowly when not chasing prey, so we call it understated and poised rather than what it is, merely saving energy for when it will be needed in the task of getting food.

There are purely animals in many animated movies, like the dogs that run through the city at the start of *Waltz with Bashir* (2008), Ari Folman (Although they exist as symbolic creatures, from a person's dream, they have no human qualities.), and we feel no empathy for them. Any connection the animator might feel with them is only there to help him do a better job of making them move in a convincingly animalistic way.

The amount of "real" animal we put into an animal character is dependent on the scenario; Daffy Duck would not look at home in "The Jungle Book" any more than Bambi would in a Looney Tune.

Motivation

The question of defining a character's motivation is fraught with confusion; many people are loath to embark on what they see as deep psychological enquiries into something they don't feel has too much bearing on the here-and-now of a character's life. "What does it matter what his childhood was like", they ask, "he's only trying to get served in the restaurant?" Likewise, the actor asking: "What's my motivation?" has become a cliché of TV comedy, indicating some self-obsessed disciple of "Method Acting."

Of course, the way motivation works does not necessarily depend upon an over philosophizing of any given situation or response. Motivation is at the heart of most actions, whether extreme or mundane. The motivation of a woman returning to a burning building to save her child is love. We need to dispel the idea at the outset that motivation is an unnecessary add-on to a performance.

All actors, whatever their chosen strategies, have to find something to connect with in a character they are playing, and delving into motivation ultimately boils down to a simple question: "Why is my character doing this?"

The answer to that must make sense. Otherwise, the audience, those people you have asked to empathize with your character, will sit there thinking: "I wouldn't do that", or "But why doesn't he just go to the police?" A large part of the work here has to be done by the writer, who needs to have thought about all these questions before the script goes into production, and if you're writing your own script, you should be aware of the possible problems because people *will* notice if there is a gaping hole in your reasoning. If, as a director, you get a script like this, it's your job to chase the writer about it so you can convincingly explain things to the animators and, as an animator, you need to go back to the director and get an explanation of things you don't understand. If the animator doesn't understand why a character he is animating is doing or saying a certain thing, then the audience is highly unlikely to know why the character behaves in this way.

However, please don't imagine I'm asking for everything to be laid out in obvious black and white on the page. Characters who really live on the screen are never obvious and their motivations are generally complex and not easily fathomable. But that does not mean we can avoid thinking about motivation or throw together a stew of character traits in the hope they will coalesce into a real person.

One name that starts to crop up when we read discussions of motivation is that of American psychologist Abraham Maslow whose "Hierarchy of

Needs" is seen as a way to understand human motivation. Often represented as a pyramid (see Figure 5.1), the layers of need start from a basis of purely physiological need, like air and food, and rise up to a level where the human is concerned to gain self-knowledge and realize his or her full potential.

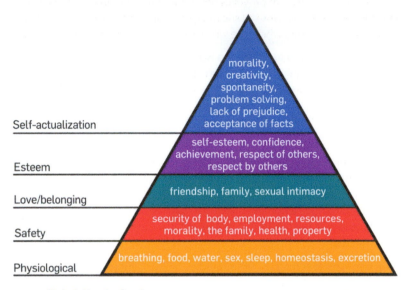

FIG. 5.1 Maslow's hierarchy of needs.

This layering is a rather simplistic view of a complex interaction, and there is much more of an exchange between these layers than the pyramid illustration shows. The Social (family, friends, love, and belonging) and Esteem (need to be respected and valued by others, as well as by self) layers could almost be one, since if one is loved, then it must bring with it a sense that one is valued and esteemed. It could also be objected that, for example, people have striven to understand themselves and the world and create beauty even while hungry or rejected by society, but these headings give us helpful pegs on which to hang an understanding of what drives a character to action.

We can use these "needs" to examine the motivation of all our characters—not just the heroes—since motivation also comes from the need to protect what we have gained on our way up the pyramid.

Let's take the Wicked Queen from "Snow White" as an example. As a queen she is rich and powerful, so the first two levels of the pyramid are taken care of, but when we come to the Social level and the level of Esteem, we can see that the Queen seems to have by-passed family, intimacy, and friendship and seems to be fixated by the need to be esteemed for her beauty. When the magic mirror tells her that Snow White is now the "fairest in the land," she sets out to destroy her rival.

The prologue to the film doesn't give us many clues, merely stating that the Queen is Snow White's stepmother and that she fears that one day the girl's

beauty will surpass her own; not really much to go on. But the fact that the Queen is Snow White's stepmother does give us some clues. Was it her beauty that caught the King's attention? Does she fear that the loss of her position as the "fairest in the land" would mean the loss of her position in society? If so, it is not merely vanity that provokes her to thoughts of murder, but the very real danger that she will lose all she has gained and be thrown down to the bottom of the pyramid where she will have to struggle for the basics of life.

I realize that the Wicked Queen is perhaps not the most deeply rendered character in animation, and I could be accused of "overthinking" the issue of her motivation, but it isn't enough to fall back on the sneering villain and clean cut hero when we have examples of characters as deep and complex as Woody from the "Toy Story" films or Lady Eboshi from "Princess Mononoke."

Of course, not all of our characters are going to be as complex and well rounded, there will always be characters we don't have time to explain or are simple one joke foils, but even a simple character should come on screen with a personality and an attitude. You have to animate him, why not take the trouble to think about what you are portraying with your animation and give him that little spark that will give the film more *texture*?

Wants and Needs

Let's say we *have* got a juicy character part to create and we've worked out what the character needs, we need to remember that doesn't mean the character realizes it. Very often the story grows out of the realization that what she needs is different to what she wants in the beginning, and one important way of analyzing a story is by asking two questions of the character: what do they **want** and what do they **need**?

In *Shrek* (2001), Andrew Adamson, Vicky Jenson, the title character, the ogre Shrek, lives alone in his swamp until it is invaded by fairytale characters banished there by Lord Farquaad. What Shrek *wants* is to get rid of the interlopers and go back to his solitary existence and for this reason he undertakes the quest to free the princess. We can empathize with his grumpy reaction to being invaded, we understand about personal space, and we've all been bothered by annoying people when we had other things to do. But we don't go along with it completely, we don't sympathize and want to see the back of all these newcomers, because, well, we're getting a lot of fun out of his reactions and we sense there is something that Shrek *needs* that is different to his immediate desire. What it turns out that Shrek needs is the exact opposite of what he starts out wanting: other people. He needs society and it takes him the entire movie to find it out.

Shrek is an engaging character right from the start, and we recognize a childlike sense of fun and a child's delight in doing just what he wants without an adult getting in the way; in his domain, Shrek delights in his farts and body odor and does just what he wants to. If we were there with him, we probably would be less tolerant but we are responding to our own irresponsible

younger self and empathizing with his pleasure in his freedom. When the other fairytale characters arrive we can understand his reaction, at some point in our childhood, we've all had to cope with the expulsion from our own little Garden of Eden, whether it be the primal move from breast to bottle, the arrival of a sibling, or the first day of school but, whether we are a school age child or an adult, we know he has to grow up and live in the world with other people; we are enjoying the ride and eager to see how he copes and how he changes.

Shrek, like Snow White's Wicked Queen, has reached stage two of the Maslow pyramid but the arrival of a problem (the invasion of his domain) starts him off on his journey to a realization that there is a gaping hole in his life, one that needs to be filled with other people (Social) who love and value him (Esteem).

To go back to Snow White; while Snow White mainly reacts rather than acts and has an insufficiently strong desire, other than to survive, the Dwarves and the Queen have very strong wants.

The Dwarves, although they are often taken to be merely comic characters, have very strong desire lines that are not a million miles away from those of Shrek. When we first encounter them, they have a settled and perfectly satisfactory life working and living together in the forest. When Snow White disrupts their grungy bachelor domesticity, they are resentful and their immediate reaction is to wish her gone so they can be left alone. But she wins them over (though Grumpy takes a little longer than the others) and their wish to see the back of her is replaced with a fierce need to protect her that sees them eventually hunting down the Queen who, disguised as an old hag, has poisoned the heroine.

By thinking about the basic needs of our characters, we can see why they want what they want and create characters that live in the mind and enhance the film in which they appear.

At this point, it is important to point out that many people share some of the things that motivate us, a desire for happiness, for example. That much seems very obvious, but what happiness means and how we set out to achieve that becomes very problematic. Then we can see that what motivates one individual may not motivate another: money, power, esteem, clothing, cookies… fish. This, of course, is completely enmeshed with our individual personalities. Even a heroic act like rescuing a baby from a burning building could be motivated by different things dependent upon personality. Bugs Bunny would perhaps be a very modest hero, accepting the accolades and esteem but NOT motivated by it. The only way Daffy Duck would enter that burning building is in the absolute certainty that he was going to get out with not a single feather out of place BUT, and here's the rub, in the certain knowledge that he would be proclaimed as hero and receive all that he considers his due.

The novelist E. M. Forster, in his book, "Aspects of the Novel," distinguishes between what he calls "flat" and "round" characters. Flat characters he says are "constructed round a single idea or quality," are easily recognized and

remembered, and are better if they are comic since a serious flat character has a tendency to be a bore. "The really flat character can be expressed in one sentence such as "I will never desert Mr Micawber." There is Mrs Micawber— she says she won't desert Mr Micawber; she doesn't, and there she is."

A "round" character, by contrast, has the ability to surprise us convincingly and has dimensions to their personality that are revealed as the story progresses. A "flat" character does not change but a convincingly rounded character has to change. So when we look at motivation, we need to remember that, if we want to create a character that lives on the screen, we must not allow motivation to become a fixed and unyielding block, that it must be tempered by other facets of personality that keep the audience guessing, and the character must learn and change.

What Are You Trying to Say?

Before we can get to the point of creating a great performance, we need to understand our characters, but before we can get to *that* point we need first to know what we are trying to say with them. The director, the writer, and the animator all need to bear this in mind; acting and direction must support the aim of the script as much as any other element does, and the aim of the script must be important to the writer.

We are asking what is this film about, not, what is the story?

Not all films are deep and meaningful; some are light and frothy and lots are somewhere in-between and sometimes that's just what you want for a Saturday night's viewing. There's nothing wrong with that.

But enjoyment and thought are not mutually exclusive; it is possible to have fun with your brain switched on, and after the immediate pleasure has faded, there is that spark that leaps to life when some incident brings the film back to mind, and we make the connection between what we have seen and what we know. And maybe we start to understand life a little bit better. I don't believe anybody would claim that "The Wizard of Oz" was a dour, overly serious movie without any fun or laughs, just because we can point out serious themes in it.

Amid all the fun, excitement, and music, "The Wizard of Oz" has themes that have continued to resonate and keep us watching for over seventy years: the quest—the voyage of discovery and return that gives us the ability to see our home with new eyes, the need to believe in ourselves and see the reality of our abilities rather than what we think they ought to be, and the allied need to see through falsehood and recognize things for what they are. It is difficult, if not impossible, to create an interesting performance if there is nothing on which to base the character: if there is no little man behind the curtain in "The Wizard of Oz," then there is only what appears to be there, a big flat green face shouting at the audience. What is more interesting is that, or the fact that, the

great Oz is a fake, a showman trying to impress the people with a light show and that as a fake he is revealed as another human with his own set of failings?

For the writer, or writer/director, it's not necessarily a good idea to start with the theme and try to build a story and characters around it, since this is likely to lead to rather abstract plotting and flat characterization; the characters in the film become signposts or ciphers rather than real people. Whatever you do, even if you just want to make people laugh, you will end up portraying something of your own thoughts and opinions on screen and there is often a definite desire to do so on the part of any creator. Your characters are parts of your own personality, reflections of your beliefs even when you give them a life, or opinions at odds with your own. Therefore, it is likely that the themes and ideas that interest you will come out without you having to make a conscious effort to force them on to the page, and it may be that you won't even recognize, until later, the themes you have created.

So how are the director and the animators going to support the intention of the script if the themes are buried in the writer's subconscious? The first step, for the director, has to be script analysis. This will provide the basis for his or her instructions to the animators, and I hope that the animators would also take the opportunity to read and analyze the script for themselves to get a better understanding of how their characters fit into the narrative and the overall arc of the film.

Having worked out what the narrative is about and how the characters fit into it, it is important to remember that even though we know what we are trying to say, the character may be completely ignorant of the fact. He or she may be opposed to the message the film is trying to deliver; we may be animating one of the bad guys or it may be that our character only slowly comes to a realization of where he has been going wrong or why he has made so many wrong turns.

Acting often involves being someone the actor could never be, someone so temperamentally different that occasionally the character repels the actor but, to create a performance, the actor must find a way of understanding the cause of the behavior he is trying to portray.

This can work the other way round too. You can't deliver an anti-war polemic if you are enamored of the trappings of war. Or rather, you can if that part of your personality is opposed by another part that is repelled by the idea. The duality can create a character that is more rounded than the cipher we mentioned above.

Irony in drama comes about when the character is unaware of something the audience can see or understand, as when Oedipus sets out to find the person who has killed his wife's late husband, the previous king of Thebes. Unknown to Oedipus, but known to the audience, the stranger he killed in self defense was not only the late king but his own father and Oedipus had, therefore, married his own mother.

In "The Wizard of Oz," the characters Dorothy meets already possess the attributes they are seeking; intelligence, compassion, and courage, but they can't see that and the wizard, who is seen as all powerful by the people of the Emerald City, turns out to have no power at all.

In "Toy Story," Buzz Lightyear does not know he is a toy, which causes complications, but when he does find out, it threatens to bring him down completely.

Or when Bugs Bunny dresses as a girl and Elmer Fudd can't see through his disguise, though it's obvious to us that this isn't going to turn out well for Elmer.

So there is no need to consciously go for a grand and serious theme when making your movie, but it should be remembered that by omitting to think of that element, you may end up producing an entertainment that has no more longevity than the time it takes to view it. If the theme is trivial or badly handled, the film may be fun while it lasts but it won't be memorable. If you stick in a theme because you think you should, or you need one as an excuse for a piece of action you've always wanted to animate, you will come over as cynical or insincere and you may miss the very things that make the story interesting.

Props

So far, in this chapter, we've been talking about internal, psychological, themes, and character drivers. With props and costumes, we're moving outside to look at the ways we can enhance a performance through the clothes and objects we associate with the character and those objects a character may use as part of the performance.

Props (Originally stage "properties," items owned or provided by the theatre rather than stage clothes provided by the performers themselves) are those items the performer actually handles when playing a part, like the glass he drinks from or the letter he tucks into his jacket pocket. All the other stuff is set dressing and in animation terms will, in 2D, be part of the scene painting or, in model animation or CG, be modeled for its appearance only (rather than to be used). In live-action, a kitchen table would not usually be considered a prop, even if the characters used it as a barrier when chasing each other around it. In animation, of course, it could be if, for example, your giant character picked one up to use as a back scratcher. Mostly, though, we are talking about those items that the writer, director, or animator uses to create "incidental business": nonverbal activity that conveys subtle indications of character. What could be more nonchalant than Bugs' way of eating a carrot in the face of danger? Combine that with the precise animation timing and delivery of his famous catch phrase and "What's Up Doc?" gives us the character in a nutshell.

Disney's "Pinocchio" is full of ways in which props can be terrific signposts to character and personality. Look at Honest John, with his nonchalantly twirled

cane that marks him out from the beginning as a showman, but that also says he's a bit too flash. He uses the cane as an extension to his arm, allowing him to literally manipulate Pinocchio as he manipulates him mentally, letting him get just far enough away before pulling him back for more persuasive, honeyed words. Note how Honest John's pretentions to learning and class are shown to be false the instant he picks up Pinocchio's ABC and reads it upside down.

FIG. 5.2 A prop, such as Honest John's cane, can speak volumes about a character. In this case, Honest John thinks it makes him look dapper, but it is also good for hooking a small wooden boy into his schemes and you can bet it has stolen plenty of things.

Props can also help out in the staging of a scene, giving the character a reason to move around a room, helping to get them into the right place at the right time. This will be looked at in more detail in Chapter 7, Scene Composition, but what I would like to concentrate on here is how the correct use of props can help directors and animators to get over the problem of "theatricality" or "staginess," the effect that comes from concentrating too hard on what the character is trying to express. As we mentioned above, in scripting a scene, the good writer will avoid "on the nose" dialogue, and sometimes, when animating, it can feel like we are doing the same thing, expressing what the character is saying by a kind of pantomime that tries too hard to get over the message. I'm sure all animators have experienced a moment when they've asked themselves what the hell they should do with their character's hands while he's talking—and come up with "Flappy Hands"™.

We know that it is not enough for the character to just say the words but even if we act out the speech, we find ourselves thinking about what our hands are doing, trying to add the right emphasis and ending up with something mechanical or something that looks like a demented seagull. (Though if that was what you were after, congratulations, you've got it!)

FIG. 5.3 War Story. What to do with the character's hands when he is speaking is always a problem. You don't want him acting out every sentence and you don't want him to just wave them around without any reason. Giving him a prop gives him something to do and allows him to emphasize a point when he needs to do so. Bill, the hero of Aardman's "War Story" uses his pipe to point with, to reinforce his gestures and, of course, the animator finds it a very useful thing to use to punctuate any gaps in the dialogue.
© Aardman.

This sort of thing can bedevil actors when they find themselves failing to produce a convincing performance or line reading and start to focus too much attention on the line or the action. When this happens, a line meant to be throwaway will become overblown and self-conscious or an important line will start to signal its presence in a way that becomes completely unnatural.

By introducing a prop and devising a bit of "business," the actor finds an activity that demands his attention and leaves the actual line as almost an afterthought and, therefore, easy to deliver.

In a purely practical way, the same sort of thing can happen with an animator; thinking about how to work with the prop and how to deal with the action, be it pouring a drink or opening a door, can take away the need for the character to "perform" the line and make it more significant than it needs to be.

In this case, concentration on an ordinary, everyday bit of business emphasizes the shock of new information, which can be aural or visual. This is a comedy standby; for example, a reaction will be more pronounced, and

funnier, if the character is in the middle of an action, like the man who, suavely pouring himself a drink, suddenly realizes he has been insulted and, in his shock, pours the drink over his hand.

As an animator, you will be fortunate if the writer has been thinking in terms of character behavior when writing the script and has taken the trouble to provide a range of props and opportunities for their use. In this way, you can start to create natural physical behavior that helps characterization or motivation become visible without the words doing the work. That way, only the important lines of dialogue, the ones that really tell the story, can stand out and the dialogue takes a back seat to the action.

In an exercise taken from the 11 Second Club, my students had to animate one character accusing another of stealing something. One of the students decided to play the scene in CG with the stolen object as a car, which had obviously been retrieved, as it was present in the shots, but, having modeled the car, he chose to have it sit there while his characters talked face to face. Without an idea to inform the acting, the characters were left to flap their hands about in a way that filled up the time but achieved little else. My suggestion to him was to have the accuser, the one who had lost the car, play the scene, paying more attention to the car rather than to the thief, as if this was his pride and joy. This gave the car owner something to do, stroking the car as if it was a person, almost a love object, which meant the emphasis was taken away from the idea of pantomiming the words and to playing a real idea. In this way, the animator could present the reason the character was so angry and explain the vehemence of the voice acting.

Props may often be an obvious adjunct to body language—like taking off glasses or smoking a pipe. Dark glasses can be used to conceal the eyes, to add mystery, or used in the way Top Cat does to show how cool he is.

Props can be narrative tools, devices to move the story along, especially in the sense that Hitchcock called the "Maguffin," the object that starts the story off and the thing the characters want to possess. The acorn that Scrat constantly pursues in the "Ice Age" films falls into this category as does the Ring in "Lord of the Rings." With Scrat, the acorn is little more than the excuse for a chase, but the Ring not only motivates the characters and helps drive the narrative, it also provides a whole set of challenges for characters like Frodo over and above the need to avoid the bad guys. The power of the ring and how different characters react to the promise of that power creates character interaction and development and establishes personality.

Props can be an invaluable aid to establishing the theme of a film and the relationship between characters, as animator and educator Patrick Smith (http://scribblejunkies.blogspot.com) points out: "In Michael Dudok De Wit's film "Father and Daughter," the very first shot establishes the deep bond between father and daughter, illustrated by showing them riding bicycles

together, the bicycle itself becomes a symbol of their connection and is used throughout the film, all the way to the end."

Often an item, like Popeye's pipe, is so integral to the character that it could be considered part of his costume or design, something without which he would not be complete. Popeye's clothing is a good example of a functional costume design that does little more than denote his identity as a sailor. Much animation design is like this, with the costume simple and unchanging, designers just occasionally adding an extra note to give a tweak to an established character, like Daffy Duck putting on a deerstalker to establish that he is playing the part of a detective.

FIG. 5.4 Barry Purves' "Next" features the character of Shakespeare himself running through all of his plays using only props and no words.

The advantages of such a system are obvious in terms of recognizability and simplicity of production, but getting the correct initial design is not easy; do we, for example, want to go with the obvious choice or should we play with expectations?

Summary

We have seen that human empathy is a trait that allows us to better understand our fellow beings to cooperate and survive. To get the audience on the side of our characters, we have to find ways of invoking that empathetic reaction and the best way to do that is if we, as animators, can make an empathetic connection to them first. We must study and understand our characters in depth before we can make them live for others. And in that study we should aim to bring out the particularity of the character by making acting choices that are not obvious and that emphasis the distinctiveness of the individual. In this way, even villains can be understood, and we can see how animal characters are but variations on ourselves.

What makes a person particular and creates a "rounded" character comes down to their motivations, their needs, and desires. Because the script cannot tell us everything about a character, in the same way that a novel can, we have more room for interpretation and need to work harder to explore motivation. A simple change in the way a character delivers a line can change the whole meaning of a piece.

Motivation has many levels and a character may be motivated to one action in pursuit of a greater motivating force, as when a young man chases after an unsuitable girlfriend to annoy his overbearing mother. Though the animator may understand the character's motivation, the character often does not and story often grows out of the tension between what he wants and what he actually needs.

Despite movie mogul, Sam Goldwyn's famous dictum that "Pictures are made to entertain; if you want to send a message, call Western Union", there's more power in a film that knows what it wants to say. Thought and entertainment are not mutually exclusive and a story with a powerful theme to it will provide the drive that makes for an exciting entertainment, whether that be a comedy, a tragedy, or an action film.

Props and costumes can be extremely useful in conveying nonverbal indications of character, and their use can become an adjunct of body language. The use of props can be built into a performance so that we can create natural physical behavior that helps personality and motivation become visible without an over reliance on acting out the words.

Making a Performance

So far, we have looked at what we might call the frame to a performance and the principles that underlie its creation. In this chapter, we will get down to looking at the physical components of a performance, the way that such things as body language, and the effort that goes into any kind of movement, can create the impression of a thinking, autonomous character, a character that seems to have a life of its own.

We will look at what human beings actually do when they interact with other humans and how they use their bodies in different situations, both mundane and extreme, not because we think that you will always be animating human characters, you probably won't be, but because human behavior is behind most of what you will do. As we've noted in previous chapters, you might be animating rabbits but, unless they are to be seen as real animals, they are acting as stand-ins for people and will need to display the kind of traits we see around us in society.

As "Ren and Stimpy" creator, John Kricfalusi says, "Human acting as I understand it doesn't mean acting just like humans, it means expressing unique and specific things in response to what is specifically happening and what the characters should be feeling about what is actually happening, such as humans naturally do. It can still be cartoony or exaggerated, and is completely compatible with cartoony physics."

The nature of the physical body is something else we need to look at too, since the way the character is constructed will determine how he or she moves. Above all, we will look at how, by getting the character right in physical terms, we can capture that most elusive of things, thought.

Body Language

When I'm out on the hill near my home taking the dog for a walk, I often encounter a lady, with whom I have a nodding acquaintance, coming the other way with her dogs. I never see her in any other context, such as in the street, so I only know her from these brief morning encounters but I can recognize her when she is merely a tiny figure in the distance, and it's all down to body language, or, if you prefer, nonverbal communication.

When we communicate face to face with another person, we are never just using verbal language and we are communicating even when we aren't speaking. There is no real agreement on how much meaning we take from the nonverbal component of communication, some people putting it as high as 90%, others as

low as 50%, but there is no disagreement on the fact that it is a very important part of how we do communicate. When we meet someone for the first time, we don't have to wait for them to open their mouth before we have formed an opinion of them and equally they of us. We may change our initial impression as we get to know them, but the way we get to know them is also based not just on what they say but also on all the nonverbal signals they give out all the time. It isn't possible to stop giving out nonverbal signals, though people who understand what's going on can often fake the signals to a degree, and actors, and by extension, animators, can use this knowledge to create a powerful performance.

As animators and directors, we need to be attuned to the possibilities of nonverbal communication because nobody gets by without it; in fact, we are made uneasy when we can't detect body language that ought to be there, and our characters will only really come alive when we make them give off the right signals. The right stance will mean the difference between a person and a sign and an understanding of nonverbal signals will help create a real personality.

The Uncanny Valley

The Uncanny Valley is a term coined by professor of robotics Masahiro Mori and is the hypothesis that the more human a robot's (and by extension a CG or puppet character's) appearance becomes, the more empathetic and positive will be the response of an observer, up to a point where that response turns to one of revulsion. As the simulation gets progressively further from the robotic and closer to the human, the empathetic response will start to return. This "dip" in response can be seen plotted on the graph and gives rise to the 'uncanny valley term.

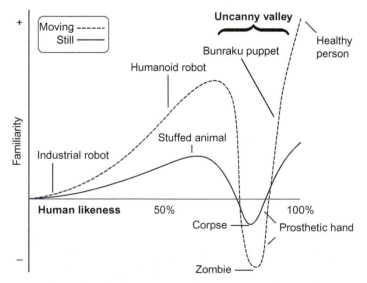

FIG. 6.1 The more human a character's appearance becomes, viewers will respond with more empathy, up to a point where that response turns to one of revulsion.

The reasons behind this aversion are not fully understood and still subject to research and speculation, including the idea that no matter how good the simulated person becomes we will still be able to tell, subconsciously, that they are somehow "other" but it is very interesting from a performance point of view. Though it was once thought that CG films would naturally have to progress to absolute realism, it can now be seen that we can stylize our characters as much as we like without losing empathy for them.

FIG. 6.2 It doesn't take much to turn a personality free sign into something with a feeling of character. Just add a touch of body language, a tilt of the hips perhaps, or a change in the shoulders.

As Brad Bird, director of *The Iron Giant* and *The Incredibles* says, "One of my problems with full animation is, often times, people do beautiful movement, but it's not specific movement. Old people move the same as young people, women move the same as men, and fat people move the same as thin people… and people *don't* move the same. Everybody moves differently…"

What Brad Bird is looking for is the study of movement that is specific to character and not just conventionally well animated and, in *The Incredibles*, he set out to make sure that each character could be recognized by their movement as much as by their design. His aim was to create within his team an agreement on who the character was and how he or she moved so that even if they all had the same body shape they could be distinguished by their movement. An aim that is very similar to the way that the Disney animators had to work with the dwarfs in *Snow White*, and the way to do this is to make sure that you have taken note of and studied body language.

The lady with the dogs walks in a very particular way that I recognize from a long way off. She has a very determined stride, a way of leaning forward as she goes, with arms held by her sides that seems very purposeful and no-nonsense, as if she knows exactly what she's about and she's completely in control. Then again, since this kind of stance could also be interpreted as rather closed off and uptight, I could assume that she was a nervous and rather fearful type who felt she had to keep moving so that no one could talk to her and possibly upset her.

So immediately we can see the problems inherent in talking about body language; if it *is* a language, it is one that is often easy to misunderstand and, unlike verbal language, doesn't actually have a vocabulary that everyone agrees on. In fact, many gestures that say one thing in one culture can mean another in another culture, so it isn't as simple as saying *this* gesture indicates *that* feeling although many of the nonverbal signals we use <u>are</u> the same across all cultures.

As we mentioned in Chapter 5, there are certain signals generally accepted as being understood in the same way across cultures and therefore held to be part of our genetic makeup. These are happiness, sadness, fear, disgust, surprise, and anger, and Charles Darwin, in his book, *The Expressions of the Emotions in Man and Animals* (1872), was the first to claim they were universal. His theory has been challenged over the years but has, since the 1960s, been acknowledged to be correct.

Even though these six traits are universal, body language isn't an exact science, though increasing investigation, using brain-imaging technologies, is giving greater insight into what goes on in the interaction between brain and body and how thoughts and feelings translate into movement, both conscious and unconscious.

It's easy to misread signals, especially if context isn't taken into account. Many lists of body signals say that crossing the arms across the chest denotes defensiveness, the person closing him or herself off from an idea, for example, or resisting an argument. It could be, though, that they were merely trying to keep warm. Shifting from foot to foot can signal shiftiness or untrustworthiness, though it could equally mean the person needs to pee!

Sideways headshaking means disagreement or disbelief in Western cultures but a similar movement in India or by people of Indian descent means agreement or that the person is listening closely.

There are cultural differences that come into play when working with artistic conventions too. While making *The Miracle Maker*, I spent a lot of time with my Russian colleagues who were doing the model animation, discussing the work they had done, and going over what I wanted for up-coming scenes. Mostly, ideas about acting were common to both sides though I tended to have a more naturalistic idea of how I wanted to deal with the story of Jesus than they did and occasionally something would crop up that took me by surprise.

For one particular scene, where Jesus is taken before the Roman governor, Pontius Pilate, we had a cast of characters arguing their case in a noisy and dramatic assembly. Pilate angrily orders them to be quiet; "or I will charge you all with disturbing the peace of Rome!" And he makes an imperious hand gesture, with arm outstretched and fingers splayed, palm pointing at the floor as he does so. So imperious and over the top that it seemed like a caricature to me and, indeed, the origins of the gesture were in various examples of painting and statuary, some of which I'd seen around Moscow.

Ironically, for the country that gave us Stanislavsky, the father of naturalistic or Method acting, they were much more likely to use artistic conventions than real body language to depict important moments of the drama. I could understand this to a certain extent; since the Revolution, they had not had general access to debates over religion or the number of different ways the story of Christ had been done in the West, from *Jesus Christ, Superstar* to Dennis Potter's play, *Son of Man*, so they had had to fall back on iconography from painting and sculpture that was still available in their museums. It was hard to change the animators' minds on this point, since they considered it a legitimate use of a specific gesture that looked both dramatic and imposing and natural to such an authority figure. It was only when I told them that, in English, "peace" sounded just the same as "piece" and it would look like Pilate was charging the crowd with disturbing a specific piece of Rome (lurking just out of the bottom of frame) that they gave in and decided they would do it again without the gesture.

(I have to say that, despite the difficulties inherent in a coproduction across so many miles and with such differences of culture the work that the Russian animators produced is absolutely terrific in its ability to reproduce complex emotions and engage the audience.)

One size never fits all when it comes to body language; there are things we can say about the kind of movement that results from certain bodily conditions, but context is all when it comes to interpreting the signals sent out by another person. As many of us will have found out to our cost, body language can be faked and people who have something to sell us try to do this all the time. This is not to say that salespeople, for example, are necessarily trying to deceive us, but the simple fact is that they have to try to give out a sense of reassuring honesty and solidity even when they are feeling below par or have worries of their own. Then there are those who **are** out to deceive, and they really need to project an image of stability. They are the ones who will have studied how to hold themselves and where to look while lying in your face.

So, if we are studying or observing people in order to reference real ideas about movement in our animation, it is a good idea not to rely on a single example of nonverbal communication but to look at all the signals a person is giving out and find in the combination a better clue to meaning.

Other factors will also come into play when we attempt to either analyze or recreate body language; we've mentioned ethnicity and context, such as temperature, but even more obvious are the differences between men and women, the young and the old. For example, young people will generally be more supple and energetic than older people and, depending on how young they are, probably less inhibited in their movements. Women, on the whole, tend to be more inhibited than men; though as social mores change (in Western societies, mainly), this is becoming less true.

Leaving aside for a moment those people like politicians, salesmen, and con-artists (and actors), whose professions demand they try to alter their body language, we can say that nonverbal communication is not a matter of choice but something we do without thinking about it. Indeed, it is something that we do even when we don't need to do it, because it is hard-wired into us. We've all seen people in the street on their mobile phones gesticulating away despite the fact that the person on the other end can't see them and, as the instructor on my speed awareness course said, "if you breathe in when driving through a narrow gap, you're going too fast". Like the man in Figure 6.3, we have to move our bodies when communicating, presumably as a legacy of the thousands of years when we had no language and had to communicate the way animals do.

You've probably seen a child wanting to tell her mother something as the mother is chatting to someone else. Unable to get a word in and told to keep quiet, the desperate need to communicate comes out as a twisty, hopping dance that has the child building up to a volcanic eruption of sound. Conversely, think of the soldier being harangued by the sergeant and having to respond while standing rigidly to attention. Quite apart from the fact he is on the receiving end of a telling off, he is unable to use any body language to explain himself, assert himself, or create a submissive posture that his hindbrain might think was a way to get out from under the torrent of abuse. Very uncomfortable.

Despite the fact that "the eyes are the windows to the soul" and our eyes are drawn to faces when people speak, we are actually taking in an enormous amount of information from a person's stance, from hand positions, and the way we tilt our heads; we communicate with our whole body. The lady with the dog is so far away from me when I first see her coming that her face is a tiny smudge but the attitude and silhouette of her body is what I recognize.

Paul Mendoza, animator on several Pixar movies, including 'UP', 'WALL-E', and Ratatouille when talking about his animation at the Bradford Animation Festival in 2010, talked about how important the eyes were to a performance but also, more surprisingly, of how much the movement of the shoulders brought to it. Our hips and shoulders are the pivot points in the body and these are the places where we show the weight of a character, with women generally carrying more weight lower down in the hips and men carrying more in the shoulders and we can immediately imagine a curvaceous woman leading with her hips or a brawny man moving with rolling shoulder movements. We tend to forget though how much our emotions can show up in the way we hold our shoulders, both men and women. Get into a tense situation and you will often find that your shoulders are heading up towards your ears and when the problem passes the release of tension allows them to slump back down. (This is how, quite literally, a person can be a "pain in the neck." Someone who annoys you, without the possibility of a release of anger will cause you to tense your shoulder muscles and give you a stiff neck.)

FIG. 6.3 It's a cliché that Mediterranean types have to move and gesticulate when talking but we all do it to a greater or lesser extent.

An aggressive character will lead with his head down and chin out but when the verbal aggression turns into action he will bring his head right down into his shoulders and his arms will come up. A person disappointed by some action or slight will slump, their shoulders drooping, and all these actions can be seen in miniature, almost in rehearsal, before a character has to do something that will arouse the same emotions in someone else. Thus, it is possible to animate a character with their back to the camera and still have the audience understand exactly what he or she is feeling.

Character Interaction

Animated films can often feature single characters going about their business until assaulted by giant letters of the alphabet or stranded alone on a desert island, and we still utilize body language to allow the audience to understand what they are feeling. In fact, lacking another person to talk to, body language is often all we have to go on in assessing the character's mental state. More usually, we are dealing with the interaction of characters and we have to provide body language that is a dialogue of action and reaction, of nonverbal responses, one to the other.

One obvious aspect of this communication is proximity, the distance characters are from each other. This, like other things, can depend on different social interaction in different societies; extended personal space can be expected in one society wherein another people will be quite happy to be quite close to each other. Naturally, this also changes depending on the sex of the persons interacting. However, it is interpreted, someone entering the personal space of another without permission will be seen as aggressive or crass. Lovers and friends, of course, have each other's permission to remain in close proximity and that easy closeness indicates the state of a relationship without the use of words. In the same way, if one character is always trying to stand next to another and the second character is always moving away, we can see what is going on without the need for additional dialogue.

So, proximity is one factor that shows the relationship between characters, but there are several other factors that can observed during interaction, including what is known as mirroring.

When people are in sympathy with one another or, consciously or unconsciously, want to give that impression, their body language begins to become synchronized, they adopt similar postures indicating a rapport has been achieved. (Speech patterns, speeds, and tones also become synchronous.) When this happens, the speaker will feel the other person is empathetic and likes them; they will feel a kind of affirmation. If this doesn't happen, communication can become very uncomfortable; unconsciously, the speaker will feel a resistance on the part of the other person.

Another important feature that can indicate the relationship between two characters relates to where they actually stand when speaking together.

Facing someone directly can be very confrontational, but it can also be a sign of two people who feel a great deal of affection for one another. Someone can be "in your face" or "up close and personal," and this face-to-face stance is always intense, so, even when people meet like this to shake hands in order to do business, they will very soon get into an arrangement that will allow them to be at an angle to one another. The classic boardroom situation is people facing each other across a large table, but modern business thinking regards this as overly antagonistic and sees sitting or standing at an angle of about 45° as much more comfortable and conducive to cooperation. You can see how this works for yourself when in conversation; if you are coming on too strong or being slightly over enthusiastic, whether it be in an aggressive or an affectionate manner, the person to whom you are talking will tend to edge round to the side so that you are not in looking directly at them.

An understanding of these principles can be applied to any kind of character, not only a human but also something quite abstract. With this in mind, we can show the relationship of a square and a triangle or two germs as well as a boy and a girl.

Eye contact is an interesting question too since reactions to it differ in different societies. In some places, it is thought rude to look an older and more respected person in the eye, in others we have the command, "look at me when I'm talking to you," All good for interesting misunderstandings.

One thing that seems to generally happen within conversations, in terms of eye contact, is the difference between speaking and listening. A person who is listening to another will usually signal interest by looking at the person who is talking while the speaker will mostly look elsewhere, only looking at the listener occasionally as if checking to see if they are still there. These roles reverse when the speaker changes. Obviously, the listener, unless they are bored or trying to be rude, will want to signal that they are attentive and considerate; looking at the speaker is the simplest way to do so. This is often accompanied by head movements, like nodded agreement, and vocal affirmations or agreement.

The speaker, in contrast, is often remembering the thing she is describing or coming up with an idea or making a joke and when doing that we tend to look away to either the left or right. This seems to have something to do with the way our brains are wired, the left side dealing with memory and facts and the right with creativity, so that we look up and to the right when coming up with ideas and down and to the left when remembering facts.

Learning about listening is a very important part of an actor's training (see Chapter 2 as it is not enough for an actor to be good at what he does with his own speech and body language; if he doesn't appear to be being listened to by others, the audience won't believe in him. The problem of working with a script where you know what is coming can lead to a flow of words and action that is artificial and doesn't correspond to what would happen in

real life where we have, at best, only a vague idea what a person is going to say. We also have to be able to react to what is said and done and that can't happen without some kind of thought on our part. Actors train to listen to one another to the extent that they sometimes do an exercise where their lines are handed to them just before they are to say them. They still have to learn those lines before they go on stage but the training in listening is what they take with them. Listening is an activity just as speaking is, and in animating characters talking together, we have to consider the nonverbal signals our listening characters are giving out as they listen. A person who is listening to someone else is not just standing there, he is taking in what the speaker is saying and formulating a response, judging what is being said or being amused by it. He may be getting angry about it or being bored, but he will have his own thoughts and his body language will let us know what they are. You may be doing a piece of limited animation where there is no chance to animate the crowd standing in front of the man giving the speech, but the poses you give them need to tell the viewer exactly what they are feeling about the speech or the speaker.

Equally, a character that enters a room but doesn't have anything to say right away or one who is on the fringes of the action but has no lines isn't just standing around doing nothing. If the character is listening to the exchanges going on, then she will have her own feelings about what is happening and her body language is going to express those feelings, even if she hasn't got the chance to act on them.

In a piece of limited animation, where there isn't chance to do much more than pose her, her body language needs to seem like a reasonable response to what is going on, while being a pose that could reasonably be held.

Disney animator Ollie Johnston always said, "Find the golden pose, and build the scene around that pose." In the same way that the director should work to understand the single most important point that the audience needs to get out of each scene, in order to understand where the film is going, the "golden pose" is the one that says what you want the animation to say in that scene. Often the pose will come out of the storyboard and, of course, it isn't the only pose you'll do for the scene, but the others will work to support that one to create the effect you are aiming for. A really good pose will read well and will show what the character is thinking. Chuck Jones was a master of the pose that was both funny and meaningful at the same time; he never over-animated things or let his animators over-animate things and always made sure that the important poses read well. What made this work so well was that, as well as holding a good pose, he made sure that he didn't have the character freeze into position but, with judicious use of cushioning and overlapping action, like a tail or ear that caught up just a little latter, he could make a much more subtle effect and keep the character alive.

Johnson also said, "It's surprising what an effect touching can have on an animated cartoon. You expect it in a live-action picture or in your daily life

but to have two pencil drawings touching each other, you wouldn't think would have much of an impact but it does." This thought reflects, to me, the need to give the characters a sense of that autonomy we mentioned in the introduction. When the characters touch, they seem to acknowledge each other's reality, quite apart from the one we give them, and it seems odd that this idea isn't used more often. Think how seldom we see characters touching in a simple, natural way, and how contact is often restricted to the Prince's kiss or the bad guy's punch.

As ever, these notes are only ever intended as the baseline from which to work, and the creation of both comedy and serious drama means moving away from the expected or the cliché to the surprising and the particular. As with any language, many of the words are the same for everybody, but the way each person puts them together, their accent, intonation, pronunciation, and turn of phrase add up to the very particular individual.

So, although many people would like to have a list of readily available mannerisms that could be relied upon to indicate certain moods or feelings, it isn't possible to set them down with any certainty. It is true that, once upon a time, acting was taught in this way, as a series of gestures that meant something specific. Actors would put the back of their hand to their forehead and swoon backward to indicate a shocked reaction to some revelation or become stooped and wring their hands to indicate servility. We've all seen this kind of performance spoofed by actors and comedians or someone playing the part of an amateur performer and the great Bugs Bunny mercilessly parodies this sort of acting, as in *What's Opera Doc?*.

The work of Stanislavsky signaled the end for exaggerated staginess, as we discussed in Chapter 2, but this telegraphing of the emotional state of the character is still too often part of the journeyman animator's repertoire, and many animators would like there to be a simple system of visual clues to emotional states. Sadly, it isn't as simple as that (what is?), but www. businessballs.com/body-language.htm is a very useful website about body language, although you need to remember the provisos we've mentioned here when you look at it.

Effort

Understanding body language and trying to get feeling into a character is important, but the physicality of a performance is vital if the character is going to be believable. Without weight and a sense of the forces acting on and through the character, all the clever posing will go for nothing. Even if the character is light as air, a thing entirely possible in animation, we need to put over some sense of the effort that goes into being that way. A cloud is insubstantial, blown every which way by the wind, but if we intend to give the cloud a personality and make it actually do something in a believable way, it will need to move itself and react to the forces that act upon it.

For all the other characters, the ones that do have weight and solidity, it is even more important to feel the forces at work and make their feet hit the ground, make their muscles strain as they pull themselves up the cliff face, and make them stagger as they carry that cannonball. Or, if they are a fish, or a bird, or a dragon, they need to convincingly move through water or air, pushing against it and being buffeted by it. Without a convincing sense of the reality of the character, all the good design, all the fine drawing or puppet building, and all the brilliant character modeling will be wasted.

When I started teaching character animation, I usually set an exercise to do with weight and I ask my students how we might show that a ball the character has to pick up is heavy.

Simple question, eh? But some of the answers I get are often very convoluted and strange. Suggestions I have had include "show cracks on the ground underneath it"; "make it shiny and metallic"; and "write 10 tons on it." I elaborate and say that, no, we won't be using color or words; in fact, we will just draw the heavy ball as a simple circle, but I often still don't get the answer I'm looking for.

FIG. 6.4 Heavy, heavier, heaviest?

Now these are not stupid people, they have just not been able to see the wood for the trees, as it were. They seem to treat it as almost a trick question. But the answer is very simple. When we take away all other clues and the ball is a pencil circle on a ground plane defined by another line, the only way we can see that it is heavy when another force acts upon it. In this case, our character comes along and tries to pick it up.

That's not the end of the story though; in trying to define how we show that the ball is heavy when lifted, the answer is not in the amount of sweat that pours off the character's brow nor the straining noises on the soundtrack, it is in the effort the character expends in trying to lift it. In showing that effort, we use many of the animation principles laid out in the classic Disney studio list, The 12 Principles of Animation, that we noted in the Introduction:

1. Squash and Stretch
2. Anticipation
3. Staging
4. Straight Ahead Action and Pose to Pose
5. Follow Through and Overlapping Action
6. Slow In and Slow Out
7. Arcs
8. Secondary Action
9. Timing
10. Exaggeration
11. Solid Drawing
12. Appeal

We won't need all of these in order to produce the effect we are looking to achieve but many of them are essential components. Appeal we'll leave aside, and assume that our character is well designed and full of personality and within Solid Drawing, we'll subsume the solid constructional values of a stop motion puppet or a computer-animated character. Staging will be useful insofar that we show the action from a vantage point that allows us to see the movement well; in this case, probable a three-quarter view from the front at eye level, but Straight Ahead or Pose to Pose animation is mostly to do with how we want to animate rather than what we are animating. Let's assume a simple character without floppy clothing, so we don't need to think too much about Follow Through; clothes aren't going to show us much in the way of effort anyway.

So our character faces the ball and goes into an anticipation; not, as some students think, an opportunity to do some funny little strong man poses before he starts, but the way in which he leans over the ball, hunkering down to be ready to use his powerful thigh muscles. This anticipation, as we will see, is one of the most useful tools in our animation arsenal when showing effort.

FIG. 6.5 First the anticipation, leaning into the ball and getting purchase. Then he braces himself, pulling backward as his arms stretch. Then, er. . .

So, he moves in to the ball, the anticipatory movement always coming as a move in the opposite direction to the way in which the main motion is going to go.

Then he starts to straighten up, and we can use squash and stretch here to show how the weight of the ball is affecting his body, with his feet, perhaps squashing down into the ground and his arms stretching and lengthening before the ball has even moved. The ball, we will assume, is a cannonball and not amenable to squash and stretch even in our cartoon universe.

The amount of Exaggeration we use is entirely up to us and depends on the way we have designed our universe. A very cartoony universe will allow for a lot more squash and stretch, a more realistic one will demand less though all will benefit from a certain amount of exaggeration.

As our character stands and the ball leaves the ground, we will be using our skills in timing to create the Slow Out that creates the acceleration from a resting position. The fact that the acceleration is slow and minimal shows how much effort it takes to get the ball moving.

The fact that the body moves up and back before the ball moves means that the movement of the ball could be classed as Secondary Action but secondary action will certainly be present as the body gets to the top of its move and the head comes up after it.

In all these actions, we can see the presence of Arcs because one thing that we really need in order to show the weight of this object is Balance. To keep the ball off the ground, the character will have to balance the weight (which is what he would be doing with his own weight if he were standing still, to avoid falling over, but now the need to be balanced is crucial). Essentially, if we draw a center line through the figure, the weight of the character and the ball must be balanced on either side of that line. Since we assume the weight and solidity of the character from the type of character he is and the way he is built, we look at the way the ball is balanced and make conclusions about the weight of the ball. So, if the ball is held at arms length, we know it isn't very heavy because the person holding it doesn't have to lean back to take more of the weight toward the center line. The heavier it is, the more he will lean back, balancing the weight of the ball with the weight of his body, and if it is *really* heavy then the whole ball will need to rest on the center line with the body acting as a stand on which it rests. The ball will move in an arc as it comes up from its resting position on the ground to its rest in mid air (and naturally there will be a slow in to the rest position as the character resists the momentum he has created).

So, a simple action, but one that relies on a large number of animation principles in order to create the feeling of effort that leads to a good performance of that action.

This may feel very simplistic; after all, what has this got to do with putting over great depths of emotion or a series of great gags that set the audience alight? But there is a reason that this is one of the early animation exercises that are given to students; if you can't get over to an audience, the effort required

FIG. 6.6 The first is not a heavy object; he hardly has to bend backward. The second is so heavy he needs to keep it balanced over his center of gravity.

in picking up a heavy ball, how will you get over the effort required to do anything? And effort isn't just what happens when we pick up something heavy, it is not exclusively to do with difficulty or big emotions, it is present in all actions.

Bill Tytla, Disney animator on films including *Dumbo* and *Fantasia* said, "The first duty of the cartoon is not to picture or duplicate real action or things as they actually happen, but to give a caricature of life and action. The point is that you are not merely swishing a pencil about but you have weight in your forms and do whatever you possibly can with their weight to convey sensation. It is a struggle for me and I am conscious of it all the time."

Everything is inert until something comes along to get it moving; it's not a new thought, it is Newton's First Law of Motion. The ball will stay put until someone comes along to pick it up or a car hits it or natural forces cause it to rust away. We will sit in that chair until we decide to get up and do something, the difference between us and the ball is that we are alive and can move ourselves, either through a conscious decision or through reflex action (when the sharp spring shoots up through the bottom of the chair). Reflex action we'll consider later but our concern here is with the action that is initiated by our character, and that action is initiated by thought and feeling.

The use of anticipation is one of the main differences between a character that can act of his or her own volition and an inanimate object. If an object moves into an anticipation before the main move, it shows volition and is alive. If it is not alive, it can only be acted on and, if it moves, that movement must be driven by an external force so that it can only accelerate from a stationary position, in the direction of the force that acts upon it.

Before we go on, I need to emphasize here that a character differs from the ball in another way in that he is not actually completely inert when he is sitting in the chair. Actions don't come from nowhere and a character shouldn't be a complete blank until the animator gets him going, he needs to be doing something, playing an action, as actors say, even if that is very minimal. The reason is, of course, that we are telling a story and the story has a dynamic, it is going somewhere. So even daydreaming is an action because it is based in personality, he is daydreaming for a reason and even if he's sitting in the armchair, bored and picking lint from his clothes, he is doing something that is meaningful in terms of the story. It may be that his girlfriend has dumped him and his daydreaming is coming out of anger and frustration. The way he picks the lint off his shirt in this case will be a lot different to the way he would be doing it if he were thinking about her before the dumping. In one case angry little flicks, in the other more languid and dreamy; both displaying a minimum of effort but both driven by internal forces and each of them requiring a different way of using the animation principles above.

If being dumped, he then comes to the conclusion that he isn't going to take this lying down, he'll get up and rush off, maybe to give her a piece of his mind or perhaps to try to make up with her. There will be effort involved in getting up in either case, but the way he gets up and the way he walks off will be coming from a different place for the different emotions. If he hasn't been dumped at all, he might be off to tell her how much he loves her; once again, the emotion is different and the simple act of standing up is changed by that emotion.

Most of the time, people don't think about their actions as they perform them. In fact, it's usually a bad idea to do so; try running up stairs and start thinking about running while doing it—a recipe for falling on your face. (The authors accept no responsibility for anyone taking them too literally and actually falling upstairs.) So, in getting up, our character's movement is controlled by well-developed motor functions, but the nuances of that move are dictated by his emotions.

You can see that, in coming up with an example of a character getting up from an armchair, I couldn't explain it in the same way I did the character picking up the ball. When the character picks up the ball, it works as a simple starter exercise, since the process is pretty mechanical and we don't need to know the backstory. On the other hand, immediately we start to think about someone getting up from a chair, we start asking questions about what is going on; what's the story here? The character's intention in getting up is now part of the equation and I wouldn't think of giving this as an exercise unless I also gave the students a bit of storyline to work with. I might say what I wrote

above that here was a man dumped by his girlfriend, sitting disconsolate, until he decides that he's going to try to win her back. Alternatively, the figure in the armchair could be Sherlock Holmes, pondering a problem and then suddenly arriving at a conclusion that springs him out of the chair, or a sad old man whose wife has died, hearing a persistent knock on the front door when he would rather be left alone. All three of these characters will be sitting in different ways and will get up in different ways, each one dependent on the story we are telling, played out through the emotions that are filtered through their separate personalities, and enacted by their various physical types.

There are a huge number of permutations in the way that these different elements come to make up the persons we create. In this instance, the young man could be fat or thin, athletic or weedy, college educated, a nerd, lazy or hard working, a country boy or a city gent, independently wealthy, down on his luck, a bit dim or junior Einstein, etc. etc. And any combination, from any country you care to name. So if he's clever, an idea may come to him in a flash, but if he's overweight he won't be able to respond as swiftly as he might like and there might be a bit of resentment there that leads to a realization that his girl might have had her reasons for dumping him. Some of this might become apparent in the way he sets his shoulders and pulls in his stomach as he goes off to see her.

Interestingly, although the student running through a range of strongman poses before having his character pick up the ball was wrong in thinking this was the kind of thing that made up anticipation, I think he had unconsciously picked up on the need for a story or idea behind the action. What he was doing was creating a reason why the man was going to pick up the ball, some kind of motivation to create an objective for him. He is a strongman and this is what a strongman does. Often students will not be able to leave it at that; just a strongman in the act of picking up a heavy object, they will also want to add a gag at the end to round off the story.

As you can see, we're storytelling animals, and they are not wrong in doing this, they are responding to the need to situate the action in an explanatory framework, they can see that there has to be a lead in to an action and there is always a follow-through. This is true of the emotional, storytelling aspect; the guy has been dumped, he gets up because he wants to get the girl back, and realizes maybe he needs to lose a little weight and be someone she can admire; and it is true of the way in which we animate the actions he goes through. When we animate, we need to be conscious of the importance of the buildup to an action and the results of that action. This is why anticipation is vital, because no action comes completely out of the blue. Anticipation tells us why the character is taking the action and the thinking behind it, even more so when the action itself is very swift, like throwing a punch. This doesn't mean that the anticipation itself has to take a long time, but if we animate the punch in the way that reads strongly and go right past the contact point, we need that flash of anticipation to tell us what is in the character's mind as he begins his move. How the character follows through from the punch is important too. Is there a feeling of triumph, of instant regret that he lost his cool, or has he

suddenly realized what he is capable of? Will he dance back, ready for the next round, or freeze as he realizes the guy he punched has friends all around?

It is important to really "feel" what you are animating, to get inside the emotional core of the action, so it is vitally important that you understand the character and the scene and how it fits into the overall structure of the film, series, whatever. There are several ways of going about this; if you are dealing with an established character, you will be able to watch previous series episodes, the director or lead animator may have written a character study or you will go through the idea for the scene with the director. However, when it comes to creating the physical performance, it is not good enough to rely on only a cerebral understanding of the character, we really need to work from the inside out.

There are two good ways of doing this that go hand in hand; acting out the action and thumbnailing the scene.

The only way to really understand how to get the body language right is knowing what you do about the character and try to act it out as them. The

FIG. 6.7 Like a throw, a punch gains more force from the wind-up or anticipation. Pulling back gives the arm further to go and it can cover the distance fast, putting power into the movement. The anticipation also acts like a spring to "bounce" the movement off. Unless you want to do this in slow motion and enjoy the distortion as fist hits face, it is more powerful not to show the point of contact and have the first travel past the point of impact. That way we feel that the blow has been so powerful we only see the result.

great Disney animators didn't shy away from doing this though they realized they weren't great actors in the stage sense (if they had been, they might well have done that rather than turn to animation), but they found enough in the acting out of a scene to give them a clue to the physical sense of a character. I realize difficulties might arise if the character is a fish or a cloud but the principle applies because, if I can refer you back to the discussion about Shere Khan in Chapter 5, the fish or cloud is really only a human in disguise. By doing even an imitation of the action, no matter how badly, you will start to find something in there that you can use. In particular, you will probably find you are holding yourself in a certain way or that the voice is being produced in a particular part of your body and you will get a clue to the way this fish or this cloud has of holding itself. Then it is on to thumbnailing the action using this knowledge. Take a look at Kaa the python in Disney's version of *The Jungle Book* (1967, Wolfgang Reitherman) and see how the animator, the great Milt Kahl, uses the long snake's body in lieu of hands and shoulders. Shere Khan asks Kaa where Mowgli might be and Kaa replies, "Search me," pulling up his body to give a shrug and then, realizing he has said the wrong thing, immediately coiling part of himself to cover his mouth as if it was a hand. Then when Shere Khan squeezes Kaa's body to feel if he's eaten Mowgli, he twists up like a shy girl who has been tickled.

FIG. 6.8 Kaa, from Disney's *The Jungle Book*, is a picture of innocence.

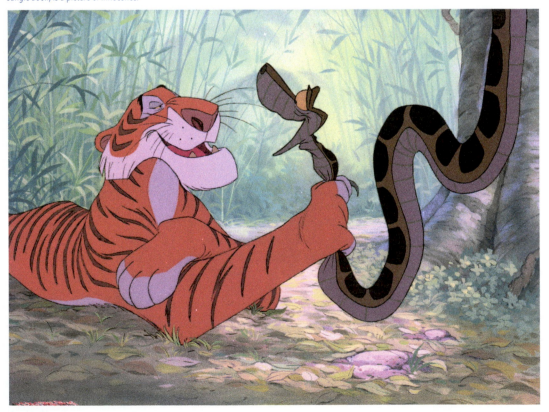

FIG. 6.9 Thumbnail sketches are a way of working through an idea, of trying out a performance before getting into the difficult and time-consuming work of animating. Here Joanna Quinn works out how a character in "Elles" should untie her bundle.

(We'll look in more depth at this way of preparing for a performance in Chapter 7, Scene Composition.)

Milt Kahl was someone who would then go on to wrestle with the insights he had gained by making thumbnail sketches of as many variations on the action as he could until he found the right one. As Brad Bird remembers:

"He believed that if his animation was better than anyone else's, it was because he worked harder. Literally each scene is the result of a lot of decisions that were made. That's why the scenes feel so rich when you watch them. He was always trying to push everything to its ultimate statement. And when you watch a scene, you're seeing one ultimate statement going on to the next."

Silence

In 1951, composer John Cage visited Harvard University and was shown their anechoic chamber, a room specially designed to absorb sounds rather than have them reflect as echoes. Such chambers feature external soundproofing and internal walls, ceilings, and floors composed of materials that absorb or scatter sound in such a way that it becomes undetectable by the human ear.

Cage went into the chamber expecting to hear nothing, pure silence, but he later wrote, "I heard two sounds, one high and one low. When I described them to the engineer in charge, he informed me that the high one was my nervous system in operation, the low one my blood in circulation."

Cage had found sound where he had expected pure silence.

Later, Cage wrote his famous piece, *4'33" (Four minutes, thirty three seconds)* (1952) in which the performer or performers are instructed to sit without playing anything for the specified time. Though it is often thought of as four minutes and thirty-three seconds of *silence*, such a performance is anything but silent; there will always be the sounds of the concert hall, the sounds filtering in from outside, and, as Cage found in the anechoic chamber, the sounds of the audience's own bodies. As the Bonzo Dog Doo Da Band noted on the album sleeve for *A Doughnut in Grannie's Greenhouse*, "The noises of your body are part of this record." The work is actually intended to get the listener to engage more fully with the act of *listening* and to realize that sounds are going on all the time. It also opens up the idea that music is not just the thing that is made by the players of instruments, but can be the whole sphere of our aural experience; music is everywhere. Arguably, this is the auditory version of what Marcel Duchamp was doing when he brought the "Readymade" art object into the art gallery; by putting a urinal on show and calling it Fountain he was breaking down the wall between high art and the rest of the world and saying that art was all around, that art is about what one chooses to be art, and that, in that case, there is nothing that is not art.

So silence does not exist and everything is art. And what has this to do with performance?

Well, I would suggest that silence must be as much a part of a performance as any of the gestures or speeches that make up what we normally understand as performance, that silence is dynamic, that silence is not an absence but a presence.

Without silence, without pauses, there is just the continuous hum of words and action and the danger is that an audience just goes along with it, lulled into a sort of trance, and misses the important stuff you are trying to get over. With the silence, the audience sits up, pays attention, just the way you do when a noise that's been going on in the background so long you no longer hear it, stops.

To stick with music for a moment, one of my favorite songs is "Doctor Feelgood" by Aretha Franklin, and one of the best, most spine-tingling moments in that song comes at the end when she puts in a perfectly timed pause before the final word. It's worth listening to the recording to see how that pause brings the song to a staggering conclusion.

Listen to your favorite comedians too, and see how much they owe to their sense of timing; see where the joke falls and reflect that timing is the ability to balance the right words with just the right pause that brings the house down.

My wife is my toughest critic and one of her criticisms of my work is that I put too much in and don't leave enough spaces. I like to flatter myself she's just like the Emperor in *Amadeus*, criticizing Mozart for having written "too many notes," but she is often right (not always, honest), and I have to bear this tendency in mind when I work and strive to achieve the perfect relationship of notes to rests.

Actor Sir Ralph Richardson said, "The most precious things in a speech are pauses. A pause will fill the void, capture attention; it will punctuate, illuminate and build the tension in a speech."

And we are not just talking about a speech, because when we talk about silence we are also talking about **stillness**, the pauses we put into our visuals that do the same job of enhancing the performance. The pregnant pause is a staple element of any comedy film but the cartoon takes it almost as far as it can go. Any Roadrunner cartoon will offer a series of wonderful examples of brilliantly timed pauses that create the comedy. Take a look at *Zoom at the Top* (1962) Chuck Jones and admire the way the timing builds a delightful tension as the Coyote tries to set up a bear trap in the middle of the road. Later, the Roadrunner comes along and the trap fails to spring even when he jumps on it, so the Coyote goes to investigate and, inevitably, the trap shuts on him. Take in the pause before it does so and the brilliant fact that Chuck Jones cuts to a shot of empty desert as it shuts, so we don't actually see anything. Then the beat before the mangled figure of the Coyote limps into shot. Of course, the pause that always occurs between the Coyote dwindling to nothing as he falls away from camera and the puff of dust as he hits the canyon floor is an example of nothingness to rank with the pause in Doctor Feelgood.

Let's be clear, though; when we talk about stillness or silence, we aren't talking about nothing happening—a total lack of sound or a freeze frame. The action may pause while speech goes on or a character may fall silent and still be moving, slowly, and subtly.

But here's an extreme example of stillness: I was once lucky enough to spend a day looking at films and talking with Terry Gilliam; this was when I was at film school and my friend Phil and I were the only animators there at the time. Terry was not as well known as he is now and, amazingly, we had him all to ourselves. While he seemed to like what he saw of our animation, he felt that the full animation style we were working in was too much work for him and he told us about his favorite of the pieces he had done for Python. The scene, he said, consisted of a dog lying on the pavement with two off-screen voices arguing over whether the dog had moved or was dead. Despite the fact that there was only one, completely immobile, illustration of the dog, he said that lots of different people swore they had seen it move. He chuckled a lot when he told us that story, but it does illustrate a serious point, two points in fact, that sound can make things come alive and that audiences want to get something out of what they see

on screen and don't mind doing some work to find it. A moment of stillness, if handled correctly, will become meaningful depending on the moments surrounding it.

These moments are very powerful for an audience, especially when they come to punctuate the whirl of the action.

Let's say that at the big reveal moment in the movie a young character asks a pretty important question, like, "If you're not my father, then who is?" The character who asks the question wants desperately to know the answer, and so too do the audience who have been following him on his quest. They can see this is the moment everything is about to change. They are hanging on every word. At this point, the revelation will mean something to both the older and the younger person, there will be a current running between them and this is where silence is at its most powerful.

The audience will be leaning forward, ready to hear what comes next, focused on the performers and trying to read into the silence. They will be thinking, trying to work things out by looking at every nuance of the movement, each glance of the eyes—and sometimes it will only be a glance that they will get, sometimes only the tension going out of the older character's shoulders as he comes to a decision.

So how long is a silence, or a beat, or how long should they be? And is a pause the same as a beat? Well, we might say that a silence is probably longer than a pause and a pause is longer than a beat but, as with body language, there is no chart of definitive answers to this. With body language, we can at least point to certain signs that seem to mean the same thing in most contexts, with silences we have nothing to go on but *feeling*. We have to learn how to judge a pause in the same way we learn how to tell a joke and realize that any example of silence or stillness comes from one thing, the action. What we shouldn't do is to fetishize the idea of the meaningful pause in the same way that an indulgent actor might try to add gravitas to his performance by pausing for a "significant" amount of time. This is just a way of saying, "Look how clever I am; I'm really emoting here."

When things stop, they stop for a reason that is completely to do with what is going on in the movie, they pause because the action demands it. It may be a revelation or a question that demands an answer, the shock of a re-appearance or the need to dredge up memories. It might be that a character has just given up in disgust with no more words to say, they might be speechless with rage or so worn out trying to get over the mountain that they slump to the ground, but they will stop for a reason and start again when another reason asserts itself.

Even the Roadrunner cartoon has its beats defined by the necessity of the action, rather than just as a pause to allow for laughter. In *To Beep or not to Beep* (1963, Chuck Jones), the Coyote is startled by the Roadrunner into

leaping up and smashing his head through an overhanging rock. The next shot is a high angle looking down on his head poking out of the overhang, and his expression is the only thing that changes, but in that static moment, he goes through a range of emotions that register pain, disappointment, anger, and the birth of a cunning plan. He makes a transition from defeat to defiance that gets him back on the search for victory and takes the story forward again. So, although we might argue that the Coyote is an entirely predictable character, never changing in his single-minded pursuit of the Roadrunner, the ability to see his thought processes seems to give him an added dimension that makes him more sympathetic and engaging. It is as if we could see how hopelessly trapped he is in this quest and how he knows it too.

If a character is angry, her rant may run up against the simple fact that she has made the object of her anger cry. She has to pause, something in her is touched and she has to rethink, to come up with a new action to change the situation. In the example above, the older man who has been acting as the younger character's father realizes that the time has come to tell the truth. He may or may not have rehearsed this moment in his mind many times but now he has to deliver the speech he is caught off guard and he pauses, uncertain of how to start. Whatever it is, the reason for the pause is in the action that leads up to it and the end of it comes when something forces speech or the resumption of action, the woman has to try to stem the flow of tears or the child's false assumption of his real father's identity forces the previous father figure to speak out.

In the BBC TV adaptation of Dickens' *Great Expectations* (2011, Brian Kirk), there is a wonderful example of a pause that is truly significant and informs everything that is to come. Young Pip (Oscar Kennedy) encounters the escaped convict Magwitch (Ray Winston) on the Kent marshes. Magwitch, a hulking brute covered in mud and blood, sends the boy to steal a file from his uncle, the blacksmith, threatening him with all manner of harm if he informs on him. Pip returns with the file and Magwitch starts to work on his fetters, expecting the boy to leave, but Pip pulls out of his pocket a piece of pie he has also taken and offers it to the convict. Magwitch just stares at him. And in that stare, the whole of the story turns and, though we do not know it yet, makes off in a different direction. In that pause, Ray Winston shows what a great actor he is as his thought processes are written on his face; though his expression hardly seems to change, we see his shock at the fact that he has been treated with kindness, though he has not been kind. We see his worldview start to change, the humanity he has lost to a world of crime, and punishment is revealed still to be there, deep within him. All without a word being spoken. Later, when he is recaptured, this moment is all that is needed to explain why he does not tell the soldiers that Pip brought him the file and why he confesses to the theft of the pie so that Pip is not blamed.

It is a wonderful moment and really highlights the greatest advantage of the use of silence and stillness, the ability to reveal the mind of a character. This

is where the concept of autonomy comes in again; we can see the thoughts going through the mind of the character but we are not privy to all of them, or we see the process but have to wait to find out what decision has been made. This means the character appears to know more than we do and, because we are human and empathetic, we can credit another being with the power of independent thought and therefore, life.

We might hope to reach the kind of acting that we see in "Great Expectations" in a feature film context, but we can keep it in mind even if we are working on a limited budget or scale. It costs nothing to add in a moment of stillness that transforms the drama but it does require the ability to empathize with how the character is feeling at any given moment and express that on screen in whatever animation technique you are using. This is where the ability to pose a character well is important and the study of body language is essential to make that pose work. The interesting question then is, how do you come out of that pose to suggest that something has changed in the moment of stillness? If, for example, the villain has been brought up short by some revelation, then decides that to give in to this new idea would be weak, and he will go back to his previous intention, he will still need to reset himself. The character is in possession of new information and cannot now act as if he were ignorant of it. His body language will now be a negation of what he knows to be true so perhaps he fights with more ferocity since he is fighting himself as well as the hero, or perhaps he has decided that he is doomed now and it is too late to change his fate so he fights with a grim resignation. However it goes, the silence is made meaningful by what is on either side of it as well as what goes on within it.

As we have noted above, animated films often feature a single character acting out a role that brings him into contact with objects rather than other people. In fact, although we know them as Roadrunner cartoons, the films featuring the fleety fowl should perhaps be better known as Coyote cartoons since we spend most of our time with him as he tries to get yet another one of his Acme purchases working. In these situations, the Roadrunner is often no more than a blur of dust and a cheery "Meep, Meep."

In these situations, the moment of silence or stillness will be brought about by an internal realization and not by someone else. But in many cases, we are working with more than one character, and this leads us on to the question of how to deal with secondary and background characters.

We have already dealt with the way one character needs to listen to another and the need for every character to be playing some kind of action or intention within Body Language, but here we need to look at the contribution others make to the effect of silence.

Say we were animating the extract from "Great Expectations" referred to above. We have the tableau of Magwitch stock still, brought up short by an unexpected act of kindness, but also Pip holding out the slice of pie and anticipating that the convict will take it from him. Since it is the effect of this action on Magwitch that we are most interested in, we do not want Pip to be

doing anything that will divert attention from him, but we have to judge the extent of this pause and how much we can do before we need to bring it to an end. And we need a natural end that will bring us back to the present reality of mud and iron fetters. Pip's, "Don't you want it then?", becomes the simple, prosaic way in which the tension is broken, allowing a hungry Magwitch to come back to himself and grab the pie.

The moment of stillness of one character may be enhanced by the activity of other characters in a scene, creating the opposite of what we usually find when our eye is drawn to activity. This can make for very powerful storytelling, but we have to choreograph the scene carefully in order to focus the viewer's eye on the thing we want them to see. It is always the case that motion will attract the attention of a viewer, but it is also true that the eye is drawn to areas of contrast and a thing that stands out by virtue of the fact it is different, whether that be a difference of tone, form, color, or motion.

So while a good strong pose is important in all animation, it is particularly important here since it will be the solidity of the pose that registers amid the surrounding action.

The motion against which you have set up the contrast also has a role to play in making sure that we are looking in the right place. What needs to happen is that the action has to become de-individuated, that is, it has to stop looking like individual actions that we want to look at and become something like a moving mass that has no focal point to lead the eye. So repetition is useful, which can be cycles where appropriate, color contrasts are toned down, the individuality of the surrounding characters is de-emphasized and the framing of the shot is designed to lead the eye to the character we want to focus on.

Reflex and Other Physical Reactions

Although we have talked a lot about the concept of characters being seen to think, and the importance of giving them motivation, needs, and wants, not all actions come out of conscious thought or volition; some reactions are built in and bypass the conscious mind. Stick your hand on a pin and you don't have to think about moving your hand away, before you can understand that you have been hurt, your hand will have moved. It used to be thought that a signal from the hurt would have to travel all the way to the brain in order for it to send back a signal to make the hand move away but we now understand that the signal from the sensory neuron goes no further than the spinal cord. There it crosses the synapse to the motor neuron and comes back to cause a muscle contraction that moves the hand away. The sense of pain comes a moment later because the signal that triggers the sense of pain does have to go all the way to the brain to be processed.

One thing to remember when animating a reflex action is that, although the hurt may be in the hand, for example, it is not only the hand that moves, the reaction spreads out through the body. In particular, when a person is

walking and steps on a tack or a sharp stone, if he only responded by lifting the injured leg, he would probably fall flat on his face. Not only is there a need to signal the leg to stop moving down and to move away from the hurt, but also other signals need to tell the rest of the body to rebalance the weight. Even in the case of small pains, there will be a tremor within the rest of the frame, an almost sympathetic action from the other members, so that if the right hand reacts to a heat source and pulls back, the shoulders may come up and the other hand may do a similar action—only later. The initial, reflex action is coming straight from the spine, the other, sympathetic action is, like the expression of pain in the face, coming from the brain's reaction to the pain and is going to be a secondary action.

This is where thought comes back into the equation since we still need to see that a reflex response is followed up with a sense of the character's reaction to the hurt and that the reaction is a function of his personality. So it might be that the big, tough gangster character still reacts reflexively when he touches the muzzle of his still hot gun but that, perhaps due to a higher pain threshold, the reaction is not so great as we might expect, and particularly, he will minimize his secondary reaction to the actual pain. In pulling in the reflex or holding down any secondary action that might normally follow it, he could be trying to show that he is a hard man or make sure that he doesn't lose status in the eyes of those around him.

In fact there is a scene of exactly this sort in *Lawrence of Arabia* directed by David Lean (UK, Columbia Pictures, 1962), where screenwriter Robert Bolt establishes the plot and theme of the movie and the character of T. E. Lawrence (Peter O'Toole) in an early scene. Set during the First World War in the Arabian Peninsula where the British are fighting the Germany's Turkish allies, Lawrence, one of the few Englishmen who can understand the region, is sidelined making maps, until the call comes to send him into the desert to recruit the Bedouin tribes. In the map room, he snuffs out a match by pinching it slowly without any sign of a painful reaction. When a corporal tries it and reflexively starts from the pain, the corporal indignantly declares that "It damn well 'urts." and wants to know the trick. The trick, Lawrence tells him, "is not minding if it hurts."

Lawrence's ability to overcome the reflex response and the pain that accompanies the burn is indicative of his willpower, a will that allows him to accomplish great feats and, incidentally, shows off the exhibitionist and, possibly, masochistic side of his character.

As an aside, I remember contributors to the letters page of Action Comics, in issues I had as a boy, spending much time debating whether Superman could actually feel anything at all if he was the "Man of Steel" and if this meant he couldn't react to anything. If you want to pursue this line, the question has lots of implications for action and character. How would Superman, in his Clark Kent disguise, notice that he'd put his hand down on a hotplate if he couldn't feel anything? I imagine that his super-speed could be used to create

the impression of a reflex before anybody noticed he hadn't had one, as long as he had some way of finding out that he was overheating. The answer that the letters editor came up with was that the nerves that control pain reactions were different to the ones that detect pleasurable sensations and therefore he could have one and be able to kiss Lois without pushing his face through hers, and not the other, so he didn't feel the impact of the bullets the hoods were firing at him.

We often deal with extraordinary characters in animation and, certainly for me, part of the fun comes in working out how the differences in their construction or abilities impact on the performances they give.

Of course, when dealing with humor, the reflex reaction is often superseded by the needs of the gag and a character will often touch a hot surface and fail to react for a beat or stand on a nail and build up a head of steam before blowing his top.

The exaggerated take that we so love in the Warner and MGM cartoons and, in later years, cartoons like *Ren and Stimpy* look very much like reflex reactions due to the speed at which they take place, but they are, in fact, the opposite. There is always a quantity of thought going on in these reactions because it is funnier to see the moment of stillness before the reaction that makes the reaction stronger by its presence.

The great progenitor of the extreme cartoon "take" and the kind of physical gag that causes a character to fly to pieces or squash into a cube is, of course, Tex Avery and his playful manhandling of cartoon conventions takes performance into areas of lunacy that have rarely been equaled. As we noted in Chapter 2, "Types of Performance" the heroes of Avery's films become the very signs of the emotions they are displaying and this type of humor is a perennial favorite of the animator who likes to really take things to extremes.

The question of how far this can go and how many of the basic principles of animation we have to conform to is an interesting one. For some, there are no limits to what can be done and the character's body can change in any way, for others there has to be something that remains constant to give the character what Chuck Jones calls "anatomy." I don't want to be dogmatic on this issue, but it does seem as if the character stops being a character unless it retains at least one element we can recognize, which, in most cases, will be mass. Notice how, no matter how extreme the distortion of form gets, a character in one of these extreme takes will retain its body mass so that it may stretch out but it will get very thin at the same time. The particular physics of the cartoon will change the nature of the body's materials so that it obeys the laws that might apply to rubber rather than flesh. The secret is that, once you have chosen the kind of laws under which your creation will work, you have to stick to them. Even John Kricfalusi, who likes to push things as far as he can, is convinced of the benefit of an "internal logic" for characters and the importance of learning the fundamentals of animation so that you can then use "controlled abstraction rather than arbitrary unbalanced distortion."

Reflex actions are a result of external force acting on the body and represent the body's non-intentional ways of dealing with them. In the case of the hot iron or the sharp stone, the character will recoil or step off the stone, but what about those cases in which the body's reactions can have no real bearing on the force ranged against it? I'm thinking here of the larger, more powerful actions of a tidal wave or an explosion where it isn't possible for the character's reactions to have any effect on the force that overwhelms him. In animation, this is as much a matter of performance as any other character actions, and the way the way the body moves has to be animated just as well as if the character were standing talking. In live action too, many of these moves have an acted component; after all, nobody is really getting shot in all those crime movies. The difference is that many of the things we see are really happening or there is a physical trick being employed to make things look real, for example, when a tank of water is emptied into the set to simulate the ship sinking or a rope is tied to a harness worn by the performer so that he can be pulled off his feet when apparently hit by bullets. In these cases, there isn't much acting needed, in fact the bullet and rope trick is done so that the performer doesn't have to act being hit by bullets, which would require him to push himself off the ground using his leg muscles and would look rather fake.

Until recently, we didn't have any outside forces we could apply to a character to, for example, knock her off her feet or sweep her away in a tsunami. In CG animation, it is now possible to apply dynamic forces to the body of a virtual actor that will then act in the same way as a real body. After that the animator can take over and add the touches of acting that might happen after the initial wave had hit. From being thrown off her feet and pushed along in a realistic way, the animator can then have the character start to try to bring her motion under control or, if that is what the story needs, to have her start to panic and thrash around. The performance in the early stages is under the control of the computer but can obviously be tweaked by the animator to create the best possible effect.

In other types of animation, it is still the case that we have to animate these things in the same way we have to animate characters talking or walking around, and we have to judge the best way to create a real feeling of the irresistible force that hits them.

What is happening in all these cases, whether created by the animator or some software, is that a character that, in acting terms, is playing an action, is hit by a force that overwhelms them and stops that action. So it can be someone standing chatting in the street who is hit by a sniper or a person running from the approaching tidal wave, but there is a change that negates what has gone before. What remains is still performance but of a different kind since it doesn't include what we might think of as acting; it is much more to do with elemental physical forces acting on a person rather than a person acting on the world. What remains in this scenario is the character's body and the way it is designed; it may lose a sense of its weight under water but its mass and the way its limbs are connected will remain. Or, being hit by a bullet,

it may lose the power to stand but it will retain the weight that will carry it to the ground. This is also partly the case where a character is being thrown around in a moving vehicle. There will be an involuntary component to the motion as the body is jolted about and a voluntary one as the character tries to keep on an even keel.

As ever, the important thing is to understand your character not, in this case, from a psychological point of view but from a physical one. You need to fully understand how she is constructed, how flexible she is, how heavy she is, in order to know what will happen to her when she encounters the external force.

Understanding the character's physical construction is also important when looking at that other order of involuntary actions, ones that come from inside the body, like sneezing or shivering. We all know how hard it is to prevent a sneeze that wants to get out or how short a warning we get when one is about to occur; it's like something else has taken over part of our body and, though we can reach for a handkerchief, we aren't going to be able to stop it. Sneezes can be extremely violent and can really shake the body around, which is where the necessity of understanding construction comes in, as they can be like an explosion that sends out a shock wave from the center of the body into the extremities, with lots of secondary actions happening in the arms and legs. A thin character can look like he is about to fly apart in a violent sneeze but an obese character sneezing could look like the shock waves of an earthquake were rippling through his flesh.

For comedy purposes, the sneeze is goldmine and we've often seen a character hiding behind a crate in a dusty warehouse as he spies on the bad guy, trying in vain to hold back a sneeze, but we could also consider how the way a character sneezes can be funny. If the demure little old lady has a sneeze that could knock over an elephant, or the muscular heavy has the daintiest of sneezes (and a tiny pocket handkerchief), we can get a lot of amusement out of the contrast. Once again, the way in which a character copes with an involuntary action can tell us a lot about who they are.

Shivering is interesting, in that it can be quick action that occurs once, as in an involuntary shiver at the thought of something eerie or disturbing, or a smaller but still rapid action that keeps on going, as when we are cold. In both cases, there is a tension that attempts to compress the body into as small an area as possible, that pulls the arms in to the sides and brings the shoulders up. Acting here has to go on against the natural tendency of the body to want to stop in order to conserve heat; there will be a tension between the mind and the body that needs to be acknowledged and worked through.

Comedy Performance

In Chapter 2, Types of Performance, we talked about the need to approach comedy in the same way as any other performance and not to step outside the role just to get a laugh. It is vital that the animator, just like an actor,

believes in a role and is determined to play it straight. The characters in a comedy are just as motivated and driven as any in a dramatic scenario and they may be engaged on projects that are as serious and dramatic, not to say dark and criminal as any tragedy or gangster film.

The Ladykillers: Bank robbers holed up in a boarding house decide they have to kill their sweet old landlady before she can tell the cops; *Raising Arizona'* A childless couple steal a baby from a family that has quintuplets; *Despicable Me*: A criminal genius wants to steal the moon and uses a trio of orphans as pawns in his game. All potentially dark and serious and all, in fact, played seriously, as comedy.

The characters all believe in what they are doing and often the laughter comes out of the discrepancy between the character's sense of himself and his actual abilities, or his intentions and the results of his efforts, but he is never playing at being the character.

Humor is notoriously difficult to pin down and what feels funny at one time may lose its sparkle at another; a joke can sometimes be smothered by too much input from others or lost due to repetition. It is essential to hold on to the "meat" of the comedy and not let that get lost. It is tempting, when a joke has been around for a while and you have been working steadily on it, to start to add embellishments because it has lost its element of surprise. But if it worked once, it is worth having the confidence to think it will work again; go back to the origin and look at the characterization and ask yourself, is this believable?

It is strange how often people doing comedy (and sometimes other genres, like the crime thriller) will allow their characters to become rather clichéd, in a way they would not in a dramatic piece. Where a character in a tragedy will have an elaborate backstory, a comedy character will often have to get by as a cipher and a coat hanger for the jokes. Clichés are sometimes useful for their recognition factor but even so you need to make them your own by finding a new way to take the characterization or the situation. By starting out with what looks like a cliché and then doing the unexpected, you guarantee that the audience will sit up and take notice and will become more involved in what you are doing. Chuck Jones always felt that what he was doing with Bugs Bunny, Daffy Duck, and the others was creating a personality, rather than a stand-up comedian whose job was to crack jokes. Over a series of films, he and his team developed those personalities so that they were not imitations of other characters or people but brought them to life in a way that makes them real stars of the screen. So much so that audiences are unhappy if they are used in ways that seem contrary to their nature and will dislike films that feature an untypical performance.

Summary

A study of body language will help you create characters that move in a way that is particular to them and that grows out of their inner feelings. Even if

characters are very similar in design, an understanding of who they are inside and the way in which that comes out in their bodily attitudes will help make them more rounded and more real.

We should be able to see that characters who are doing the same action are not doing it in the same way and from their differences understand who they are. By giving them their own repertoire of gestures, you help create their personality.

Characters need to be able to interact; it is by playing off each other, by responding to each other, and by listening that they come alive.

The physicality of a character comes from the effort they put into each action; they need to be solid and believable, but effort is driven by motivation and motivation will change the nature of an action.

Silence and pauses are just as important as sound and movement. Movement, like music, needs pacing and rhythm, accents, and pauses in order to let it read. As Pete Lord says (Interviews), animation is an art of simplification and exaggeration; let the action read.

Reflex actions are non-intentional and are driven by internal forces we can't control. What is important for performance, however, is what comes after, how the character's reaction to the stimulus reveals facets of his personality.

Comedy is not about the animation, it's about the joke. If you can get the gag over with the minimum of movement, do that rather than over animate and kill it with the embellishments. As long as the action does not run counter to the personality you have created for the character, you can do as much or as little as is needed.

Scene Composition

In this chapter, we will be taking a look at the way in which the various elements of an animated film come together in order to create a coherent whole. We will take a look at the manner in which some aspects of preproduction and production, such as animating and editing, may impact and shape the acting and performance within animation.

The way in which a film narrative is devised and constructed, the manner in which it is divided and structured into separate sequences and scenes, and the way in which, in their turn, the individual shots are planned, staged, filmed, and then finally put together within the edit suite determine and establishe the nature of the overall storytelling. Not only that, but to a large degree it influences the manner in which an animated performance is approached and determines the type and range of animation/acting that is suitable for that particular narrative.

Given that the film's structure has such far-reaching implications for all elements of the storytelling, it is difficult to overestimate the importance of good planning and communication between those individuals, directors, producers, and writers who have an overall vision for the story and those who have the responsibility within the production process. Much can be lost between concept and production. If the director is to get the performance, she requires from the characters it is necessary for the animators to understand fully the performance that is required of them. They need to be well informed and well prepared. This involves utilizing the skills and expertise of a range of individuals not just within the production crew but those involved in concept.

An animated performance begins long before the animator gets to work on the project and there are many stages within the production pipeline that need to be successfully concluded before a single frame of video is shot. Exactly where and when a performance begins is an interesting idea to explore. No doubt for some, perhaps for most films, this process begins with the script and will vary depending on the nature of the story. The composition of the story, through the script, will determine the manner in which it is ultimately played out on screen. I would like to suggest that while many changes will be made along the way, it is the script that provides the first composition of the story *and* the first tentative composition of the scenes.

For an animator having to deal with turning in a believable performance through their acting skills and with a range of characters, scene composition

becomes of paramount importance. This element, along with many of the other creative and practical decisions regarding the film, will have already been made for them. However, it is the way in which a scene is composed; how it is lit and from which angle it is shot, the nature of the shot, and the cinematography that are critical in the telling of a story and to the acting. The way all the scene elements come together and are seen and heard in relationship to one another creates the mood, contextualizes the action, and creates the environment in which the performance can be built. It is not just the story, it is the manner in which the story is told through scene composition, which structures the story *telling* that forms the basis on which the performance is delivered. All of these present a very distinctive and highly creative "voice," one that is often instantly recognizable as the work of a particular director. On the other hand, if this is not done well, the results may be rather prosaic and formulaic.

The ways in which stories are visualized vary a great deal, with different approaches to visualization being more appropriate for different kinds of stories and different genres of filmmaking; horror, comedy, westerns, drama, sci-fi, etc. The rather spectacular shots of bathing beauties in an escapist film such as *Gold Digger's of 1933* (1933) choreographed by Busby Berkeley, or the magnificent way in which John Ford depicted features of the great American wild west, such as Monument Valley, in a string of Westerns, is not only testament to the individuality of the creative voice but also the appropriateness of the visualization to these particular subjects. Many animators have developed their own distinctive voice that is reflected in the way in which they compose their films. The films of Jan Svankmajer possess a distinctiveness that is almost instantly recognizable in the way in which they are composed. His choice of shots, including the use of extreme close-ups, his use of editing, sound design, and even, to some degree, his use of animation timing make them unique.

FIG. 7.1 The way a story is visualized should be appropriate for both the narrative and the audience. The genre of film and the animation sector the project sits within and even the age of the audience will determine how a project is developed visually.

FIG. 7.2 The visualization of narrative using traditional graphic techniques probably allows for the widest range of styling. The earliest examples of animation were created using drawings, and to this day, the charm, appeal, and sheer beauty of the drawn and painted mark continue to attract audiences of all ages. Used for high-end feature film animation and the simplest of children's animation and everything in between drawn animation is increasing being made utilizing computer technology. With access to drawing programs on tablet and handheld devices on the increase drawn animation continues to have a bright future.

Planning a Scene

The planning of a scene or a shot, particularly one that involves multiple characters, can be likened to choreography. The shot will have a dynamic of its own that reflects the nature of the narrative at that juncture on the timeline. Each shot sits next to its neighbors creating a time-based journey through the storyline; sometimes, this may be smooth flowing and sometimes it will be discordant and jarring, but it is this juxtaposition of shots and scenes that creates the structure and pacing of the film. The individual shot or scene needs to be planned if this overview of the narrative flow is to make its way through to the acting. Good planning through the storyboard, animatic, and layouts ensures that this happens and allows the animator to concentrate on the acting and performance and get the most out of a scene.

Planning a scene and its performance does not happen at a single specific moment within the production pipeline. It runs throughout the entire

production process though naturally enough there are points within the process when planning a scene takes on a more significant role.

It would seem obvious that most of the answers to the performance and acting lie within the script. Obviously, the other production processes and stages within production pipeline build upon the script and preproduction development and little by little draw out the latent performance within the script.

Rather than feeling constrained by all of this planning, it should provide the animators with a structure for the sequence within which they can concentrate on the acting within an established context. The planning should provide information from which they can gain a very clear understanding of the things that happen, when they happen, who these things happen to, who is in the shot and who isn't, who is speaking and to whom, what are they saying, and why they are saying it. Relying on this type of planning, the animator is liberated to concentrate on the issue in hand, acting.

The mechanics of scene composition and performance is achieved through a range of different processes and documents such as the storyboard, the animatic, layouts, dope sheets, and bar charts. We shall cover them here in brief, though for detailed information on their use you should look at the other relevant texts that cover production. There are plenty to choose from.

Storyboards

Storyboards are often the first point within the production process where the script takes on a visual life of its own. Yes, the storyboard will usually be preceded by the creation of concept art and often by character designs, but while both concept art and character designs explore the visual language of the film, it is the storyboard that concentrates on the story and the manner in which it is told. It is at this point that the script begins to come *visually* alive on its journey from the page onto the screen; it is at this point that the first glimmer of a performance and acting may be glimpsed.

A story can be told in a thousand different ways and a film can be shot in just as many ways, each one of them is likely to give the original story a particular spin or flavor. This is where the art of the director as storyteller comes to the fore, it is the point where the voice of the director can be heard and the eye of the cinematographer can be seen. Through the medium of the storyboard, the distinctive creative approach of the filmmaker becomes evident.

Storyboards may be usefully divided into three different categories or types, each with their own distinct purposes. These are thumbnail or rough storyboards, presentation storyboards, and working storyboards. Let's take a look at each in turn.

FILM: SCENE:

SHOT: SHOT: SHOT:

SHOT: SHOT: SHOT:

PAGE:

FIG. 7.3 Though they may vary greatly depending on the nature of the project, it is through the storyboard that a story is explored as a visualized sequential narrative.

Thumbnail or Rough Storyboards

Thumbnail storyboards are usually drawn up as a way of visualizing the action of the story in very quick order. The intention at this stage of production is to explore ideas and test various cinematic (and performance) options. If you allow yourself to get bogged down with making beautifully rendered drawings at this stage, you will never be able to keep up with the pace at which ideas can be generated. The nature of the rough board concentrates on the idea and *not* on the detailed drawings or the inclusion of technical information. There is also the possibility that the level of investment made in drawing beautifully detailed drawings for an initial storyboarding means one becomes reluctant to throw out bad ideas and unsuitable shots simply because too much time (as it seems) has been invested in making these drawings. Keeping the drawing simple at this stage means you are more likely to be open to the possibilities of making changes, altering the sequence, discarding bad ideas, and replacing inappropriate shots with more appropriate ones. It is vital to keep your ideas fresh and lively at this stage.

The storyboard will always be worked up from this point to a point where it is in a more presentable state for a client or producer and is of more practical use to a production crew. The thumbnail storyboard may be drawn up in a single color and I generally rough out my boards on A4 paper either using dark blue Col-erase animation pencils or I will use a pen (which stops me from being tempted to making alterations on top of the drawings). At this point, there may be little by way of technical information and I limit myself to arrows that denote any camera moves I intend. The use of post-it notes for individual storyboard panels is a good idea as they can be stuck onto a wall or flat surface and be moved around quickly to give alternative sequences of shots. Remember the rough storyboard is for your eyes only. Once you are happy with the way the sequences are working, you can then start to create other storyboards with more detail.

FIG. 7.4 The focus is on idea development in thumbnail storyboards, not drawing quality.

Presentation Storyboards

A presentation storyboard presents the visualization of the narrative for approval by a client, producer, or others with a vested interest in the production. They are created to show off the project at the preproduction

stage, to gain approval for the ongoing development of the project, and to gain approval and clearance for progression to the next stage in production. Perhaps, the most important role the presentation board has to play in the production is to secure production funding to allow the production team to start their work. Naturally there is much still to develop in terms of performance but much can be gained at this point with the producers receiving useful feedback that more often than not ensures the ongoing creative development of the project. This may result in a much clearer idea of the storytelling aspect of the project, which in turn starts to shape the animation performances that will be undertaken a little further down the pipeline.

There is usually little technical information included at this presentation stage as the purpose is to check the validity of the visualization of the idea. It is presumed that most production details will be dealt with during the later stages of production. The script, in all likelihood, will have already received approval before the presentation of a storyboard, and this next stage in the process is simply to assess the creative viability and suitability of the project and gain an idea of what the finished thing will look like.

On a practical level, the number of panels used in a presentation storyboard may be rather limited at this stage as it is only a general impression that is sought and not a detailed breakdown of the actual content and movement within each of the shots. While the technical detail may be missing, the standard of the visuals is an important aspect of the presentation. It is often the visual element that will sell the idea. While the standard of drawing for thumbnail storyboards may have been of secondary importance, the standard of draughtsmanship and the quality of the images for presentation boards are much more important. Color is often a key factor at this stage, and while drawings are used to illustrate actions that may be undertaken by puppets, CG models, live action, or a combination of all three in the final animation, it is useful to create a presentation storyboard that is as close to the final film as possible. The clearer the idea of the finished item you can present the better for all concerned.

Animation is a very expensive and time-consuming process, and while it is not possible to eradicate *all* errors from the production process, it is vital that as many mistakes as possible are avoided before the animation begins. Client approval of the project at this stage by signing off the presentation storyboard is a key moment within the production pipeline. Once approval has been given, it may become an expensive and often painful process to make changes during production.

Working Storyboards

This is the term given to those storyboards that are used by members of the production team during the actual production of the film. These may also be known as production storyboards. Their purpose is to give all the

FIG. 7.5 The standard of drawings for presentation storyboards needs to reflect the production standards of the finished project and replicate as closely as possible the look of the finished film.

members of the production crew the appropriate and correct information they need during production including technical information, direction, notes on sound, including dialogue and perhaps music, and they provide a visual representation of the action within the shots.

I would like to take this opportunity to sound a cautionary note here and encourage you to take great care when drawing up working storyboards and the way in which you compose a scene as any mistakes made at this stage can be rather costly further down the line. I have found this out to my own costs. Many years ago, I worked as a storyboard artist on a production of the then popular children's TV series *The Shoe People*. The first series had been created within a single studio in south Wales and any errors within production were kept to a minimum because queries could be dealt with simply, quickly, and more importantly cheaply. However, for the second series, all the animation was done in China. My storyboards would be shipped to China along with the animatic and the other necessary elements of preproduction. A robust production pipeline was in place, and on the face of it, the process was all quite straightforward. However, the director and I had failed to take into account the cultural differences in the way in which

storyboard images are read and the different traditions and experience in animation production.

One of the sequences I was storyboarding involved a character coming under attack by a swarm of very angry bees. I tried to explain the shot using a number of panels that I thought illustrated the scene quite well. In the first panel of the shot, the character could be seen standing in his garden simply enjoying the sunshine; the second panel showed the character reacting to a noise off shot and turning his head to look over his shoulder in the direction of this noise. The third panel illustrated the fear on the face of the character as he realized that this swarm of angry bees were heading his way. All well and good so far, it was on the final panel of the sequence where I made my mistake. What was *intended* was to illustrate the character flailing his arms over his head in an effort to ward off his attackers. In order to do this, in an efficient and what I mistakenly took to be an effective manner, I drew the character with his arms appearing in multiple forms in the air complete with whiz lines to indicate that he was waving his arms in a vigorous and rapid manner. It all looked good to me and incidentally to the director who checked it before shipping to China.

What we got back was not what either of us had expected. Instead of a frantic and panicked action of a character waving his *two* arms above his head, we were treated to a character with *four additional arms* (three on each side of his body complete with whiz lines) that suddenly appeared as if by magic and waved gently to and fro. It looked like a multiarmed Indian god. There was nothing else for it but to reanimate, repaint (this was in the days of acetate and paint and trace departments), and reshoot, a very expensive mistake.

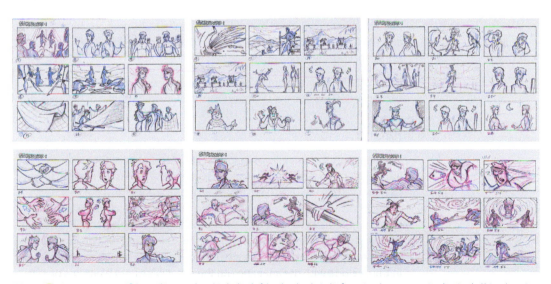

FIG. 7.6 The important aspect of the working storyboard is the level of detail and technical information that accompanies the visuals. Using these, in conjunction with other preproduction material such as character design sheets and layouts, even a large animation crew is able to produce work that is consistent with the aims of the director.

The Animatic

While there can be little doubt about the importance of the storyboard within the production process, there is one aspect of the medium of film that they cannot fully represent; time. This is where the animatic, or as it is sometime referred to, the story reel, comes into its own. The role of the animatic has a vital role to play in the preproduction process of animation and goes a long way to further composing sequences and scenes and assisting animators to create a good performance. The animatic takes the entire process of story development one step further. In addition to the visual elements of the storyboard, the animatic gives the opportunity to add two other vital ingredients to the mix: time and sound. By the relatively straightforward process of placing the storyboard on a timeline and adding sound to the mix, the story can now be experienced for the first time as an audiovisual time-based project. The process gives the project pacing allowing the production team to gain a better idea of the flow of the narrative and the dramatic dynamic within it. It is this pacing of the film and the individual sequences and scenes within it that go to make up the film and will begin to bring it to life. The addition of sound in the form of dialogue, music, and sound effects also does a great deal to build and develop the narrative.

Timing

It may be worthwhile at this point to discuss in no great detail time, timing and the use of dynamics within the medium. I have found it helpful in the past for students to get a fuller understanding of the use of time as a creative material to be used by filmmakers and animators much in the same way as a painter uses paint. It helps if we consider the possible categorization of timing and the ways in which we can use these different categories of time: pacing, phrasing, and animation timing.

Each of them deal with timing in very different ways, we shall go through each of them briefly in turn before returning to the overall subject of the animatic.

Pacing

This describes the dynamic of a film in its totality and describes the interrelationship between the various sequences. The nature of a film is that its narrative dynamic is played out across many scenes from the very first frame to the very last. It is through pacing that the drama is developed, how tension is built and how mood is established. For the most part, films consist of slow sequences and fast sequences in the action they contain, the duration of the individual shots, the manner in which the shots have been edited, and in the use of sound. At certain points, the film will be loud while at others it will be quiet. It is in the juxtaposition of these elements that pacing is created. I am not a great believer in creating rules for the creative process, but in very general terms, one can perhaps appreciate that action is best delivered

through faster pacing (shorter scenes containing faster movements), whereas emotions such as love and tenderness may be best delivered through slower pacing (longer scenes with slower movements). The way these elements are presented and changes between the different elements (sound, shot length, and action) will determine the nature of the storytelling. Put simply, pacing has everything to do with storytelling and has less to do with detailed performance within each shot. That is in the realm of phrasing.

Phrasing

This is a form of timing that can be used to describe the actions of characters and other elements within a single shot or scene. I liken the use of phrasing in animation to dance and similarly as all dance is determined by choreography that shapes it. Phrasing not only determines the variable movements and dynamics of figures but also how they move, how they are positioned within a shot or sequence of shots, and how they interact with another elements within the shot. Sometimes the figures will move quickly, sometimes they will move more slowly, and sometimes they will be at rest, not moving at all. Stillness is a vital element in creating an animated performance as movement. It is not the speed of the movement that determines a performance it is the *variations* between the speeds of the different movements that creates the performance. The shift of mood and temperament and the dramatic actions are planned for within the animatic and executed at the animation stage. In this way, movements come together in a meaningful way to create performance. I have written elsewhere that timing gives meaning to motion, perhaps I could extend this to say that phrasing creates performance from action. Not a very elegant term I know but I hope it gets the idea across.

Animation Timing

This is a term that may be used to describe the speed of individual animated actions either of characters or of objects. This applies equally to the movement of inanimate objects as well as the actions of animate beings. The manner in which a drop of water falls from a leaky tap, the action of wind on water, a bouncing ball, a waving flag, the throwing action of a figure, a figure standing up or sitting down, walking, running, and all of the thousands upon thousands of other actions that we see in an animated film from the most simplistic to the most elaborate and complex are created through animation timing. This is certainly not to suggest that this is simple to achieve or has no part to play in the creation of animated acting. Far from it, indeed it is the way in which the three types of timing, pacing, phrasing, and animation timing, are used that create the magic of animation.

For the moment we are discussing animatics and in doing this we are for the time being more concerned with the pacing of the film. The pacing of the film is a critically important aspect of filmic language. The duration of the individual shots, how they are cut together, the pacing of the narrative, and the relationship between sound and image come together in an edited form

that forms the basis for the rest of the production. In live action, it is easy to shoot alternative takes, and different versions of individual shots, which often result in the ratio of footage shot to that which ends up on screen, can be as much as 10:1, if not more. With such a large amount of film footage at the director's disposal, it makes the editing process an extremely creative and demanding one. However, animation is such an expensive process that editing begins at the storyboarding and animatic stage in order to ensure that the ratio is as close to 1:1 as possible. The last thing you want to be doing is making animation that doesn't end up on the screen. In this regard, editing animation scenes at the postproduction becomes akin to assembling predetermined parts that when planned and executed well come together rather like a very finely crafted jigsaw puzzle, each part dropping into place.

There are very real advantages for the animator who can make the most of this process of preproduction editing. Having a comprehensive storyboard at your disposal provides a good visual indication of the story and viewing the animatic gives a very real sense of the pacing of the film and suggests the phrasing of the action within the sequence. Even at this early stage, the scene is composed ready for the animator to begin her work. With this information at her disposal, it becomes much easier for her to make the animation timing appropriate to the dynamic of the sequence. It not only takes out all of the guesswork, but it also allows the animator to concentrate on the performance.

By getting a sense of the dynamic of shots either side of the one on which the animator is currently working, she will be in a better position to gauge the dynamic of the shot *before* commencing animation.

Preparing the Shot—Layouts

The early pioneers of animation mostly worked solo, which often included camera work, and layouts would have been rather rudimentary. However, with rising popularity of the art form and increasing demand for product, the studio system was developed to meet the demand for large volume output. The production of animation was industrialized, and specialized roles within the production team were developed. The layout artist became a critical role within the production pipeline. Because of the specific skills required of the layout artist, many of them still come from a fine art or illustration background and share many of the skills of the storyboard artist and background artist. While the industry has come a long way since those early days of the animation studio, many of the skills remain the same. Layout artists still need to have a good understanding of spatial composition for screen-based work and a grounding in cinematography and the staging of action. This needs to be balanced with specialist technical knowledge of layout and animation production, and naturally enough, they need to have an ability to draw very well in a variety of styles and using a range of media.

Before an animator is finally turned loose on a shot, there is usually a fair degree of necessary preparation of the scene that is undertaken by

different members of the production crew. Each of the shots will be set up in preparation for the animation through the use of layouts that provide more detailed information regarding the physical aspects of a scene than can be found within either the storyboard or the animatic. Originally, the term "layout" was coined to describe a process that applied to 2D classical animation though as animation has increasingly come to mean CGI this has shifted somewhat, and while the process of planning remains important, some of the tools may no longer be directly relevant to CG production. With the advent of digital 2D animation, much of what was originally undertaken using physical resources (drawings on animation paper), layouts, and scene plans is now being facilitated within the animation software itself. There are versions of digital ink and paint software available that all incorporate features that cover layouts, dope sheets, paint and paint affects, and camera facilities. While this allows for more ease of use and flexibility in how a scene is structured and shot, it does not do away with the need for planning and composition.

The source of information for creating the layouts is to be found within the storyboard and the animatic, and while the layout material for the individual scenes conforms to the visuals within both storyboard and animatic, they also contain far more detailed information for use by the animators and others within the production team. At first glance, the layout drawings resemble the panels of a storyboard, they reflect the same approach to cinematography in the way the shot is composed and framed though they give a more detailed breakdown of the separate elements within the shot and how each of them come together to form a coherent whole. This range of material will normally include a detailed layout drawing of the background rendered in great detail (usually in a single color, black or dark blue are the most likely) and illustrate the perspective and tonal values of the scenes environment. Separate elements that work as part of the scene such as overlays and underlays will also be included.

Overlays

Overlays are those, mostly nonanimated elements that form part of the environment, sometimes geographic features such as trees and rocks, sometimes manmade elements such as buildings, or if the shot is an interior one it may include furniture or some architectural feature that sits on top of the background and are dealt with independently from but in conjunction with the background. If camera moves are involved in the animation, these elements are often moved and timed independently from the background in order to create the illusion of depth including through parallax shift. This is the illusion created when one moves in relation to features within an environment that appear to move at different rates and different distances. Objects, that are closer to the observer appear to move further and faster than objects further away. The net result is that environmental features appear to shift their position in relation to one another and thereby create the illusion of screen depth.

151

Underlays

Underlays are those elements that appear behind the main background. This often includes such things as sky or space elements or very distant features that do not seem to shift (or have very minimal shift) when we move such as the moon or very distant mountains. Underlays may also include such images that may be viewed through gaps in the background such as the view seen through a window in an interior shot.

Field Guides

Part of the responsibility of the layout artist is to produce field guides. Field guides are made to work in conjunction with the layouts in order to define the screen space for that particular shot and indicate how the backgrounds and other elements are framed and seen by the audience. They indicate how the environment and the characters within it should be used by the animator for the duration of that shot. A field guide not only frames the shot but it also indicates any change in the framing that is required within the shot through camera moves such as zooms or pans. Put very simply, the layout drawings provide the composition of the shot and the field guide determines how the shot is framed and how the camera travels over or through the background or the environment.

The choice for a particular framing of a shot and the size at which the animation is produced may not only result in a more efficient production of animation but it may also determine the final results. The size of a shot is determined through the division of the screen in zones known as fields. These divisions of the screen space (either 4:3 or more commonly 16:9) are achieved through the use of a tool called a graticule. The graticule is a guide that divides the screen space into areas that conform to the same ratio as the screen size. These divisions are based on the positioning of the central point of the screen and extend outward from this point along diagonal lines to the four corners of the screen. The fields are set out in zones located at points that run along these diagonal lines and have upper and lower horizontal edges and left and right edges that run parallel to the edge of the screen. The fields themselves need not have their centers located at the center of the screen. They may appear anywhere within the screen to take advantage of a particular aspect of the background. These fields may also move and change size during the shot in order to create the necessary camera move. Figure 7.13 shows a sample field guide.

The choice of field size for any given shot is determined by both the aesthetic considerations of composition and cinematography and the practical constraints of production. Long shots or shots that contain a great deal of detail are generally composed on a large field size; not only will this allow for far more detail to be included in the shot but it makes the animators' work a lot easier particularly if dealing with drawn animation. Close-ups are generally designed to be created in smaller field sizes. This is not only more economic in terms of the animation drawing, smaller drawings *may* be quicker to producer than larger ones, but it may also make the production of those drawings a lot easier.

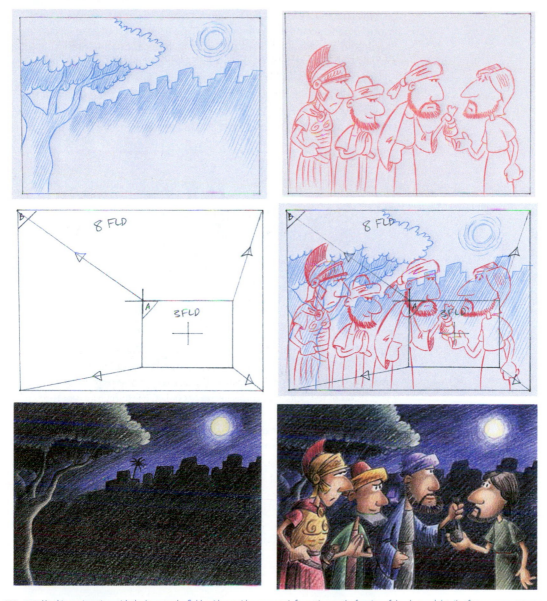

FIG. 7.7 Used in conjunction with the layouts, the field guide provides accurate information on the framing of the shot and details of any camera moves. With the advent of digital 2D, the use of traditional field guides is being superseded by animation software that includes these framing tools. However, layouts continue to offer the animator the opportunity to plan out the shot before the animation begins.

There is yet another very important use for the layout drawing other than for creating animation. Background artists use the layout drawings to produce the on-screen artwork, which include the overlay and underlay elements as well as the backgrounds themselves. Animators and background artists will more often than not work independently from one another; it therefore

becomes necessary for the backgrounds to be an *exact* transcription from layout to background as the animator will be using a layout as an accurate description of the environment and will match the animation to those layouts. Any discrepancy between the layout drawings and the finished backgrounds is likely to result in errors when the animation is shot. There is possibility that the animation may fail to sit properly within the shot. It is vital that the scene composition created by the layout artist is followed strictly by both the animator and the background artist if all of the elements are to come together

FIG. 7.8 The layout is a template for the background that the background artist must follow precisely as the animator will be using the layout as a guide in creating the animation. Any differences between the two may result in errors.

seamlessly in the final shot. Layout drawings and field guides may also include notes on the direction that include light sources, lighting direction, and the quality of the lighting as this will impact on the type of shadows produced. The last thing you want is for the animation to have shadows that do not match with the background and environment lighting; unless of course that is the effect the director is seeking in which case this should also be indicated by the layout artist.

Naturally similar processes of scene composition are useful for both stopframe and CG animation though they do not necessarily entail the same technical drawings used for drawn animation. The point of the layout process remains the same, to stage the action and ensure that the animation fits within the environment. Set design and mock-up will still comply with the original vision as established in the storyboard. The important thing here is to recognize that scene composition that includes the staging of action within the scene environment is a key element of the design process that impacts directly on the animated performance. It not only sets up the physical aspects of the scene but sets a framework within which the animation performance will be played out.

These preproduction processes are undertaken by a number of individuals, the director, storyboard artist, art director, and production designer through to the layout artist, and are intended to do one thing, that is, assist the animator in creating animated performances.

Character Layouts

In addition to the environmental and background artwork layout, artists may also be responsible for creating character layouts. These are drawings that indicate how the character appears within the shot and how the character uses the screen space throughout the duration of the shot. Character layouts give the animator a good idea of how they move within and through the shot and at what point they interact with it. Used in conjunction with the layout, they are also useful in illustrating how the characters or other animated elements use the environment and how they relate to other characters and props within the shot. They demonstrate to the animator how a character may, for example, open a door and go through it, how they may climb over a fallen tree, or wade through a stream. This kind of thing provides the animator with an idea of the staging of the action and composition of the performance, what elements it entails, and how it seen by the audience. I have covered a little more on this below.

Whereas the layout drawings compose the environment and field guides compose the shot, the character layouts compose the action. You can probably see now that these are very useful tools in creating a performance. The entire process, completely unseen by the audience, is intended to plan

out a scene or shot in line with the directors' original vision and eradicate as much as possible any errors and all of this before even a single frame of animation has been made.

Bar Charts and Dope Sheets

Additional technical information that relates to the composition and planning of individual shot and how the performance is outlined by the director is to be found within bar charts and dope sheets.

The bar chart is a document that tracks the different elements of the film in its entirety frame by frame. The bar charts provide a shot-by-shot breakdown of the entire film. It identifies the start and end point of the separate shots. The director indicates instructions on action and directing notes and also provides the location of any dialogue on the timeline. A phonetic breakdown of the dialogue is also included. The bar chart is technical transcription of the animatic, the length of the individual shots that were established in the making of the animatic is now evident in the form of a frame accurate sequence. The information for the bar chart is taken from the animatic. The bar chart in its turn provides information to be used on the dope sheets.

FIG. 7.9 A bar chart represents a timeline broken into individual frames. Space is allowed for notes on direction and for dialogue, which can then be broken down phonetically to enable lip sync.

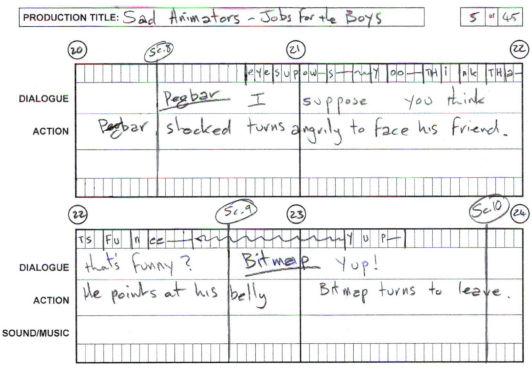

PRODUCTION TITLE: Sad Animators – Jobs for the Boys 5 of 45

FIG. 7.10 In this example of a bar chart, you can see how the start and end of the individual scenes are identified on the timeline. Other information appears on each of the individual sheets, such as production title and page number. This is good production management practice and helps to reduce the risk of errors which may be costly.

Dope sheets (also called expose sheets) were initially created for use within 2D classical animation. They not only identify the same kind of production information that is present on the bar charts, such as production title, they also provide the animator with information specific to each of the individual shots. Shot and sequence number, the name of the animator and assistant animators, and shot length through a frame count are unique to each shot. As with the bar chart, dialogue is included and a phonetic breakdown of the dialogue provided. Direction notes on action and camera instructions are also included. Most importantly, dope sheets are used by the animator to annotate and track the animation drawings and the animation timing. Digital ink and paint software has a dope sheet facility that resembles the more traditional ones and as with those traditional dope sheets enables the timing of the animation to be shifted and changed along the time line. Other 3D and digital 2D animation software has a built-in timeline that serves much the same purpose as the traditional dope sheet, the frame-by-frame tracking of animation elements that sit alongside one another in layers on a timeline.

FIG. 7.11 While the use of a traditional dope sheet has changed with the development of digital 2D animation, it is still a very useful tool for animators to plan, track, and change the animation timing as the animation is being made.

All of this information that is a result of careful planning and preparation and scene composition goes into each shot before the animator begins the task of creating a performance. Armed with the necessary material such as a storyboard and animatic that covers the relevant sequences, dope sheets, layout drawings, and field guides that cover the individual shots, the animator is all set to begin work.

Blocking Out Animation and Action

Before the finished animation is undertaken, there is yet another stage that assists in scene composition, blocking out the animation. Blocking is a term taken from theatrical stage direction and refers to a process where the positioning and movement of characters are planned and rehearsed well in advance of the actual performance of the play in order to create a coherent piece. Bringing together all the different elements, the actor's position within the environment, the position of props, the lighting sources, and sound cues are very much like the choreography of dancers. The stage direction for this process is the responsibility of the director or perhaps the animation director or lead animator. It is important for the composition of the scene that the characters are positioned throughout the shot in such a manner that the audience is directed toward those aspects of the action and the elements of the shot the director deems to be of importance and that they are seen clearly without any distraction, and the shot is read by the audience with little ambiguity, or perhaps it would be truer to say with no *unintended* ambiguity. Blocking offers the opportunity to gain an insight into the dramatic effect of the performance before the animator has undertaken the final thing.

In its simplest form, blocking entails placing the character at particular places within the environment at various points on the timeline. Used in conjunction with any camera moves, it is then possible to ascertain almost exactly what the final outcome will be. It is particularly useful to see the blocked-out animation alongside the dialogue. This will help with the creation of body sync, the eye contact between characters, and the line of sight for the audience. This is very important at this stage to synchronize the movement of the characters to one another and to the movement of the camera and any lighting effects that you have in mind. The last thing you want is to create movement that obscures from the sight of your audience any element of the shot that is important. The movement of a number of characters in shot at the same time may, if not handled well, be very distracting.

A sequence in the film *The Hunchback of Notre Dame* (1996) illustrates how a scene can remain clear and unconfused despite a multitude of elements appearing on screen together and regardless of how busy with activity the entire screen seems to be. A grand parade of fools is lead into the city square by the Harlequin figure. It is a scene alive with action of one sort or another and there is hardly a square centimeter where nothing is happening. The main

focus of the scene is the Harlequin who dances and sings his way through the sequence under a veritable snowstorm of confetti. But at no point does the attention of the audience wander from the important elements of the scene. By categorizing the animated action, it is possible to analyze how the composition of all this action makes possible a scene that remains clear.

The primary action is of the Harlequin. The parade characters represent secondary animation and are smaller in shot though all of their actions are still quite visible. They have their acting roles to play though they are *not* the focus of attention, they are doing interesting things and have their own distinctive movements and they do demonstrate variable dynamics throughout the duration of the shots. The crowd is split into two distinct categories, one animated and one still. The animated members of the crowd provide tertiary animation; they wave little flags, they wave their arms and some of them seem to dance on the spot moving to and fro. All this is undertaken through cyclical movements that are relatively short and simple; however, because there are so many of them and the actions of each cycle varies from that of their neighbors, they give the illusion of full animation. They provide the necessary background action to the entire scene, they demonstrate life without acting. Behind the active members of the crowd and in the background, there are other members of the onlookers that don't move at all, they simply provide volume. If all of the crowd had have remained still, they would have been noticeable in their stillness, by composing the action in this way the scene looks sufficiently lively without distracting from even the secondary action of the additional characters in the parade. The confetti snowstorm could also be considered as tertiary action. It falls in such volume and each piece flutters with such action as to be believable and to provide a sense of public celebration and jubilation without ever obscuring any of the action.

In 2D classical animation, the blocking of animation may be achieved through the use of key drawings to make what is termed a key pose test. A key pose test is a process in which the key drawings are made and then shot in accordance with the animation timing that is created at the same time as the key drawings. Using these timings, it is possible to place the drawings along with the background on the timeline at the very point they will appear in the finished animation. Naturally they will appear as a series of stills with no animated movement, but even at this stage, they will provide a good indication of the phrasing of the animation and the flow of action before any in between drawings are made. It is a most effective and efficient way of testing the performance before committing to the very time-consuming work of creating in-betweens and cleaning up the drawings for the final animation.

Blocking animation should be seen as one way of rehearsing for the final animation. As we have already seen rather like the stage directions in theatre, blocking-out animation will provide you with the bones of a performance,

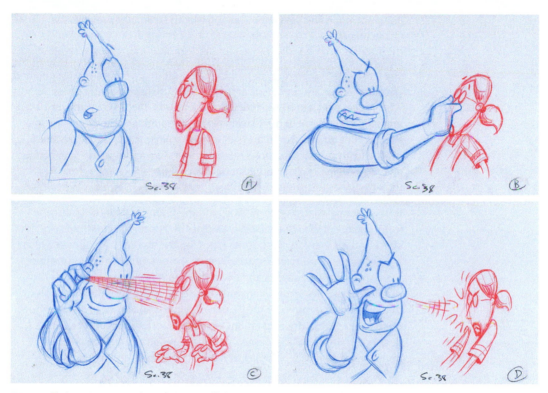

FIG. 7.12 The key pose test serves the same purpose as blocking out animation, to test the movement of characters before undertaking more time consuming animation.

establish the phrasing of a sequence, and ensure that all is well before the creation of a character performance begins in earnest.

The huge advantage that blocking animation offers the animator is the ease and economy with which you can make any adjustments and changes to the animation at this stage rather than later on when it can become a rather costly exercise. Once the animation is blocked out to your satisfaction, it is with increased confidence that you can proceed to creating more polished and refined animation. The bottom line is that blocking can save you an awful lot of time and money.

Scene Dynamics and Screen Space

Even with all of this planning, there is still plenty of scope for the animator to create a distinctive and individual performance. The way in which scene dynamics and character interaction work together create the *potential*; for performance, this is further determined by the capacity of the individual animated characters for performance and acting. This is interpreted by the animator. A performance may well start with the directions given to the

animator, but it finishes with the acting that the animator provides the characters with.

Exactly how the spatial relationships work between characters and how they share the screen space may determine the performance dynamic. Making one character dominant over another may initially be shaped by the processes we have covered, but it is not constricted by them. The art of character-based animation is in the acting, and with all the preparation in the world, the final thing comes down to the acting skills of the animator. It is *not* a mechanical process with a set of prescribed rules. You will learn and develop your acting and performance skills through study and practice.

Part of this study will be to explore what the screen offers in terms of space. It has potential that extends well beyond the boundaries of the landscape format shape of the screen itself, regardless of its size. The creative use of this space and the way it is composited is not limited to a flat surface over which images move. While screen space offers us the potential for demonstrating extreme depth with objects and environments viewed over immense distances, naturally, many animators choose to work within the flat plane of the screen and some use the illusion of flatness and artificial depth to great effect. Size and aspect rations are also important. The IMAX cinemas depend on the use of the viewer's peripheral vision in the creation of an immersive experience. This may be marvelous for showing off huge and spectacular subjects like the Grand Canyon or journeys in space but not so good for dealing with intimate shots involving close-ups of faces and the like. Similarly films created for projection in astronomical domes offer potential for immersion but as a medium for drama they are so well suited. At the other end of the scale, handheld devices cannot really do full justice to those vast landscape subjects.

FIG. 7.13 Many animated films exploit the potential of screen depth despite the flatness of the screen on which it appears. The advent of virtual reality simulators that incorporate 3D filmmaking with dynamic motion synchronized seating has allowed for a more immersive experience. Using CG-generated environments, the audience not only sees these huge spaces but can enjoy the illusion of travelling through these spaces. The screen has been shattered and the illusion of great depth achieved.

FIG. 7.14 There are plenty of examples of animation that have been made purposely to emphasize the flatness of the screen.

Considering the screen as a single plane may also have its limitations. By fracturing the screen into different zones and using different shapes within the screen, it is possible to not only breaking free of the constraints of the single frame but also of the single viewpoint. Some of the short films of Zbigniev Rybczynski (*Tango* 1970) and Paul Driessen (*On Land, at Sea and in the Air* 1980) are perfect examples of how screen space can be used in an interesting way, to tell a story from different viewpoint simultaneously, to fracture a storyline, and to present alternative views. By using interiors, exteriors, intimate spaces, and wide shots and using different lenses, he has managed to create a rather unique cinematic experience a very distinctive voice.

The way in which the scene is performed is to a large degree determined by the choice of shot and how it is presented on screen, from what angle it is seen and from what distance it appears to be from the camera. This not only determines the *way* a story is being told but it can change completely the story itself. Seen from different viewpoints, the story may be changed to such a degree that it is possible to telling completely different narrative. Consider for a moment an incident such as a minor traffic accident. Looked at from the perspective of the different people involved, the event could be told in very different ways. There was a commercial for the Guardian newspaper that ran in 1986 that depicted a young, rather aggressive young man seemingly running to attack a business man in the street in a completely unprovoked manner. The sequence ran for a second time from a different angle and showed that far from attacking the businessman the youth pushed him out of the way of a falling object and thereby prevented serious injury. So far from

FIG. 7.15 The aspect ratio of the screen need not be a restrictive format. The fragmentation of the screen into different zones of different sizes and shapes may provide you with the chance to tell different kinds of narratives and create different kinds of performances.

being a young thug, he turned out to be something of a hero. Same event, different viewpoints, different stories.

The use of the close-up, the long shot, and the camera moves such as tracks and pans all contribute toward creating a specific mood within a narrative and will affect the nature of the performance and acting. A good example of how the choice of shot and camera angle helps create a narrative can be seen in the work of Bill Plympton. In his short film *One of Those Days* (1988), he uses the POV (point of view) to great effect in which all of the action is seen through the eyes of the main protagonist, effectively the audience becomes that character. The only time we get to see an alternative view of the character is when he (we) look in the shaving mirror.

Rehearsing Action for Performance

We have already looked at blocking animation and as we have seen it can prove to be a very effective process, but it is only one way of rehearsing a scene and composing a performance. We are all different and choose to work in different ways, so it is up to you to explore the different ways of rehearsing your animation though I would suggest that there is more than one process you can apply.

Certainly one of the simplest and quickest ways I know of is to create thumbnail drawings of the key elements of the shot. Drawing up alternative actions as very simple poses that fall within the constraints of the shot can be done quickly, easily, and very effectively in a number of ways. I always

choose to do this with a pen on a single sheet of A4 paper. I keep the figures small and draw them up with little or no detail. Often they resemble nothing more elaborate than a stick figure. What I am looking for at this stage is body language, balance, and some kind of *suggestion* at movement. Many years ago, when I was working with the animators on the *Walking With Dinosaurs* series, I encouraged them to use this process to figure out the actions they were looking for. I would go into the studio to find little yellow post-it notes attached to practically all the desks space including the sides of the computer screens. They found it very helpful in rehearsing the actions they later achieved in CG. The beauty of this process is that you really don't have to draw that well in order to do it.

However, I believe to get a better idea of the action, how it actually feels to undertake a certain action there is little to compare with going through the actions yourself. I was once charged with the task of animating a young, powerful, rather arrogant, and very deadly princess. I was none of those things, so in order to compose my performance for her, I first turned to the storyboard and then the animatic to get a sense of the flow of the sequence. At the same time, I was listening time and again to the voice track to get the correct intonation in speech and from that an insight into the movement. This was a key character acting out a pivotal moment within the story and if she was going to be at all believable I simply had to get this right. I felt I had little option other than becoming the character in both action and speech, so I would spend a time each day over a period of about a week rehearsed her actions in front of a mirror and delivered the dialogue as I played the voice track over and over again. I suppose I did this for around a week between animating other shots that weren't so demanding until I had finally gained the necessary confidence in my performance to put pencil to paper. It paid off and I got out of the performance everything I wanted. It is perfectly possible to rehearse the performance of a character that is different in age, gender, and weight from that of your own, and with just a little imagination, it is even possible to rehearse the actions of a different species. One of the more bizarre examples of this was when a student of mine, now a highly experienced and very highly regarded director of animation, was in the position of having to animate an injured pterodactyl struggling along a beach. He rehearsed this very successfully by filming the action as he dragged himself along on crutches using these alone to support his full body weight while his legs trailed limply behind.

Summary

All of these processes and development tools are used to compose the scene before the animation begins. Much of the work carried out at this stage is never seen by the audience, unless of course the different stages such as storyboards, layouts, and backgrounds are included in the special features of the DVD or make their way onto web sites. They may be only of passing

interest to the general public but they are a source of intense study for the practitioner and they do play a vital part in getting ideas onto the screen. Far from being an unseen and therefore unnecessary part of production, they make the production process effective, efficient, and most of all they make the entire thing more economic.

Most relevant to the reader is the way in which these processes enable the animator to take movement, regardless of how elegant it already is and transform and elevate it into a performance and *that* is the difference between making animation and making a performance.

Working with Actors

In this chapter, we will be taking a look at how animators work alongside "real" actors in their efforts to gain more from their animated performance. We shall look at some of the practical considerations of working with actors and how this impacts on production. To this end, we will go on to explore the differences and similarities in the disciplines of live-action and animated acting and performance and look at how technology is being used to create an emerging new form of animated actor.

It has usually been the case that working with actors in animation has involved recording them to provide voices for our characters, and this is still the way that animators and directors most often engage with actors. (I'm taking it for granted that, by now, we are considering ourselves as actors of a kind, when we produce an animated performance, but here I will refer to actors in the same way that the general public see them.)

Sometimes we are asked to combine live action of an actor's performance with animation and this is something that is very prevalent in the world of advertising, whether it be cartoon characters interacting with kids in a breakfast cereal commercial or a drawn man creating a car out of a cardboard box, but it has been part of animation history since the early days of cinema. The "novelty" films Charles R. Burroughs c.1920, featured animated elements within live-action film, though these early, proto-animation techniques had been exploited by Georges Melies' 'trick film' as early as 1896. live-action characters featured within animation in one of Walt Disney's early successes, *Alice in Cartoonland*, in the 1920s and have become common since then.

It is also becoming more and more common that we have the opportunity to use actors in a motion capture studio to create a character performance. This section will look at working with actors in the sound studio, on set, and on the motion capture stage and how to help them create the kind of performance we need for our project.

To start out, I have to admit it; I'm a bit in awe of actors. Obviously not when they are pretending to be stars and flouncing around demanding that their trailer is bigger than the set and that all their grapes must be peeled for them, but when I see them working, and fully engaged in a part, I get the same thrill I get when watching a great musician. The ability to conjure up a personality, often so unlike their own, and to bring to life a page of simple dialog is, to me, akin to the musician who turns black dots into the most heavenly music.

I imagine that you can tell that I am, myself, neither a musician nor an actor; I do a bit of singing but put me on a stage and ask me to portray a character and you will get as good an imitation of a piece of wood as you've ever seen. So I am highly impressed by the alchemy that happens on stage or screen when a troupe of skilled actors comes together to create a performance. I hope that when animating a character I can bring to bear some of the same techniques that an actor might use and, with the ability to rehearse the performance in pencil and on screen many times, create something equally capable of moving an audience.

I think a lot of students and first-time directors have similar feelings about actors, since so many are very resistant to the idea of using proper actors in their productions and prefer to use friends or acquaintances to provide their voices. It can be intimidating to work with someone who has a lot more experience than oneself, someone who may even have worked for a famous director in his or her time, and it's perhaps natural to expect a certain amount of condescension and to feel embarrassed at giving direction to such an exalted person. In my experience though, actors are generally very open and keen to work on all kinds of projects, even some of the most famous will be ready to do a day's work if the project is interesting enough. And you don't have to go after a major name; there are lots of terrific professionals who don't get their names over the title and would be happy to do the work for the experience—and even happier if you have even a little money to give them. The acting profession is notorious for the number of actors who are out of work at any one time, and actors like to work as much as anyone, so a small fee may be better than none at all. They also like to be able to practice their craft and your project might be something that will give them experience they haven't had, a different kind of role or a medium (animation) they haven't tried. And, who knows, you might be the next superstar director and worth cultivating.

A word of warning though, don't think you can get away with paying nothing, or very little, if you actually do have money to spend. Actors often have very sharp agents and you don't want the kind of reputation that sort of behavior can bring, especially when you are starting out.

So, when students are working on their films I will often encourage them to think of the actor they would most like to have for the role and then see if they can get him or her. Sometimes the names they come up with are the stuff of fantasy and completely unrealistic; a Hollywood A-list star isn't even going to get your e-mail, let alone consider it and, even if they did, they are likely to be booked up for years. There is often someone less exalted but just as talented out there, and I have known students get good results from working with local amateur dramatic societies, but don't forget that there are a host of fantastic character actors or bit part players who never get the lead roles because they aren't movie star gorgeous, but can really bring a script to life, and, in animation, they *can* be the handsome hero or the beautiful princess.

But, in the end, if you want A-list talent, there is nothing stopping you asking, you may find that the e-mail does get through and your intriguing idea has Johnny Depp returning your call. Nick Park was just a student when he asked Peter Sallis, who already had a thirty-years career on stage and TV, and had worked with people like Laurence Olivier and Orson Welles, to be the voice of Wallis in his final year film, *A Grand Day Out* (UK, National Film School, 1989).

FIG. 8.1 Peter Sallis and Nick Park celebrate a very successful partnership. © *Aardman*.

The Voices

Casting

More important than getting a well-known voice for your film though, is getting the right voice, the actor who can put across what you want the character to portray and the right sound for the character. It is self-defeating having a famous actor, with a very recognizable voice, if the audience is going to see the actor every time the character speaks, rather than your character on the screen. One of the criticisms leveled at Dreamworks' animated movies, when comparing them to those of Pixar, is that Dreamworks use star voices as a way to get audiences into the cinema rather than for their suitability for the character. While Pixar is not afraid to use a famous actor in a lead role, Tom Hanks is hardly an unknown, after all, neither are they afraid to go with a lead voice from a less famous actor. Ed Asner, the voice of Carl Fredricksen in *UP*, has had a long career in film, and particularly TV, but he is by no means an A-lister and other studios might have been tempted to go with an actor like Jack Nicholson or Dustin Hoffman. And when they use Tom Hanks it is

for a very good reason, as John Lasseter explained after they had used him in *Toy Story*: "Tom Hanks has the ability to make all kinds of emotions appealing. Even when he's yelling at somebody, he's likeable. That was crucial because Woody behaves pretty badly when he's not head toy any more."

I always used to regard it as an article of faith that it was no good having a thin actor's voice coming out of a fat character. While I still think this is true to some extent, in that a fat character with the voice of a famously fit and toned actor will produce some kind of discontinuity, I have seen enough actors give a great vocal performance in a role that does not look anything like them, to know that a good actor can do all kinds of clever things with his or her voice. After all, Mike Myers is physically unlike Shrek but the voice he devised for the character works extremely well (whatever you might think of the "Scottishness" of his accent). And Jennifer Saunders voice worked perfectly in the role of the trainee fairy in *Prince Cinders* Derek Hayes (UK: Animation City, 1993) though she wasn't a spindly schoolgirl.

Having said that you probably should look beyond your circle of friends for voices, it often happens that, when you've lived with the animatic for a while, the scratch voices you may have used come to be the character voices and you can't see a character without hearing that particular voice. In that case feel free to break the rule and go on using the voice that works. This is the kind of thing that happens in major movies all the time, probably the most famous being Brad Bird's voicing of Edna Mode in *The Incredibles*, but at least four of the crew of *Shrek*, including storyboard artist Conrad Vernon who voices the Gingerbread Man, provided character voices. The main thing is, if it works, use it. But make sure it does work, and not just for you and the rest of the crew, but for people who don't know you. In-jokes can be hilarious while the film is being made but they will mean nothing to the audience, so make sure a voice can stand on its own as the voice of the character.

In casting for our film you need to be wary of looking for the actor who seems to be "like" the character you have in your head. Either you will be thinking of other performances by that actor and therefore stereotyping them or, if you actually know them, you may be mistaking the reality of the actor for their ability to play a part. At film school my codirector and I cast a stand-up comedian and entertainer for the role of an entertainer in our final year production, thinking that it would all come naturally to him and he would be happy playing someone like himself. The recording session was a disaster (though he kept us laughing throughout) and later we had to find a real actor to take over the part. What we had forgotten was that, though the main character was ostensibly an entertainer, keeping people happy in time of war, in the story he was also a con-man who comes to realize that what he has been doing is wrong and that he has been exploiting the audience just as much as the government that started the war for its own gain. What we needed was a real actor, a person who could do more than handle the joke telling aspect of the story and, luckily, we were recommended someone who did an excellent job with the part.

While it is important to really know the film you are making, inside-out, you need to leave enough space for other ideas to come in. There are some directors who are very clear what they want and have a cast iron view of the story and the way they want the film to be; they will listen to no ideas but their own and often find it hard to take advice. Stanley Kubrick is a director famous for knowing his own mind and what he wanted and was very secretive, even with his collaborators. To my mind, he had earned the right to work in his own way, but with directors who are starting out I think this is often a sign of immaturity and a fear of the unknown and can result in disaster as soon as one of the problems that inevitably bedevil a production turns up. It is much better to be flexible and open to suggestions and this applies particularly to the contribution of the actors who, after all, are being asked to make a character their own and to inhabit a part so, in a casting session, it is worth listening to what the actor is bringing to the table and not throwing different ideas out immediately in preference to your established idea of the character. So rather than finding the actor who looks like your character, it is better to find the actor who can understand the character and get inside his head.

If you are lucky enough to be able to afford a casting director then use their knowledge and experience to help you get the best possible choice of actors, but make sure that they are on the same wavelength as you and you are working towards the same goals. If you can't afford outside expertise then, by all means, get advice from friends. The same rule applies; make sure they understand what you are trying to do and they are seriously trying to help the production rather than find an actor they'd like to meet.

When working with an actor in a casting session, it is useful to have someone else (preferably another actor) on hand to read in lines so that you can concentrate on what the actor is doing and not be having to think about reading to him. Not only can you see what the actor's ideas of the character are, you can find out how he works with others.

It is often the case that a director will find actors with whom he feels very comfortable and will go on using them in many films. They will become like a stock repertory company and, if they are as multifaceted as Robert DeNiro with Martin Scorsese and Johnny Depp with Tim Burton, they will form a partnership that will help every film become the best it can be. Finding somebody on the same wavelength as you is a great thing, whether it be an actor, an animator, or a designer, and it can save a lot of time and create something very special. The trust that is built up can break through obstacles and allow a collaborator to push into new areas, confident that he has the support and backing of the director and that he is allowed to fail without recrimination and that there will be a chance to learn from that failure and create something better than it would have been by playing it safe.

In fact, one of the director's functions is to make the actor feel safe to experiment and play with a role in order to produce the best possible work.

Cartoony or Noncartoony Voices?

When looking for your actor you need to think about the style of your movie and answer the eternal question; is this to be done with cartoon voices or noncartoon voices? These days few people automatically assume that an animated film or ad needs a special kind of "cartoon" voice; at least those who make them don't. I have seen several websites and have been sent many voice showreels that assume that, because I make animated films I need a special subsection of animation voices, most of which are over the top and attempt to be funny, but fail. A lot of films and TV programs do use voice actors who do exaggerated or intentionally quirky voices but this is a choice and not compulsory for animation; as ever, if it works, use it.

Working out what the vocal characteristics of a character are going to be is, in many ways, a similar procedure with cartoon voices as with naturalistic voices; as with everything else it has to come out of the personality and serve the needs of the story. This is where the director who has a good idea of what she is after can work with the actor to create a character performance, with the director building on what is in the script to give the actor a sense of the tone and feel of the piece.

The Rehearsal

A common misconception is that the rehearsal is the place where the performance is decided upon and finalized and that the recording session is then the place where that performance is captured and recorded. What the rehearsal is actually about is opening up the script, delving into it, and coming to some common understanding; it is about finding out what the movie is about for each character and it is about playing with the material. The idea is not to fix things in stone and then make a recording of them, but to explore the possibilities of the text and clear up any problems the actors may have with it. What we want is to make the performance in the recording studio feel fresh and real, to make it seem like this is the first time these words have been uttered so the rehearsal is there to get everybody to that point.

There are some directors who do not like to rehearse, believing it removes the spontaneity of a performance but, unless they are very lucky, they will be using the time in the recording studio as rehearsal time. Those who make an animatic with a scratch track will, to a certain extent, have been rehearsing themselves but they will still need to convey what they want to the actors and hear their interpretation before they can see whether they are on the right track.

Sometimes, whether you like it or not, you won't be able to get much time to rehearse. If you are a student, and lucky enough to get the actor you want, you may only have her in the time she has between performances of a show. Even if you are working on a feature film you may not have the actor for long, such are their busy schedules. What you will need to do, whether you have

time or not, is to have done your homework and be ready for any questions the actors may have about their character or any other part of the story. You need not have every answer; some of the answers to questions are not going to fall into place until you have worked through things with the actor, and it is good if you are able to admit that you need input on things. Pretending that you have all the answers and then proving that you don't is not a good idea, but being open and ready to put the work into exploring the areas that are unclear will pay dividends.

You *will* need to be able to talk about what the film is about and what it means to you personally, and you will be expected to have an idea of the backstory and objectives of each character. You don't need to go into a rehearsal and deliver a lecture on all this before anybody can get down to work but these questions will come up and you will need to have a good answer. In some cases it is easy to work out why characters are doing things but in others, for example where the film is set in a completely different milieu or time period to our own, you will need to have done your homework and be able to give the actors a convincing reason why they are acting as they do.

I have directed several films that have had either a science-fictional element or been set in the past and, in these unfamiliar surroundings, it is important to be able to answer any questions actors might have about motivation or behavior. It is not enough to answer that that is just how things are, since it gives no clue to behavior or objective, and leaves an actor floundering and liable to fall back on stock, hero or villain acting. In these circumstances, the director should already be a master of the milieu, almost a resident there, and when I work on such a film I tend to do so much research that I feel, for the duration of the project, like a world expert in the subject. This is not only essential for relations with the actors but also for the other members of the crew, as an animator is just as likely to ask why a character is doing some unfamiliar action as an actor is.

Since we no longer inhabit the world of the Old Testament prophets or the court of Louis XIV we have to give the audience a way of relating to the characters that does not depend on being totally familiar with the mores of the time. Naturally, emotions have not changed and people back in the past have all the same drives and desires that we have; no doubt people in the future will continue to have the same emotions and the director's job, in these cases, is to find a way to make those emotions clear in an unfamiliar setting. If the actor wants to know why a character would act in the way he does, we need to be able not only to locate his actions in the historical setting, but to make it clear how that relates to us now. This is another of the jobs that need to be done before you can get started on the work with the actors; more necessary homework. So, in recording the actor, Anthony Sher, for *The Miracle Maker*, I had to have some good answers when he asked about the character's position in 1st century Judean society and the motivation for his actions. Not only did I need to satisfy him on the customs of the time but also to give him

a basis for understanding his actions that would work for a contemporary audience. And given that Anthony Sher is Jewish and I'm not, I had to make sure my research was convincing.

Even a present day setting, where we could be reasonably be expected to understand the motivations of a character, will need research and thought about the reality of each person in the script so that you will have a good idea of who this person is before you go into rehearsal or recording. This does not necessarily mean having a completely fixed and immutable take on the character, because an actor may have many interesting things to add, but you do need to have something to add to; you need to have an opinion of the character.

Research is not confined to the historical or science-fictional, it is a component of any investigation of the script, whether you have written it yourself or have received it from a writer. Directors who write their own scripts can often take things easy on themselves and fail to do the in-depth work needed to make the script watertight; if they haven't shown it to others and listened to criticism, they may find themselves in trouble when an actor wants to know something about their character that is not in the script or is confusing. A lot of these problems can be ironed out if you can listen to criticism or take notes from people who don't understand what the script is saying; even people whose judgment you don't really trust can be useful if it is a case of something they don't understand. People who worked with one very well-known producer (naming no names), used to say; "Always listen if he tells you something isn't right, but never listen if he tells you what to do about it."

What you really need to work out for yourself is the point of each scene and what each character wants to get out of it, you need to understand the meaning of the scene and what its purpose is within the structure of the film. Every scene in a film has a purpose; if it doesn't it should have been taken out early on. Even slow and meditative scenes will tell us something about the characters or set us up for something important later on, so you should always ask yourself what elements of character or plot change in the scene. How has the character developed, or what new information have we been given, so that we come out of the scene with a different idea of some element? Then we need to know what this scene changes in the overall journey of the character or characters. Knowing this you will be able to guide the actors on their explorations of the characters.

You may well want to show examples of design work, character turnarounds, or other preproduction materials to give the actors a better idea of what their character is going to look like and the environment in which he will operate or you may show them the storyboard to give a better idea of the physical actions the character will undertake. Alternatively, it can be difficult for people not used to the process of animation to understand boards and sketches so you may want to just give them a verbal description of the scene and let them take it from there; you will find what is best for you by trying things out.

If it is possible to work with the actors before you go into the recording, then you have the time to build the character with the help of someone who is used to getting inside the skin of other people. Take the time if you can.

FIG. 8.2 Despite not understanding the language of the characters in "Skywhales," the way it was said combined with their body language to make it clear what was going on.

Collaboration

When Phil Austin and I created our film *Skywhales,* set on a planet where the inhabitants floated miles above the mist shrouded ground on islands of vegetation, we decided that the characters should speak to each other in a completely alien language. We wanted them to be able to converse and that the addition of a language would make for a more real alien world. We felt that we could make the speech understandable by the use of body language and so we got together with the actors to see what we could come up with in the way of a special sound. We spent quite a while making meaningless noises that all seemed to end up sounding like something from Eastern Europe. It was only when one of the actors hit upon the idea of making sounds while breathing in, rather than out, that we got the sounds we wanted.

After we got the sound, the next thing was to get the sense. We wanted the speech to sound like there was real communication going on, so we wrote out an actual voice script in English and allowed the actors to "translate" it as they went on. That way we got a repetition of sounds, for words and phrases that were the same in the script and a huge bonus in the way that, when the actors had to come up with the translation "on the fly," the dialogue felt wonderfully spontaneous.

In the end, of course, this is your creation, so you need to be satisfied that you have got the character that you want and you must be confident in your own ability to spot the attributes that need to attach to that character. Stick up for what you believe in and what you want, but come to the table with an open mind and a willingness to listen and learn and everyone will benefit and the project will only get better. Not all the ideas need to be yours and you don't need to have all the answers, this is a collaborative medium and nobody working with you will feel that you have stolen their ideas if you use one to make the film better. Sometimes it can happen that, having worked on a film for a long while before the actors even come in, things can become a bit mechanical and even boring and that a surprising idea or take from an actor can blow the cobwebs away and make things fresh and exciting again but the only way to capture this is to be prepared. Thorough preparation is the only way that you will be able to give the actors what they need and the only way to be ready to grab those spontaneous moments that John Stevenson talks about in his interview on the book's bonus website. It may be a cliché but it's true; Fail to prepare, prepare to fail.

The Recording

You would have noticed, if you watch the extras on animation DVDs or read interviews with actors who have provided character voices, that most recording sessions for feature animation take place with each actor recording his or her part separately to the other actors. Usually this is put down to the difficulty of getting well-known actors together at the same time, though this doesn't seem to be a problem when they all have to appear together in a live-action movie. The difference, I suppose, is that they are usually fitting these sessions in around live-action work and the upside to this way of recording is that you can get the actors that you want even if their schedules do not allow them to all be in the same place at the same time. With a live-action film, actors often have to drop out of a production they have been in line to do if the schedule comes to conflict with one on which they are currently working. In this way you can get a lot more stars into one movie than you might have been able to get if they all had to be there at once.

I have always tried to record actors together wherever possible, believing that interaction brings out a more natural performance style and that actors working together like this create a better rhythm than ones working in isolation. However, we can point to a host of hugely successful films where the actors never met up until they were walking down the red carpet at the premiere, so it really depends on the circumstances of the production and your own style how you prefer to go about this. In *Rango*, directed by Gore Verbinski (USA, 2011, Paramount), the actors not only got together to record the voices, they wore costumes and performed in a rudimentary set in order to get into the spirit of the thing. When Verbinski, who had never done a fully animated movie before, was asked by the New York Times why he had

done things this way, he replied; "I guess fear, really. Fear of a microphone and a cold environment and nobody's reacting to anybody. We didn't want a performance that was too clean. If people are running, I want to hear them out of breath in the next line when they stop and talk."

Working with the actors together in one room does mean that there is an organic feeling to the takes and allows for the possibility of ad-libs, it allows the actors to work off each other, but it also means that there is much less room to open out a performance if there is a piece of action the actor has forgotten or doesn't know about. In this case, it is a lot harder if there is no room to get the scissors in between two sentences, but not always impossible. Because of this, it is the director's job to know exactly what she needs from a scene and already have a feel of the rhythm of the film in her head (see below).

Even when the actor is recorded alone, there will need to be someone who reads in the other character's lines to him and I'd advise hiring another actor to do the job, because they will be able to produce a performance of the lines that will give the main actor something to feed off. What you are trying to avoid is a performance that becomes too technical because the actor is thinking of the problems of the editor rather than his own.

If you can't afford to hire an actor just to read in the lines (and on low budget productions it is sometimes possible that an actor who has a minor part will be willing to do this for a small extra payment, or even the experience) try to get someone other than yourself to do it. What you need to do is to focus on listening to the actor's performance, and you can't do that if you are trying to read in lines.

Be Open to Change

If you have had time to prepare and rehearse, you may have shown the actors things like storyboards, if not you may want to take them in to the recording. As above, this might help certain actors and not others, so be prepared to do quite a bit of explaining with regard to what will be going on up on the screen while these words come out. This is where the need to have the film fixed in your head is vital; you need to be able to answer any question that gets thrown at you with regard to the character, staging, or the environment. However, this doesn't mean that everything is fixed and set in stone at this point, the director who has a real grasp of the film will also be the one who can change things if a better idea comes along. Any change to a personality or to interactions between characters will ripple through the film changing things before and after that point, so a new way of saying a line that opens up a whole new way of relating to a character will have repercussions for existing relationships and ones to come. It is at this point that a director who has really got inside the film will be able to make the decision that this new point of departure can be incorporated into the structure and that things can

be changed to accommodate it. Don't be afraid to give yourself time to think it through; you can tell the actor that what he or she has done has given you a new idea and that you need a moment to process it. Nobody will want to rush you if they can see you are engaging with the material and an actor will be happy he has given you food for thought. Once again, let the actor into the conversation and work through the ramifications with him if that will help you.

There is always a terrible pressure when you are in a recording studio to keep moving and just get the lines due to the high cost of the studio and the, often higher, cost of the actor's time. This is why rehearsal is useful, but if you haven't had that and you come upon some part of an actor's performance that is going to affect the film, for good or ill, you need a little time to work through the ramifications. If you have a good producer, he or she will understand the need for a momentary pause and will be able to give you a little space to think. A good decision at this point may well save time and money down the line.

How to Talk to Actors

If you have done some acting you may find nothing easier than understanding and talking to actors but if you are the typical animator who reserves his acting for the pencil or the computer, you may find that it is difficult to get over what you want. Actually, if you are directing the film, then you will be a lot more outgoing than that implies and you will be used to talking to people like producers and able to give direction to animators and all the other people on the film crew. Even so, to many of us, the actor is a strange beast and it is not always obvious how to handle them. [If you really have problems in this regard (and can afford one) I would recommend hiring a voice director; not to take over completely, but to translate what you want into what the actor is used to hearing. It may only be a problem with terminology.] But actors, even the famous ones, are just people and people who have agreed to be here in the recording studio with you because they saw something in your project that they wanted to explore. They are used to the collaborative nature of the process and, most importantly, you are the director and you know so much more about this film than they do so they know they could take the script in lots of different directions but they want to work with you to find the right one.

The other important thing to remember is that it is a daunting business being an actor and putting yourself out there all the time, on stage or in front of the camera, and they may well be more nervous than you are. From being worried about how they will react to you, you will find yourself looking after their well-being by creating a space in which they can do their job and explore the role in complete safety.

Before each take, you need to say a little something to get the actor focused and moving forward. At the start it is easy, you will need to give them the context of the speech and the actual, physical actions you envisage the

character doing; unlike a live-action film, they won't actually be able to do the actions and any physical gestures will be limited by the space available in the booth or the studio and they will have to act the physicality of the performance. Unless you set up a studio in the way that Gore Verbinski did for *Rango* with boom mikes to follow the actor, he will be constrained to the space in front of the microphone but many actors will try to get as much real physical movement as possible into their performance in order to make the end product fit the character's action and you will need to be clear what exactly is happening in the scene.

Once this is clear, any other remarks you make will need to help take the performance forward. Having done your homework, there should be a number of different ways that you have come up with to do a line or imagine possible thoughts going through the character's head (See John Stevenson on working with actors on the book's bonus website.) and you should be able to bring something new to bear on each take if the actor is not finding what you want. If he is getting there and it is just a question of a slight modification you need to be encouraging, acknowledge that you're making progress and come up with a note that will improve the performance. Don't be afraid to take the time to think something over but don't leave the actor hanging, wondering if he has done the right thing; it is best to say thanks and ask for a moment to think about how that take will fit into the scene. You have the advantage of having the film in your head, and since it is an animated film, it will not be as obvious to the actor how it is going to turn out as it might be if you were shooting a cowboy movie in the middle of the desert.

If a take is unusable because of a technical problem, it is no good telling an actor to do another take just like the last one, that will take them out of the moment and have them looking back and attempting to call up something they have already done, which will lead to a stilted performance. Instead, try to keep them moving forward by your use of language: "I'm afraid we had a problem with that take. Can we go again and keep the energy flowing?" Or "Can we go again, it's working really well?"

We all prefer praise to criticism and actors are no exception to the rule so it is important to keep things buoyant and give praise where it is due, but actors aren't stupid and know when something isn't right, so it is also important to be honest. If a scene isn't working, it is worth taking the actor into your confidence and confiding in him that there is a problem. It may be something that the actor hasn't understood, or the actor may not be getting into the part, and in both cases you will need to find a way to help him through it. In the former case you will need to take responsibility for not explaining things properly (even if you think you did) and you need to find the words that will make things clearer. It may have something to do with an assumption that you are making that is not shared by the actor or a bit of information that is missing that seemed so obvious to you and yet was not obvious to him. In the latter case it is worth thinking about the way you are giving direction and asking yourself whether you are giving playable direction.

Verbs

One of the best ways to help get over obstacles in obtaining a performance is to employ the technique of working with **verbs** rather than trying to psychoanalyze the character. The problem with going ever deeper into a character's psyche is that most characters, rounded characters, are too complex to explain easily and any analysis will often go round in circles or become so simple that it isn't possible to get anything interesting out of the character. Simply saying, "do it faster," or "take it easier" can work in certain circumstances but used too often become bland and meaningless. Asking for "more anger" doesn't hang a performance on anything real and is impossible to quantify; how much anger is enough?

The idea of using verbs is that, as my primary school teacher used to say, a verb is a "doing word," and character comes out of action. Some verbs are more useful than others when recording dialogue; since we are dealing with character interaction those are obviously ones that involve someone else, what acting coach Judith Weston calls "action verbs." So when we want to deliver a character who is angry with another character, it is often better to ask the actor to "scold" or "intimidate," actions that are very playable.

It is well worth reading *Directing Actors* by Judith Weston to get a very full and useful account of the idea (and of many others vital to the process of acting and directing).

Line Readings

I have always understood that it is wrong to give an actor a line reading, i.e. acting it yourself and saying, "do it like that," and it surprised me when a couple of the people I interviewed for the book's bonus website said that they had done this or, in one case, been asked by the actor they were directing, to do this.

My resistance to the idea comes out of the fact that I don't think I could give anybody a clue to what I really wanted by acting it out; as I said at the head of the chapter, you would get a fine imitation of a plank. Nevertheless, I can see that there are ways in which this can work. Joanna Quinn is adamant that, since she is the one who knows the material, and knows what she wants, she can give the actors a better idea through acting it out than she could by explaining things. What she also goes on to say is that, in acting it out in front of them, the actors can see the kind of thing that the characters will physically do when she has animated them. In Joanna's case, this is even better than showing them the storyboards since she will be in total control of the animation and the end result is likely to be very close to the spirit of her acting. In addition, she is clear that the actors will build on what she gives them and she is very happy with that. Some young directors will have an idea of a performance and will not be confident enough to let the actors explore the different possibilities inherent in the idea. They often try to get

a performance that exists in their head into the head of the actor by acting it out and expecting the actor to follow to the letter, a technique that rarely works due to the fact that what we hear when we speak is not what other people hear as anyone who listens to a recording of their own voice will know. If, as in John Stevenson's experience with Dustin Hoffman (Interviews), the actor asks to hear our version of the line it will be so that he can understand, in some small way, how we hear it in our head before he builds his own (better) version.

Feedback

Finally, make sure there is only person who gives the actor direction. That person will usually be you, the director, but you may have a voice director to whom you have delegated the task, something that can occur when you have a series to direct and the voice recording takes place in another city or another country. When I directed *The Miracle Maker*, I had the fantastic support of voice coach Joan Washington who not only helped get the actors on the same page with respect to their individual dialects for the movie, but gave invaluable support when I had to find ways to work with some very famous actors, many of whom had not worked on an animated movie before. Even so it was important that the feedback to the actor came from me, the director, even when we had both discussed what I was going to say and would probably have said the same thing.

A Few Extra Thoughts

Be inventive, don't be too rigid about what you want because good things can turn up when you allow yourself to play. Similarly, if you are seen to be open and ready to listen then you can give the actors space to make mistakes. When they know that you are prepared to try things differently and that there is not just going to be one take the pressure is off and they can concentrate on coming up with a real performance. Mistakes can also lead to insight and new ways of doing things if you are not completely wedded to one way of doing things.

Concentrate. The director's immersion in the scene is vital and the only way to know whether you have the performance you need. That concentration will also communicate itself to the actors and make them feel supported in what they are doing. I often listen with my eyes closed when playing back a take so that I am not distracted by what is going on in the studio and I can see the character rather than the actor when I hear the voice.

Try it yourself. I would always recommend that a director ought to have some understanding of all the jobs on a production, from top to bottom. Even if he can't do them all, understanding what they entail will give an insight into how long something might take, will allow him to make useful suggestions when there are problems, will garner respect from the crew, and will make sure

nobody can pull the wool over his eyes when he asks for something difficult. While a lot of directors agree with this idea when it comes to the technical jobs on a production, a much smaller number will have actually tried to do some acting themselves. No doubt, like me, they realize they have no talent for it but, without at least having a go, it will be very difficult to understand what the actor has to do to produce a performance. It will also mean that the empathy between director and performer is harder to achieve and there will be fewer ways in which you can help the actor to come up with the characterization you want.

There's no need to join your local amateur dramatic society or do the odd open mike comedy night, though both are good practice, but it is worth seeking out any part time acting classes or workshops in working with actors. They can often be found through local arts organizations, theatres, or directors' professional bodies. It is well worth seeking them out.

Live Action and Animation

Most of what we've been talking about in the above section is applicable when working with actors who are actually going to be seen on screen and, indeed, will also come into play when we start to talk about Motion Capture, but it might be worth taking time to look at a couple of other things you might want to think about when your acting talent is in vision.

It might seem like a very modern idea to have to act without the benefit of a set or without the other characters being there and, if we are talking about CG and digital environments, it is indeed a pretty new thing. But of course, the VFX shot has a long history within cinema, and we are still celebrating the skill of a film maker like Ray Harryhausen who could make skeletons fight with real actors and metal giants menace men in sailing ships. We have seen Gene Kelly dance with Tom Mouse and Mary Poppins flew in to dance with a bunch of cartoon Cockneys well before there were computers to help out. What we often forget, though, is that acting started out without sets or props, and that costumes were the clothing of the day rather than historically accurate recreations. Greek, Roman, and Medieval stages paid little attention to sets, and the chorus or the actors would speak lines containing information about where they were supposed to be. The creation of more detailed and realistic sets dates from the Renaissance, when the discovery of the rules of perspective, and their subsequent use in architecture and painting, led to an interest in creating the illusion of a more realistic world on stage.

Even in the movies, with realistic sets or location shooting, the actor has to cope with the unreality of the camera crew behind the camera and the microphone dangling over her head when she is supposed to be totally alone on a desert island or floating in space.

Let's not forget too, that actors playing Macbeth have been looking at nothing and asking; "Is this a dagger I see before me?" since the play was first

performed, so making believe that there is something there when there is just an empty set is part of an actor's training.

This is not to say that it should be as easy to perform under these conditions as it is when there are all the sets, props and other actors around and we need to make sure that we give the actors all the help they need to get into the world we are hoping to create.

The first thing we need to do is something that is important anyway, and that is to make sure that we have gone over the story and all the attendant character considerations before we start. The actors need to understand what is happening in the scene and what bearing it has on their character and the rest of the story, so you need to discuss character objectives and motivation as much, if not more, than you would normally do. It is worth going through everything you have that can give them some clue as to how the finished scene is intended to look, whether it be storyboards, color stylings, character designs or any finished animation. This should help them to get a sense of the space they are operating in and the feel of the piece so they can adjust their performance to fit.

It may take a little time for the actor to get used to the lack of set or costar so you need to allow time for acclimatization, for the actor to find and start hitting the marks, for example, before you can go for a real performance.

It will be up to you to make sure that there is a consistency in the performances, especially where some scenes will be shot in conventional settings and some will be created in postproduction. It will be much easier to maintain consistency where the whole project is done in the same way, but if this is not the case, and there are some scenes where the actor is working with other actors and some where he is working to something like a ball on a stick, you will need to be on guard for any change in the way these scenes are played.

When you have done your preparatory work there are a few practical considerations to bear in mind, one of the most important being eyelines. As we have noted before, it is human nature to look at the eyes of the person you are listening to and the audience will be attuned to where the characters are looking. If the eyelines are consistent between characters, they will give much more credence to the situation, even if it is obvious that it is make-believe. This is what makes a film like *Who Framed Roger Rabbit* work so well, even though we know it is impossible and Richard Williams, in *The Animator's Survival Kit*, is particularly useful on this point.

In *Captain America, The First Avenger*, directed by Joe Johnston (USA, Paramount Pictures/Marvel Studios 2011), Steve Rogers, a puny weakling who wants to serve his country, is transformed into the eponymous hero by the use of a "super serum." Chris Evans, who plays Steve Rogers in both his sickly and super-heroic selves, needed to be slimmed down for the former part of the role. Some of this is done using a skinny stand-in actor with Evan's face digitally attached, but most was done by digitally shrinking his actual body.

183

In doing so, it was important that the eyelines between him and the other actors matched since he was at least six inches taller in the Captain America role. To do this, he would look at his costar's brow in dialog scenes and they would look at his chin and, when riding in cars, his seat was actually built lower than that of the actor next to him.

Similarly, it is often best to try to get what you want in camera, when you are shooting, rather than leave things to be fixed in post. If, for example, you have a character talking to a robot with glowing eyes, and the CG robot will be added later, it is better to shoot the actor with a little extra light falling on his face from those eyes. It is tempting to add the light in postproduction, but there is a difference between a face that is modeled by real light and one that has had light added by computer. Although it isn't impossible to create a realistic effect in this way, it is something that will take more time, effort and money and you may find that there is just no detail in the shadows that you can pull out when you try to lighten that area. Likewise, anything that will set an animated character into the world you are creating that can be done on set or on location, should be done, especially simple stuff like creating a bit of shadowing from the cartoon character on the actor. As long as you understand what you are going for in the scene it should be an advantage rather than a hindrance.

Motion Capture

The process of capturing the motion of various subjects for analysis and as part of a process of producing animation goes back quite a long way. One of the earliest and arguably best known examples of capturing, or perhaps more correctly in this instance, recording motion, can be seen in the work of Eadweard Muybridge, the British photographer who conducted a series of investigations into the motion of animals and humans in the latter part of the 19th century. Through his now famous sequences of photographs, we have gained a more thorough understanding of animal and human locomotion and other movements. His work remains relevant to this day and is used by animators and artists alike.

One of his contemporaries, Etienne Jules Marey, was also working in the same field of motion analysis but he was more interested in the mechanics of motion and the analysis of animal locomotion and dynamics. To this end, he developed a series of devices and conducted many experiments using both animal and human subjects. His inventions were used to automatically record the various motions of a figure and represent these movements in graphic form. His mechanisms represent some of the earliest known motion capture systems.

While Muybridge was interested in recording of motion and the commercialization of his results through the publication of large portfolios of photographs, Marey was more interested in the practical implications of his findings to the furtherance of medicine and our understanding of locomotion.

The first practical example of how motion capture influenced animation probably comes with the development of rotoscoping by the Fleischer Brothers around 1915 and first used on the *Out of the Inkwell* series starring Koko the clown. The process of tracing off, by hand, individual frames of previously filmed footage of a live subject gave the animation a completely naturalistic action. Using rotoscoping, and other techniques and methods of referencing live motion, quickly became standard practice, particularly in feature film animation where a higher standard of animation with more naturalistic action was sought. Disney's *Snow White* and the Fleischer Bros. *Mr. Bug goes to Town* are both examples where the rotoscope is used to help create animation for the main characters. Its use in *Snow White* has been criticized as creating a separation between characters done in this way, like Snow White herself, and those done in a traditional animation way, like the Dwarfs, but in the Fleischer film it serves to enhance the difference between the world of humans and that of the insects who are the main characters.

Modern day motion capture follows in these same traditions and still seeks to make major contributions in the field of medicine and more latterly has applications in sports science, though it is perhaps the way it used in entertainment that we have come to know it best. Used quite extensively within the computer games industry, it has been a valuable tool for sometime in the creation of animated actions that then form the basis of the game play. While this initially resulted in what could legitimately be classified as generic actions, the move has been away from this and toward achieving more individual movements that are associated less with *typical* actions and more with *individual* actions. This has led to a more performance-based approach to motion capture. The distinction between real and the animation actor is becoming increasing blurred.

There is a very big difference between simply capturing motion and capturing a performance. In searching for ever more naturalistic animation that involves capturing the traits and behavior of individual personalities, we have seen the rise of the animated performer. A new breed of actor has been born from this discipline and foremost amongst them is Andy Serkis. Most noted for his performance as Gollum in the Peter Jackson feature *Lord of the Rings* (2001–2003) Serkis has become widely acclaimed for his various roles and has won a number of awards.

His acting skills are much in demand and lead roles in *King Kong* (2005), *Rise of the Planet of the Apes* (2011), and *The Adventures of Tintin* (2012) demonstrate the potential of performance capture and Serkis' talent. This seems to be nowhere better illustrated than in his performance of Gollum which is particularly evident in the sequence in which Gollum is seen to engage in an internal argument with his other personification, Smeagol. Both Smeagol and Gollum struggle over whether he/they should kill the hobbits he/they are guiding towards Mount Doom in Mordor. The acting is subtle, with the performance of both personalities (within the single character) being very distinctive. It is clear that the acting of the performance capture actor at

this level is about thinking, emotions, and internal dynamics that make up a character's personality and are dealt with in exactly the same way as any other acting job. This is not simply about movement or action.

Naturally, there is still a good deal of animation being made in which the need for action is paramount with far less emphasis being placed on acting. Still, it could be argued that even in these cases the physicality of the performance captured needs to be handled with care if the movements are not to end up being rather simplistic or over the top not really naturalistic but simply imitating naturalism in a rather crude manner.

In this regard, the role of the actor creating a performance capture sequence is not dissimilar to that of an animator dealing with a figurative character based subject. They will both need to 'become' the character they are acting if they are to get the best possible performance. If they can think like the character they are then in a better position to be able to move like them and if they can move like them they can then begin to *act* like them.

In order to avoid formulaic or generic movements, it is important to understand that personalities have individual mannerisms. Consider for a moment how you are able to recognize at a distance family members, friends and even passing acquaintances. They are recognizable from their gait, their body language and behavior that may be evident even if only glimpsed for a second or two. There can be no doubt about it that it is easier to establish the action of a generic character. Take for instance the animal behavior of a primate grooming a fellow member of the troop. Such an action may be recognizable as the movements and behavior of a chimpanzee but the difficult here is not in creating the action of a chimpanzee (though even that is not easy) but in creating a performance for a character with a personality and *recognizable* animation for a *particular* chimpanzee. This leads us back to the realm of acting and performance, not simply creating movement.

Mannerisms that may be associated with a particular character and are then associated with that character by the audience need to be built up over a period of time. Gollum not only had his distinctive voice and that dreadful cough, he also moved with a distinctive gait. Even when not walking, the way he held his head, the manner in which he hunched his back and his cowering mannerisms were all very distinctive and became quickly recognizable.

It is interesting to note that Serkis has a thriving acting career that includes but is not limited to performance capture though there is little doubt that the term *performance capture* has gained currency because of his performance abilities.

Less well known to people outside the industry is William "Todd" Jones whose work has been seen in films such as *Lost in Space* (1998), *Harry Potter and the Order of the Phoenix* (2007), and *John Carter* (2012), as well as numerous computer games. Todd has lots of interesting things to say about performance capture on the book's bonus website, but it is interesting to note here that, having worked with Aardman Animations, he finds his attitude to creating

performance is identical to theirs, that he and the Aardman animators are doing the same thing.

Jones says, "The character, the narrative, the hook into how that performance may work, those processes are all the same… Your end result is to provide a believable, empathic character for an audience, who will respond to it. It works because they engage with it… by giving it a rhythm that represents life, the audience breathes life into it and they believe it. It only works if the audience believes it and the easiest route I've found, to that, is me believing it first."

FIG. 8.3 Todd in performance capture suit.

So it is important that the performers you are using for performance capture are treated like any other actor since what they provide will be the basis of the character performance. It often happens that you will need to tweak the data you get to ramp up or exaggerate the acting so that, for example, a character

design with very heavy brows raises an eyebrow much higher than a human performer could. Even so it will be the initial performance that will give you the essence of the character and the skills of the performer need to be combined sympathetically with the skills of the animator who takes the data further.

Practically speaking, there will also need to be assistance on set that will help the actor to give a believable performance, especially where outside forces are concerned. As noted in Chapter 6, Making a Performance, bullet hits in live-action films are often made more dynamic by harnessing the actor to a rope and pulling him over so that it appears that an outside force is acting on him and he doesn't have to push himself over. The same trick is used in the motion capture studio to simulate bullet hits and other techniques need to be invented to portray other forces impacting on the character. Animator Billy Allison, who often works with performers in motion capture studios, before going on to work with the data in the computer, talks about what he needs to do to help out in creating a performance: "For physical impacts etc., say like firing a gun etc., I would actually get onto the mo-cap area and hold the gun and make it 'fire' so that the whole jolt shows in the character's body and doesn't simply look like its them acting the recoil. I actually hold the prop and hit it with my other hand to create the recoil effect."

The implications of performance capture on animation production are far reaching. The use of motion capture in games animation and feature films has been possible because of the substantial budgets involved in their productions. However, with the development of technology, we have seen the prices tumble. The use of interactive gaming consoles such as the PS3, Wii and the Xbox 360 and others that use motion tracking through cameras, hand held devises and other sensors for their interactive games the technology of motion capture is become increasingly prevalent. This has opened up possibilities for its application within productions that have far more modest budgets. So fast is this technology developing that anything that I am likely to write here will be out of date by the time it is sent to print. Suffice it to say that I currently have postgraduate students working motion capture set ups they developed independently within their own very modest studios using off the shelf hardware and software available on the internet for less than £500. They are then applying the motion capture data to the models they have built in Maya. Now it is fair to say that this does not, as yet have the sophistication of the more established motion capture facilities used for the likes of *Lord of the Rings* but as more developers become involved this technology, as happened with the other tools of production this more technically advanced kit will reach the hands of independent producers and students alike. We are already seeing motion capture being implemented in more modest TV productions. It is not that long ago that animation production required considerable investment and was the sole prerogative of production studios and broadcasters. Animation is now being made in schools as a matter of course; how long will it be before motion capture enters the classroom?

If there is one constant thing in life, it is change. Everything changes, all the time and animation is no exception to this rule. In recent years, we have seen very many changes to the way in which animation is produced, distributed, and consumed but far from seeing these developments as a threat I believe that most animators are very keen to adopt new technologies and embrace these changes. Most are very keen to explore the possibilities that these developments offer. Just as rapid prototyping and 3D print technology is having an impact on stop-frame animation the developments in motion captures are set to have a major impact on how we produce and therefore how we teach animation. There could be even more of a case for animation students to engage in acting and performance classes.

Summary

Working with actors can be challenging, especially if they are new to the demands of animation, but if you are well prepared and know your material thoroughly and come to the collaboration with an open mind, there should be few problems.

Make sure you get the best actors you can and don't settle for friends' voices because you think they will be easier to deal with; you will notice the difference further down the line.

Be open to the fact that this is a collaborative process and that the actor may have some insights to bring to the table, but make sure that you know what you want and what you need to get. If you know your story and the characters as well as you should do, then any suggestion can be quickly mulled over to see if it slots into the overall structure of the piece. You can then either accept it or reject it with thanks and a short explanation that it doesn't work with your overall concept.

Likewise, if you start to have fun in the studio and the actor is making everybody laugh (or cry) don't lose sight of the film as a whole and the fact that this has to fit with all the other performances and the theme.

If you can, get a better understanding of what the actor has to do by doing some acting yourself, whether it be amateur dramatics, stand-up, or acting classes.

Remember, if the audience is to believe in a character, the actor has to believe in him too, and for that to happen, you need to believe in the character and the actor's ability to create him.

Index